MYSTERIES
OF THE
SNAKE GODDESS

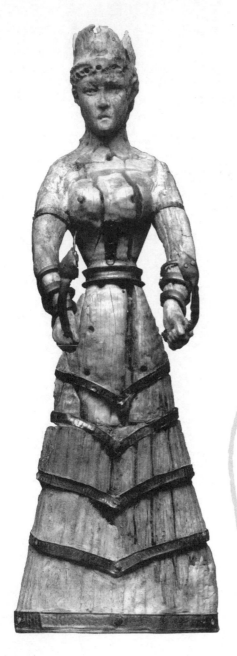

What is the Lady?
The gold and ivory
Boston Snake Goddess,
actual size.

Mysteries

OF THE

Snake Goddess

ART, DESIRE, AND THE
FORGING OF HISTORY

Kenneth Lapatin

Houghton Mifflin Company

BOSTON NEW YORK

2002

For information about permission to reproduce selections from
this book, write to Permissions, Houghton Mifflin Company,
215 Park Avenue South, New York, New York 10003.

Visit our Web site: www.houghtonmifflinbooks.com.

Library of Congress Cataloging-in-Publication Data

Lapatin, Kenneth
 Mysteries of the snake goddess : art, desire, and the forging of history /
 Kenneth Lapatin.
 p. cm.
 Includes bibliographical references and index.
 ISBN 0-618-14475-7
 1. Minoans. 2. Art, Minoan — Forgeries. I. Title.

 DF220.3 .L37 2002
 939'.18'072—dc21 2001051892

Book design by Anne Chalmers
Typefaces: Minion, Deepdene

Printed in the United States of America

QUM 10 9 8 7 6 5 4 3 2 1

In memoriam

ÉMILE GILLIÉRON *père et fils*

and all other fashioners of Minoan art

ἐπεὶ δὲ τῶν τὰ Κρητικὰ γεγραφότων οἱ πλεῖστοι
διαφωνοῦσι πρὸς ἀλλήλους οὐ χρή θαυμάζειν ἐάν
μή πᾶσιν ὁμολογούμενα λέγωμεν

> Seeing that the greatest number of those who have writ-
> ten about Crete disagree among themselves, there should
> be no occasion for surprise if what we report should not
> agree with every one of them.
>
> —Diodoros of Sicily, *Historical Library* 5.20.8,
> first century B.C.

CONTENTS

Prologue 1

1 THE BOSTON GODDESS 4

2 THE PALACE OF MINOS 30

3 THE DIVINE MOTHER 66

4 BOY-GODS, BULL LEAPERS,
 AND CORSETED GODDESSES 91

5 EVANS AND THE GILLIÉRONS:
 MAKING AND MARKETING THE PAST 120

6 THE ROAD TO BOSTON 140

7 SNAKE GODDESSES, FAKE GODDESSES? 153

8 THE UNCERTAINTIES OF SCIENCE 176

APPENDIX 1:
 The Cast of Characters 191

APPENDIX 2:
 Some Unprovenienced Cretan Statuettes 194

APPENDIX 3:
 Analytical Report on the Ivory Snake Goddess,
 by Richard Newman, Head of Scientific Research,
 Museum of Fine Arts, Boston 196

Notes 205
Bibliography 227

Acknowledgments 248
Illustration Credits 252
Index 256

MYSTERIES

OF THE

SNAKE GODDESS

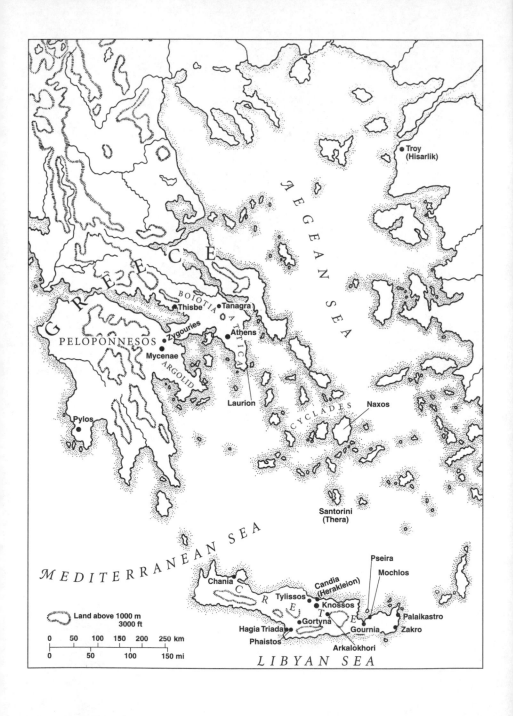

Troy
(Hisarlik)

AEGEAN SEA

G R E E C E

BOIOTIA
Thisbe • • Tanagra
PELOPONNESOS
Zygouries •
• Athens
Mycenae •
ARGOLID
ATTICA

Laurion

Naxos

CYCLADES

Pylos •

Santorini
(Thera)

MEDITERRANEAN SEA

Pseira

Mochlos

Chania •
Candia
(Herakleion)
Tylissos •
• Knossos
C R E T E
Palaikastro
Gortyna •
Gournia
Zakro
Hagia Triada • •
Phaistos
Arkalokhori

Land above 1000 m
3000 ft

| 0 | 50 | 100 | 150 | 200 | 250 km |
| 0 | | 50 | | 100 | 150 mi |

LIBYAN SEA

\mathcal{P}ROLOGUE

"What is 'the lady'?"

Ron Phillips motored down to Oxford from his home in north Wales that Saturday morning in May and made his way straight to the Ashmolean Museum. Built around artifacts donated to Oxford University by Elias Ashmole in 1677, the Ashmolean boasts of being the oldest public museum in the world, and its collections are outstanding. Phillips, however, had not come to see the exhibits. The retired policeman was working on a case. In researching British military cemeteries on Crete, he had encountered an anomaly: the grave of an American, Richard Berry Seager, who was not even a soldier. The Michigan-born Seager, handsome, charming, and independently wealthy, had enrolled at Harvard in 1900 but soon dropped out on account of poor health. Having suffered from a "weak heart" since childhood, he journeyed to Germany to consult a specialist. Little is known about his movements for some time, but by the winter of 1902–3 he was in Athens. Although his doctor reportedly gave him only a short time to live, Seager traveled widely during the next two decades, devoting himself to archaeology. At the beginning of May 1925, he sailed to Egypt. He had witnessed the spectacular opening of the tomb of Tutankhamun two years earlier and wanted to follow the progress of the excavation. According to his biographers:

> After visiting the dig at Luxor, he left Cairo on Saturday, May 9. He appeared to have been in perfect health while in Cairo, but he complained of a bad headache. He reached Alexandria about

noon, and he immediately boarded the boat for Crete. Later he took some tea and was cheerful despite not feeling well. When he awoke on Sunday morning he had a fever and was in a daze, but coherent. By that evening he became comatose. When the steamer arrived at Candia, Seager realized where he was and even recognized the boatman operating the lighters, but he was barely able to move. He was taken to a small private hospital where he was put in a comfortable room.[1]

Seager's friend Sir Arthur Evans, renowned as the excavator of the Palace of Minos at Knossos, received in Athens a telegram informing him of the American's sudden illness. "I was so anxious to do everything possible," the strong-willed Evans later wrote to a cousin, "that I took steps to get a despatch boat given by the Greek Government — which they would have done — to take the best doctor in Athens, but before anything could be done we received news of his death."[2]

Seager was only forty-two when he died, on 12 May 1925, and because he had visited Tutankhamun's tomb, his death was soon attributed to an ancient Egyptian curse. But the archaeologist was far more intimately connected to Crete than to Egypt. He had excavated at various sites on the island since 1903. The generous, soft-spoken American was well liked by the local people as well as by the foreign archaeologists who, since the beginning of the century, had been uncovering the legendary "Minoan" civilization. Arthur Evans informed his cousin that he himself got to Crete "just in time for the funeral. It was a very impressive public one, in which the Government as well as the local authorities took part, and we finally laid him in the little English cemetery on this side of Candia, beside British officers that he had known. He had taken a little house near here and it is a great loss. He was the most *English* American I have ever known."[3]

In the course of investigating Seager's life and sudden death, Ron Phillips had encountered certain letters in which the archaeologist cryptically and apprehensively asked for news about "the Lady." Seager wanted to know what had happened to her and whether he

could get her back. He worried that she might think fit to visit upon his head "her displeasure at being dragged about." Curious to learn who this Lady was, Phillips quite reasonably thought that someone at the Ashmolean might be able to enlighten him, for Seager, with the permission of the Greek authorities, had sent the museum (as well as the University Museum in Philadelphia, the Metropolitan Museum in New York, and the Museum of Fine Arts in Boston) artifacts he had excavated on Crete. Moreover, Seager's friend Evans had for many years served as keeper of the Ashmolean and had later become a generous benefactor, giving it the finest collection of Minoan antiquities to be found outside of Crete. Evans had also bequeathed it his archaeological notebooks, letters, and other papers. So it was here that Ron Phillips sought clues about the "Lady."

Saturday, however, is not a good day for conducting business in museums. Offices are closed, and staff are away. And Phillips had only a few hours before he had to return to Wales. But he was lucky, and so was I. My wife and I were renting a drab suite of college rooms in Oxford. We had planned to take a walk through the countryside that morning, but had not yet gotten started. The curator on duty at the Ashmolean was Michael Vickers, who, like his colleagues in other departments, has to work occasional weekends. Vickers, whose official title is senior assistant keeper of antiquities, has long had charge of the museum's classical collections, the artifacts from Greece, Rome, and the prehistoric Aegean. He also oversees the Evans Archive. When the retired policeman showed him rough transcriptions of Seager's letters, Vickers recognized at once that the "Lady" in question must be the gold and ivory statuette of a bare-breasted female snake handler known as the Boston Snake Goddess. Vickers knew that I had been on the trail of the Goddess for many years — indeed, his help had been invaluable to me in tracing the histories of other Cretan ivory figurines, including two that had once been in Evans's own collection. Now he phoned me excitedly, and I raced to the museum to meet the jovial Phillips. And while it was he who had come for answers, he delivered to me a crucial piece of the story that follows.

1

𝒯HE ℬOSTON 𝒢ODDESS

More cannot be said; but none need regret that the Knossian Goddess — so admirably reconstituted — should have found such a worthy resting-place and that she stands to-day as a Minoan "Ambassadress" to the New World.

— Sir Arthur Evans, *The Palace of Minos* 3:440 (1930)

JULY 28, 1914, IS NOT usually remembered as an auspicious day. On that date, exactly one month after Archduke Francis Ferdinand and his wife, Sophie, were assassinated in Sarajevo by Gavrilo Princip, a Serbian nationalist, the Austro-Hungarian Empire declared war on Serbia. The armies of Russia, Britain, Germany, and France soon mobilized, and thus began the greatest conflict the world had yet seen. Over the course of the next four years, World War I transformed the face of Western civilization. Empires crumbled, new nations emerged, millions were killed and millions more wounded. In 1914, however, most Americans were far from these events (the United States did not send troops into combat until 1917). At the end of the year, Lacey D. Caskey, curator of the Classical Department of the Museum of Fine Arts in Boston, could write that "the event of the year is the gift from Mrs. W. Scott Fitz of an ivory and gold statuette of the Minoan Snake Goddess."[1]

Acquisition of the bare-breasted female snake handler (Fig. 1.1) was indeed a coup for Caskey (Fig. 1.2), who had been curator for only two years.[2] In 1914 the Museum of Fine Arts (MFA), founded

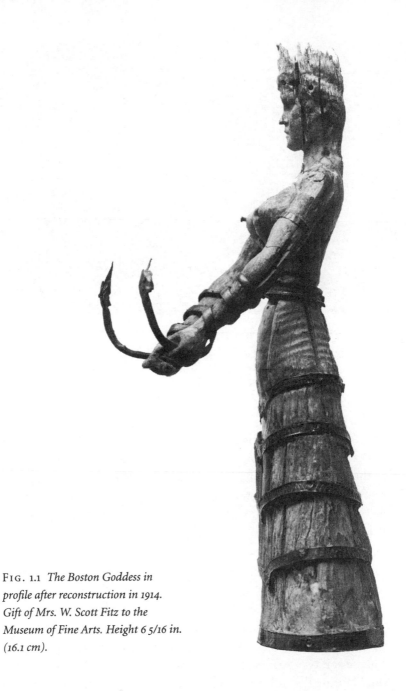

FIG. 1.1 *The Boston Goddess in profile after reconstruction in 1914. Gift of Mrs. W. Scott Fitz to the Museum of Fine Arts. Height 6 5/16 in. (16.1 cm).*

FIG. 1.2 *The staff of the Museum of Fine Arts circa 1928, including Lacey Caskey (back row, third from left), Edward Jackson Holmes Jr. (front row, center), Ashton Sanborn (front row, far right), and Charles Henry Hawes (front row, second from left).*

only forty-four years earlier, already owned an outstanding collection of Greek vases and classical marble sculpture but possessed nothing of the caliber or antiquity of the Minoan Snake Goddess. The 16.1-centimeter-tall statuette was rightly called "chryselephantine," a term derived from the Greek words for gold, *chrysos,* and ivory, *elephas.* (The ancients knew ivory, imported from Africa and the Near East, long before they ever saw the animals that were its principal source. Thus elephants take their modern name from the substance of their tusks.)

Chryselephantine statues were the most celebrated artworks of classical antiquity. Their materials were so expensive that they were entrusted only to the most skilled craftsmen; the malleability of gold and the ability of ivory to hold fine carved detail allowed exquisite results. During the Golden Age of Perikles, in the fifth century B.C., the

sculptor Pheidias fashioned a monumental chryselephantine statue of Athena, over forty feet tall, for the interior of the Parthenon on the Acropolis. He later produced the gold and ivory Zeus at Olympia, which came to be ranked as one of the seven wonders of the ancient world. Both of these statues were destroyed in Late Antiquity and are known today only from the descriptions of ancient authors and representations on other artifacts. In fact, of the hundreds of chryselephantine images known to have been created by the Greeks in the first millennium B.C. and by the Romans later, only fragments survive, and most of these have come to light only since the appearance of the Boston Goddess.[3]

In 1914 the Minoan Snake Goddess was immediately recognized as a relic of a civilization much older than that of Perikles, Pheidias, and other Greeks of the classical age. She was attributed to the Minoans, who had flourished a millennium earlier on Crete, the southernmost of the Greek islands. The remains of their prehistoric culture had only recently been unearthed by Arthur Evans (Fig. 1.3), Richard Seager (Fig. 1.4), and other pioneering archaeologists of the Aegean Bronze Age. And, as the museum's director, Arthur Fairbanks, would gratefully write to the benefactress, Mrs. Fitz, no collection outside of Crete could boast anything like her.

The Goddess cuts a striking figure, though precisely whom she represents, and thus what she signifies, is far from obvious. Staring ahead intently, she holds both hands forward at the level of her hips, grasping golden snakes that turn their raised heads back toward her as they coil around her arms. She wears a low "tiara" and the typical Minoan dress known from other Cretan images: a long, wide skirt with multiple flounces or tiers, a belt encircling her narrow waist, and what seems to have been a tight-fitting short-sleeved bodice or jacket cut so low in front as to expose her ample breasts, one of which retains a golden nipple. Multiple drill holes elsewhere on the statuette seem to indicate that further gold ornament has been lost.

For six years before he was hired by the museum in 1908, Lacey Caskey had lived in Greece, and for half of that time he had served as secretary of the American School of Classical Studies at Athens, the

FIG. 1.3 *Arthur Evans at Knossos, circa 1900–1904.*
FIG. 1.4 *Richard Berry Seager as a dashing young man.*

principal American archaeological outpost in Greece. Thus he recognized the chryselephantine figure as exceptional. On account of her similarity to battered components of ivory statuettes excavated by Evans at Knossos in 1902 (Figs. 2.15 and 2.16), and to similar images made of faience (a glazed quartz compound) that had been unearthed there in 1903 (Figs. 2.17 and 2.19), Caskey attributed the Goddess to the sixteenth century B.C., "the period in which Minoan art reached its highest development." Indeed, in the feature article of the museum's *Bulletin* for December 1914, he declared that the statuette "would be accorded a place of honor even among the treasures of the Candia Museum or in the Mycenaean Room of the National Museum at Athens." In the museum's *Annual Report* for 1914, he added that the Goddess, which he called "a veritable masterpiece, . . . should do much to arouse an interest in Boston in this wonderful prehistoric civilization which, after having lain submerged, like the lost Atlantis, for three thousand years, has been brought to light again by the archaeological discoveries of the past fifteen years."[4]

Museum officials frequently tout their acquisitions, but the Boston Snake Goddess was truly remarkable, and by associating the statuette with ancient myths, the young curator was following the lead of other archaeologists, notably the lordly Evans, whose excavations of the Palace of Minos at Knossos had made headlines from the first days of digging in 1900 and had earned him a knighthood in George V's 1911 Coronation Honours. By the time the Goddess arrived in Boston, Sir Arthur and other archaeologists, including the globe-trotting Richard Seager, had unearthed a hitherto unknown early European culture that seemed to reveal the truth behind Cretan legends of the Labyrinth and the Minotaur, Theseus and Ariadne, Daidalos and Ikaros.

Long considered "the most refined and precious object to have survived the ruin of Minoan civilization," the Boston Goddess has herself been mythologized. Caskey, for example, not only associated her with Atlantis but also observed that although her "pose is strictly frontal, it is not stiff and rigid, but on the contrary full of life and energy . . . the shoulders are drawn back, and the chin is held in so that the outline of the back forms one sweeping curve from the top of the headdress to the waist. It is the pose which is illustrated by all the known representations of Minoan men and women, and which seems not to have been an artistic convention, but a feature of the actual appearance of this aristocratic race."[5]

Today art historians and archaeologists write rather less confidently about the verisimilitude of works of art of any period, however naturalistic they appear. Lifelike representations might seem to be objective windows onto past realities, but they, like all images, project cultural ideals rather than depict actualities. Consider the airbrushed photographs of supermodels on billboards and in fashion magazines. In the early years of the twentieth century, however, the newly discovered Minoan civilization was all the rage, for it seemed to provide Europeans with not only the roots of the "Golden Age of Greece," long considered the foundation of Western culture, but also a sophisticated early society in its own right, a rival to the "Oriental" cultures of ancient Egypt and Mesopotamia — known as the cradle

of civilization — which had already been unearthed and whose arti-
facts, whenever possible, were carted home for further study.

—————

The earliest record of the gold and ivory Snake Goddess in the files
of the Museum of Fine Arts consists of a flurry of letters between Di-
rector Arthur Fairbanks and Mrs. W. Scott Fitz, letters that convey
some of the excitement occasioned by the appearance of the God-
dess. The entire correspondence is not preserved, but in reply to a lost
missive from Fairbanks, Mrs. Fitz wrote a letter (Fig. 1.5) from The
Narrows, her vacation home at Manchester-by-the-Sea, on Boston's
North Shore, on 28 July, the very day Gavrilo Princip assassinated the
heir to the Austro-Hungarian throne:

> Dear Mr. Fairbanks,
> I am delighted to hear of the new treasure trove that you
> have procured for the museum and I write to say that it will give
> me the sincerest pleasure to present it to the museum and to
> feel that we are the possessors of what appears to be a most un-
> usual acquisition. When the statuette is in condition I shall hope
> to see it and I rejoice with you in its possession. Yours very
> cordially,
> Henrietta G. Fitz July 28th

This letter and others written shortly thereafter make clear that al-
though Mrs. Fitz gave the Goddess to the museum, she never actually
owned it. Rather, she generously agreed to underwrite its cost, sight
unseen.[6]

As the postal service was apparently more efficient in 1914 than it
is now, Fairbanks was able to respond (Fig. 1.6) the following day:

> 29 July, 1914
>
> My Dear Mrs. Fitz,
> Your letter just received gives me very great pleasure. The little
> gold and ivory statuette from Crete, in spite of its somewhat

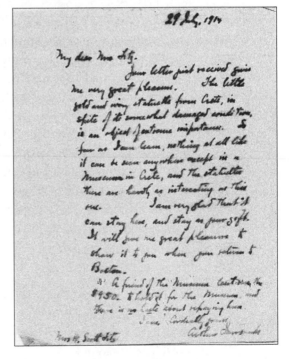

THE NARROWS
MANCHESTER·BY·THE·SEA

Dear Mr. Fairbanks
 I am delighted
to hear of the new
treasure trove that
you have procured
for the museum
and I write to say
that it will give
me the sincerest
pleasure to present
it to the museum

and to feel that we
are the possessors of
what appears to be
a most unusual
acquisition. When
the statuette is in
condition I shall hope
to see it and I
rejoice with you in
its possession. Yours
very cordially
 Henrietta G. Fitz
July 28th

FIG. 1.5 *Mrs. Fitz's letter to the museum's director, Arthur Fairbanks, 28 July 1914: "I am delighted to hear of the new treasure trove."*

FIG. 1.6 *Fairbanks's reply: "Nothing at all like it can be seen anywhere."*

damaged condition, is an object of extreme importance. So far as I can learn, nothing at all like it can be seen anywhere except in a museum in Crete, and the statuettes there are hardly as interesting as this one. I am very glad that it can stay here, and stay as your gift. It will give me great pleasure to show it to you when you return to Boston.

A friend of the Museum lent me the $950. to hold it for the Museum and there is *no haste* about repaying him.

Mrs. Fitz sent a check by return mail.

A true Boston Brahmin, Mrs. Fitz (Fig. 1.7), née Henrietta Goddard Wigglesworth, was born of the union of two of New England's oldest and most prominent families, the Goddards and the Wigglesworths, whose ancestors had come to the colonies in the 1600s. Henrietta, whose father served in the U.S. Congress, enjoyed life at the highest levels of Boston society, and in 1871 she married Edward Jackson Holmes, the youngest son of Dr. Oliver Wendell Holmes and brother of the future Supreme Court justice. After her husband died in 1884, Henrietta wed Walter Scott Fitz, who had made a fortune in the China trade. She developed an interest in Eastern as well as Western art, and in addition to the Snake Goddess she donated to the museum pieces of Asian sculpture and European paintings, including works by Fra Angelico, Tintoretto, and Monet.[7]

Enlightened by Fairbanks as to the "extreme importance" of the Goddess, Mrs. Fitz seems to have had little doubt of the significance of "possessing" the gold and ivory figurine, repeating that word in each of her letters. In his promptly penned note of thanks, Fairbanks employed the same term, revealing the cost of the statuette:

1 Aug. 1914

My dear Mrs. Fitz,

Your letter has reached me enclosing the check for $950. in payment for the Cretan statuette. I feel sure that this is a possession which will bring renown to the Museum, and I am delighted to have it here as part of your collection.

FIG. 1.7 *A genuine Boston Brahmin: Henrietta G. Fitz, in a drawing by Henri Royer, 1927.*

In the summer of 1914, $950 was a considerable sum. Just a few days prior to this exchange of letters, it would have been enough to buy at auction at Christie's in London paintings attributed to Tintoretto, Jan Steen, Hans Holbein, *and* Poussin, with enough left over for half a dozen or so Rembrandt etchings. But the Museum of Fine Arts already possessed numerous Old Masters, whereas the newly discovered Minoan civilization had only recently begun to capture the imagination of the Western world. An exhibition of finds from Knossos at London's Royal Academy in 1902, for example, was so popular that it was extended into the following year. Frescoes recovered by Evans were extolled as "the Oldest Masters," and other finds were considered to "bid fair rival to those of the Orient, and to give European Civilization an undreamed of antiquity."[8]

The arrival in Boston of a precious relic from this "wonderful prehistoric civilization," an artifact acclaimed as even more interesting than similar figurines in Crete, no matter its damaged condition,

FIG. 1.8 *The pride of the Classical Collection.*

brought joy not only to scholars like Fairbanks and Caskey but also to Mrs. Fitz, whose son, Edward Jackson Holmes Jr. (Fig. 1.2), would, perhaps not coincidentally, later become director and president of the museum.[9]

———

Fairbanks's prediction that the statuette would bring renown to the museum has certainly come true. The Snake Goddess has been highlighted in literally hundreds of publications, both popular and academic. Numerous books have featured her image as a frontispiece; she has graced museum guides and catalogues, handbooks and encyclopedias, and has appeared in newspapers, magazines, and scholarly journals (Fig. 1.8). Over the years, her enthusiasts have praised her "vigorous life," "proud pose," and "keen expression." They have seen her as "charmingly serene," "an exquisite characterization of fragile beauty." Her "softly modeled face," "subtly realistic," has been thought to impart to the figure a "radiant" or "delicate, high-bred" beauty. To her admirers, she is "demure," "expressive of individuality," "arresting," and full of "resolute charm." "Rendered with a freedom and a naturalness that are exceptional," she "shows all the distinguishing

FIG. 1.9 *The Goddess enshrined.*

features of Cretan art at its best," is the product of "the highest period of Cretan accomplishment," and thus has been considered Boston's "rarest treasure." She has been extolled as "the finest piece of sculpture in the round to have survived from the great Minoan civilization" — a "unique" masterpiece; "undoubtedly one of the most enchanting works of art in existence."[10]

The Goddess's status as the jewel of the museum's collection of ancient artifacts, apparent in numerous editions of the *MFA Handbook,* was reaffirmed in late 1994, when the Aegean Bronze Age artifacts were reinstalled and she was given pride of place, enshrined in her own free-standing case in the center of a newly refurbished gallery (Fig. 1.9). A spotlight was specially calibrated to protect her from damage by overheating, for in the years since her acquisition she has been reconstructed more than once. In 1996 she was featured — not

for the first time — in the popular Art in Bloom festival, in which New England garden clubs create "delightful floral interpretations" of the museum's best-known artworks. On this occasion members of the Falmouth Garden Club fashioned a predominantly white, deliberately drooping bouquet of roses, freesia, tulips, lilies, asters, carnations, and other plants that was displayed beside the reigning spirit of the new Bronze Age gallery. "The cascading downward orientation of the flowers," visitors were told, "reflects the symbolism of the snakes on the statuette's forearms, her connection with the earth and the underworld."[11]

The exalted reputation of the Snake Goddess outside of Boston is evident in a quiz published in the popular women's magazine *Mademoiselle* in 1967 (Fig. 1.10). Readers were asked to identify the locations of sixty "art sensations" from twenty-five American public collections. Framed by such masterpieces as Leonardo da Vinci's *Ginevra de' Benci* in the National Gallery in Washington and the Museum of Fine Art's own "Bartlett head" of Aphrodite, as well as works by Masaccio, Raphael, Degas, Rodin, Seurat, Kandinsky, Picasso, Pollock, and others, the Goddess was described as "the finest known piece of its kind . . . the pride of a marvelous New England collection."[12]

But for all of her renown, the Snake Goddess's exact origins are unknown. She has no verified archaeological *provenience.* (A crucial distinction, only now coming to be recognized linguistically, is made throughout this book: "provenance," a term often used in the art world, denotes the history of an object, that is to say, through whose hands it passed; "provenience," a less elegant-sounding word, means its precise origin, or archaeological findspot.) In fact, in the fullest account of the Goddess to date, published in the *American Journal of Archaeology* in 1915, Lacey Caskey provided a full description and analysis of her construction and dress as well as a short discussion of symbolism. But the curator was reticent, even cagey, about the origins of the statuette and its arrival in Boston, venturing no more than the statement: "According to information believed to be reliable, it came

FIG. 1.10 *"Where is it?"*
Mademoiselle's *"art sensa-*
tionals." The Goddess stands
in the company of works by
Leonardo, Raphael, Masaccio,
Rodin, Degas, Picasso,
Kandinsky, and Pollock.

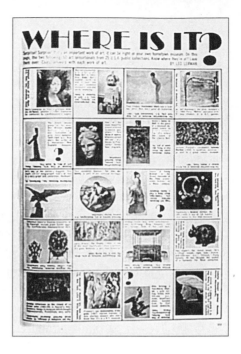

from Crete, but no details as to the time, place and circumstances of its discovery have been ascertained."[13]

Nonetheless, David M. Robinson, the W. H. Collins Vickers Professor of Archaeology and Epigraphy at Johns Hopkins University, who later excavated the site of Olynthos in northern Greece, wrote confidently in the March 1915 issue of the popular journal *Art and Archaeology* that "the little figure was lately unearthed on the island of Crete." Others have written with equal assurance of its "excavation" or "discovery." And as recently as 1996, one Aegean Bronze Age specialist stated that the Goddess was found in the sacred cave at Arkalokhori, twenty-seven kilometers southeast of Knossos, a site looted of bronze artifacts by peasants in 1912. Precious metals found there in the mid-1930s occasioned further pillaging, and the cave is widely believed to be the source of a gold miniature double ax acquired by the Museum of Fine Arts in 1958.[14]

In the late nineteenth and early twentieth centuries, archaeo-

logical sites were frequently looted and the artifacts smuggled to satisfy the demands of an eager art market. Unfortunately these practices continue today. The antiquities laws of the Ottoman Empire (which ruled Crete until 1898), of the protectorate of the Great Powers (which controlled the island from 1898 to 1913), and of the Hellenic Republic of Greece (which Crete joined in 1913) required that all but the most insignificant artifacts and "duplicate" objects similar to those already in public collections be turned over to the authorities. Such regulations, however, were frequently circumvented.[15]

The acquisitive desires of foreign museum curators and private collectors were satisfied initially by chance finds and purchases from local antiquarians, as is clear from Arthur Evans's diary of his first visit to Crete in 1894. He had gone to the island looking for evidence of prehistoric writing systems, for he was hoping to prove that early Europeans were no less literate than ancient Egyptians and Mesopotamians. He was particularly interested in engraved gems.

> March 15. Candia (Heraklio). Arrived considerably the worse for voyage. Juno, Austrian Lloyd, bad. 24 hours voyage from Piraeus. . . . Able to visit bazar: found Chrysochoi and a man from whom I bought 22 early Cretan stones at about 1 1/2 piastres apiece, 2 small Greek heads from Gortyna, some coins, one silver from and of Phaestos, and a small marble image from Phaestos, in that case very remarkable as it is exactly like those from Amorgos. . . .
> Mar. 16. Visited "Jean G. Mitsotakis, Vice Consul de Russie à Candie." He had a whole collection of things from the Cave of the Idaean Zeus. . . . Secured 21 gems and Mycenaean ring from Knossos.

Evans then traveled about the island, acquiring more antiquities in Rethymnon to the west and recording that "East Crete produced a good harvest of early engraved gems."[16]

Not only did Evans purchase antiquities from the locals, who had been digging up buried treasures for a long time and were now busy collecting materials to meet the demand of foreigners, but, like other visitors to the island, he also conducted unauthorized excava-

tions. Years earlier he had plundered Roman tombs at Trier, in Germany, and robbed skulls from a church vault in Ragusa (Dubrovnik) in Yugoslavia. Now he illegally removed antiquities from the caves at Psychro and Trapeza as well as Karphi. Evans was well aware of the laws against such activities and, as he once wrote, of the damage done by "explorers whose relic-hunting zeal outruns their patience in keeping scientific observations." For the archaeological value of artifacts lies in their context — associated items that can often reveal their age and significance — as much as, if not more than, in their beauty. Evans, nonetheless, also thought that laws restricting unauthorized digging were "frivolous," and he agreed with those who felt that state ownership of all antiquities left collectors, private and public alike, with no option but illicit removal, which resulted in loss of context and "permanent injury to science."[17]

Evans's early correspondence, preserved in the Ashmolean, is full of references to the smuggling of antiquities and attempts to prevent it. "The name of Lord Elgin is always on Greek lips," he wrote in 1899, referring to the Scottish nobleman who carried off the Parthenon marbles. That same year Professor Edward Capps, who later became chairman of the Executive Committee of the American School of Classical Studies at Athens, reported that

> the demand for Greek antiquities has become so strong, and the prices in consequence so remunerative, that the business of smuggling such goods out of the country has reached enormous proportions. The Athenian dealers in antiquities have representatives in the principal capitals of Europe. They do business directly with the management of museums on both sides of the Atlantic, and openly claim to be able to fill orders for almost every variety of Greek antiques. . . . The business of exporting antiquities has become so extensive, and is so openly conducted, that ignorance or indifference on the part of the Government is no longer possible.[18]

New laws controlling the export of antiquities were passed in Greece and similar measures adopted by the Cretan assembly in 1899.

Only objects declared "unsuitable for the museums" could be taken out of the country. "Exportation of all other classes of objects is absolutely forbidden. Those found guilty of illicit exportation are to be imprisoned for not less than three months or more than five years. The manufacture and sale of imitations of antique objects are also forbidden." Collectors, non-Greek excavators, and the institutions that financed them all feared that they would not be allowed to export many "duplicates" and certainly not spectacular finds. Yet because the supply remained limited and demand high, looting continued, and not just in the countryside. In 1901 inscribed clay tablets "clearly purloined from Knossos" appeared on the Athenian market. An examination of the daybooks and pay records from the authorized excavations led to the conviction of one of the workmen, a certain Aristides Hajijannakis, who was dubbed "Aristides the unjust" in contrast to the fifth-century Athenian statesman famous for his rectitude. The modern Aristides was tried, convicted, and sentenced to three months in prison.[19]

In 1908 Evans himself, who had long been suspected of smuggling antiquities, evaded an inquisitive Cretan customs agent by defiantly tossing a parcel into the harbor at Candia. Although his admirers at that time and later did not want to believe that the parcel could have contained antiquities, he eventually admitted that he had jettisoned part of a vase given to him by "an American who had been digging on a site on the east of Crete," presumably his friend the witty and generous Richard Seager. Evans, however, did not suffer the same fate as Aristides. Government officials apologized, and it was the customs agent, one G. Phiorakis, who faced dismissal "as a satisfaction due to Dr. Evans."[20]

—⊶⊶⊷—

The prevalence of looting at ancient sites and the illegal exportation of antiquities led many to believe that the Boston Goddess had been "surreptitiously abstracted" from Knossos at some point just after the turn of the century and smuggled to America a decade or so later. In the first volume of *The Palace of Minos,* published seven years after

the statuette's arrival in Boston, Evans wrote, "There are, indeed, good reasons for believing that the beautiful crowned female figure of ivory holding out two gold snakes in the Boston Museum . . . had belonged to the same Palace reliquary in the Domestic Quarter at Knossos as the ivory figure of the Leaping Boy" [Fig. 2.16].[21] Sir Arthur revealed those reasons in volume 3, published in 1930, explicitly associating the Boston Goddess with unreconstructed fragments seen by Seager:

> It is now allowable to say that my friend, the late Mr. Richard Seager — whose premature death has extinguished so many hopes of Cretan exploration — saw the fragments, together with a good deal of dust of decayed ivory that could never be reconstituted, in private hands at Candia shortly before the Great War. Like all those connected with the excavation, he himself shared the belief that they had been obtained — in all probability, some years previously — from the Palace site of Knossos. I even found a direct tradition rife among our older workmen of the surreptitious removal of ivories from the same part of the area from which the relics of the "Treasury" were brought to light. More cannot be said; but none need regret that the Knossian Goddess — so admirably reconstituted — should have found such a worthy resting-place and that she stands to-day as a Minoan "Ambassadress" to the New World.[22]

Thus Evans provided the Goddess with a Knossian provenience and offered a scenario of how she had been removed from her archaeological context. Twelve years before her arrival in Boston, Evans and his workmen had excavated the components of ivory leapers that he mentioned in volume 1 — exquisitely carved but badly damaged and stripped of most of their gold ornament (Figs. 2.15 and 2.16) — in a deposit of other precious material underneath and around a stairway northeast of the so-called Queen's Megaron (between rooms 25 and 27 on the plan, Fig. 2.5). It was here that he imagined the Boston Goddess had been found. For although "no trace of ivory images bearing a divine character" had been recovered with the leaping figures, Evans

thought that the deposit *should* contain "images of some more sacred import." Indeed, that was "only what we should have expected." He and his workmen searched further but found nothing. This he blamed on "careful plundering in ancient times." The Goddess, he believed, was twice despoiled: once by ancient pillagers, who had also stripped the composite chryselephantine leapers of their golden raiment, and again in modern times, by some of his own workmen, who had spirited her off to the New World. He thought "that the complicated structural environment from which the remains of the original Treasure had been gradually extracted and reassembled . . . with various avenues of subterranean access — would have given quite exceptional facilities for surreptitious abstraction."[23]

It certainly seems possible that such pillaging had occurred. Yet the meticulous Knossos daybooks kept by Evans's assistant, the more experienced but less well-heeled Duncan Mackenzie (who has been praised as "one of the very first scientific workers in the Aegean" and whose excavation records are to this day considered to be "outstanding examples of systematic archaeological reasoning"), contain no record of disturbed earth in that area of the Treasury that yielded the remains of the ivory leapers.[24] No one recorded the removal of the Goddess from the earth. She has no archaeological context.

If the Goddess had been illicitly removed from the Treasury at Knossos in 1902, how did she get to the Museum of Fine Arts in 1914? Caskey, whose brief obituary in the *New York Times* mentions his acquisition of "such world-important pieces as the famous Cretan snake goddess," had nothing to say on the subject. Twenty-five years after Caskey's death in 1944, however, David Pickman, the museum's manager of public relations, apparently wishing to satisfy widespread curiosity on the occasion of the MFA's centennial celebrations, provided further information, revealing that the Goddess had been "brought to Boston by a Cretan immigrant." More details soon emerged. According to the museum's *Centennial History,* the statuette "was painfully reconstructed at the Museum of Fine Arts from hun-

dreds of ivory slivers and gold fragments, obtained in a cigar box from a Cretan peasant who was a passenger in a steamship bound from Piraeus to Boston in 1913." Perhaps this date is a typographical error, for there is no evidence in the museum's files for the Goddess's presence in Boston before the exchange between Mrs. Fitz and Arthur Fairbanks at the end of July 1914. The first photographs (Fig. 1.11) of the statuette reveal its fragmentary condition before restoration, and Caskey's 1915 article explains that Paul Hoffmann consolidated the badly desiccated fragments of ivory by soaking them in paraffin and replaced the missing parts of the Goddess's skirt with wax (Fig. 1.12). The right arm was almost entirely lost, so that limb was refashioned in plaster by Donald Quigly, a pupil at the Museum Art School, and its gold snake, also only partially preserved, was completed with gilded lead. Caskey further noted that "the original tip of the nose which had flaked off was discovered by the repairer among the numerous tiny fragments of ivory and replaced, adding greatly to the individual character of the profile." About the Cretan peasant, however, he said nothing.[25]

Caskey's successor as curator of the Classical Department of the Museum of Fine Arts, Cornelius C. Vermeule III, published a fuller account of the Goddess's arrival in Boston in the fashionable art journal *Apollo,* also as part of the museum's centennial celebrations:

> The story of the statuette's arrival in Boston is, perforce, an unusual one. Shortly before the first World War a Greek-speaking Boston lady returning from the American School of Classical Studies in Athens heard that there were Cretan emigrants travelling steerage in the ship. Eager to help them with their new life in the United States she won their friendship during the voyage. One man, evidently a workman near Knossos, showed her the Snake Goddess in fragments in a cigarette tin. She urged him to go immediately on arrival to the Museum of Fine Arts, with which she was connected.[26]

The masterpiece, we are told, was purchased "at a fair price," presented to the Department of Classical Art, and eventually restored.

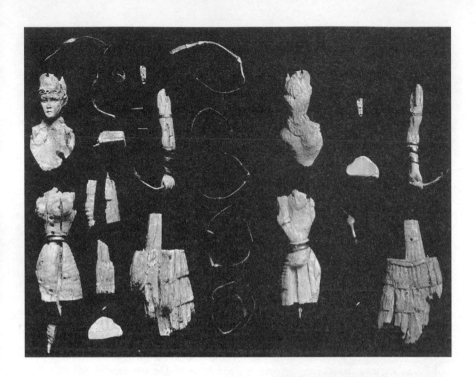

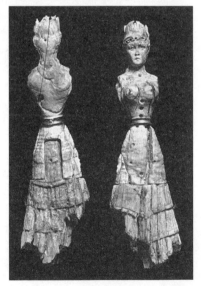

FIG. 1.11 *In pieces: the Goddess before her first reconstruction in 1914.*

FIG. 1.12 *Work in progress.*

This anecdote is charming, but there is, strangely, no record of the identity of the Greek-speaking American female archaeologist connected with the museum. It has been suggested that this shadowy figure was Harriet Boyd Hawes, the excavator of Cretan sites east of Knossos. The first woman to direct archaeological projects in the Aegean, she was a friend of Evans and mentor of Seager, who first dug with her at Gournia in 1903. Her obituary in the *Smith College Quarterly* even went so far as to state that she excavated the Snake Goddess. It is true that her husband, Charles, an anthropologist, was hired by the museum in 1919 (Fig. 1.2) and that she did assist Greek immigrants settling in Chicago in 1903, but Harriet Hawes was a fierce defender of the right of Cretans to their patrimony, and it seems unlikely that she would have participated in the illegal export and sale of such an important object. "I never was a collector," she once declared. In any case, it could not have been she who met a peasant on board ship and directed him to the museum in 1913 or 1914. She left Crete in 1905 and did not visit Greece again until 1916, when she served as a war nurse on Corfu. She returned to Crete only in 1926. In the summer of 1914, she was vacationing with her husband and two small children in Nova Scotia.[27]

Another version of the Goddess's journey to the New World, slightly different from Vermeule's, is preserved in the museum's files. In June 1956, Cyrus Ashton Rollins Sanborn (Fig. 1.2), a longtime museum employee who had studied in Athens and been an assistant in the Classical Department before he became museum librarian in 1922, recalled the tale of a similar shipboard encounter, but he used the *masculine* pronoun to refer to the Bostonian who befriended the Greek man traveling in steerage.[28]

Male or female? Museum friend or archaeologist? Cigar box or cigarette tin? Do these inconsistencies matter? To this day, fragments and splinters of ivory labeled in Caskey's hand as belonging to the "Ivory Snake Goddess from Crete" (but too minute to be employed in either of the statuette's two major reconstructions) are stored in an attractive green tin (Figs. 1.13 and 1.14) labeled "Savon

FIG. 1.13 *A soap tin from Germany, labeled "Ivory Snake Goddess from Crete Fragments."*

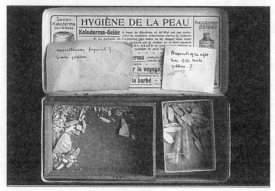

FIG. 1.14 *Leftovers: fragments of the Goddess not used in the restoration.*

Kaloderma à base de Glycérine et de Miel" produced by "F. Wolff & Sohn Parfumeurs, Fournisseurs de la Cour de Bade" of Karlsruhe in Baden, winners of the Médaille d'Or at the Exposition Universelle Paris 1900 and of the Grand Prix at the Exposition Universelle St. Louis 1904. But Caskey routinely stored small objects in tins of this type, so there can be no certainty that the Goddess actually arrived at the museum in this one.[29] Still, the colorful German soap container, measuring 17 by 7.8 by 5 centimeters, is large enough to accommodate the reconstructed statuette and could have held all of her fragments.

Whether the Goddess was delivered to the museum in a soap tin or in some other receptacle, and whether she was directed there by a man or a woman may not ultimately be important, but further inconsistencies in the accounts of her arrival are more significant.

FIG. 1.15 *Professor Ernest A. Gardner, the voice of skepticism: "it cannot be doubted that we have before us a product of Cretan art . . . but that it looks more modern."*

Port records and transatlantic liner schedules indicate that *not a single ship* sailed from Piraeus to Boston in either 1913 or 1914.[30] The oft-repeated story of a shipboard encounter with a Cretan workman appears to be an invention, a cover story of sorts, and, to judge from Sanborn's recollections in 1956, one fashioned more than a decade before it was embellished by Vermeule in 1969.

The most famous object in the Classical Collection of the Museum of Fine Arts not only has no archaeological provenience, its provenance too is uncertain. Some experts, moreover, have even gone so far as to question the style of the figure. Within six months of Caskey's publication of the Goddess in the museum's *Bulletin,* an unknown reviewer in a highbrow English art journal, the *Burlington Magazine,* wrote of his unfavorable impression of the work. Professor Ernest A. Gardner (Fig. 1.15), Yates Professor of Classical Archaeology at the University of London and a former director of the British School at Athens, found the Goddess's resemblance to statuettes excavated by Evans at Knossos to be "obvious at first sight," and in the 1915 issue of *Ancient Egypt* he opined that "it cannot be doubted that we have before us a product of Cretan art. But," he continued,

the style of the figure, both in face and hands, is extraordinary, and differs in artistic character from any representations of the human form hitherto found in Crete. The head, in particular, is quite unlike anything known to us in early Aegean or in classical art; it recalls rather the sculptures of Gothic cathedrals of the thirteenth century, such as Rheims and Bamberg, but that it looks more modern.[31]

"Modern" was a term often applied to Cretan art in the early twentieth century. The New York aristocrat, art critic, and philanthropist Mariana Griswold Van Rensselaer made numerous references to the Goddess's "modern" aspects and even commented that her face was one "that we might expect to see on the street in Boston rather than behind the glass of a cabinet of antiquities."[32]

Arthur Evans too found the physiognomy of the figure to be "curiously modern." Like Gardner and others, he observed that the eyes "are sunk to their natural depth below the brow, a method of treatment practically unknown to ancient Art of any kind before the Fourth Century B.C." Largely on account of her facial features, the Goddess has been described as "Anglo-Saxon," "European-looking," "Victorian," and "Edwardian."[33]

Professor Gardner did not mince words: "Under these conditions the question of the genuineness of so remarkable a work must occur at first to any critic. But the possibility of modern forgery appears to be precluded by the materials and their condition; and there were no opportunities for any such imitations of Minoan art between the destruction of the palace at Knossos and its modern disinterment." On this point, however, Gardner was mistaken. Materials can be weathered in a variety of ways, and there were indeed opportunities for the production of "imitations" of Minoan art between Evans's early discoveries just after the turn of the century and the surfacing of the Goddess in Boston in 1914. Cretans had produced fake antiquities even before the discovery of the Minoan ruins, as we shall see. In fact, their reputation for deceit dates back to antiquity. The ancient Greek

verb *kretizo* (literally, "to speak like a Cretan") means "to lie," and the Romans had a similarly low opinion of the island's inhabitants. The poets Ovid, Lucan, and Statius referred to *Creta mendax* ("false Crete"), and the Apostle Paul's remark "Cretans are always liars" was translated into Latin — *Cretenses semper mendaces* — and thus became a commonplace.[34]

Caskey was in a better position than other scholars to know just how the Goddess came to the museum. As if in response to critics, he wrote obliquely of "information believed to be reliable," indicating that the statuette originally came from Crete.[35] Thus, no matter how the chryselephantine Goddess made her way to Boston, it is to Crete that we must turn for more information, for her similarities to artifacts that Arthur Evans recovered at the Palace of Minos are unmistakable.

2

THE PALACE OF MINOS

> The serious scholar must bear in mind that the world he
> is exploring is infinitely different from the one he is fa-
> miliar with, and that his knowledge of it, however consid-
> erable, must always be limited; that his experience of life
> is usually immature, based as it is on the observation of a
> brief interval of time, while the material at his disposal is
> a heap of isolated ruins and fragments which often, seen
> from a single angle, seem inauthentic, but later, when
> transposed into their true context, belie such premature
> judgment.
>
> — Johann Jakob Bachofen, *Das Mutterrecht* (1861)

BEFORE ARTHUR EVANS began his investigations of ancient Cre-
tan civilization in the late nineteenth century, the term "Minoan" had
a rather restricted meaning, referring only to the mythical King
Minos. Ancient authors, including the Greek historians Herodotos
and Thucydides, who composed their celebrated accounts of the Per-
sian and Peloponnesian wars at the height of the Classical Age in the
late fifth century B.C., had written of that monarch's great maritime
empire. Scholars and historians ever since have been intrigued by
the nature and extent of the "Minoan thalassocracy." Minos's rule
was said to have stretched across the Aegean Sea, encompassing the
Cyclades, the coasts of the Peloponnesos and Attica to the north, the
shores of Anatolia (modern-day Turkey) to the east, and even Sicily
to the west.

Minos was a powerful ruler. He was, after all, the son of Zeus, the
supreme god of the Greeks. His story has many variants, and the mul-

tiple versions preserved in Greek and Latin texts are retold with great verve and sensitivity by Roberto Calasso in his extraordinary book *The Marriage of Cadmus and Harmony*. The basic elements are as follows: one day, as the daughter of the king of Phoenicia gamboled with her companions along the coast at Tyre or Sidon, Zeus espied her and, as was his wont, was filled with desire. Transforming himself into a magnificent bull, the god appeared before her. Enticed by the beauty and mildness of the beast, the maiden climbed onto its back, whereupon Zeus instantly took to the water and transported her across the Mediterranean to Crete, the island of his birth. The Phoenician princess's name was Europa, and their voyage has been commemorated in art and poetry for millennia, not only by Homer, Horace, Ovid, and numerous other ancient authors, painters of frescoes and vases, gem carvers, and sculptors (Fig. 2.1), but also by Boccaccio, Spenser, Tennyson, Dürer, Giorgione, Titian (Fig. 2.2), Rubens, and Rembrandt, to name just a few artists inspired by the tale.[1]

Minos, the offspring of the union of Zeus and Europa, was renowned in classical Greece, not only as the powerful king of Crete but also as a judge in the Underworld, along with his brothers Rhadamanthys, Aiakos, and, in some versions, Sarpedon. There is, however, a darker side to this pretty picture of an enlightened ruler fathered by Zeus. Engaged in a contest for kingship, Minos set up an altar along the coast and prayed to his uncle, the sea god Poseidon, to provide him with an appropriate victim to sacrifice. But so handsome was the perfect white bull (again, a bull) that emerged from the sea that rather than offer it up, Minos kept it, sacrificing instead a lesser animal from his own herd, arousing Poseidon's anger.

Soon thereafter, in the inimitable custom of the Olympians, the affronted god excited in Minos's wife, Pasiphaë, an unnatural passion for the marvelous white bull, which the king had set to pasture in his fields. To satisfy her lust, the queen commissioned the skilled craftsman Daidalos to fashion a hollow wooden heifer (Fig. 2.3). Concealed within this contrivance, which was outfitted with a leather hide, retractable wheels, and appropriate orifices, she was able to con-

FIG. 2.1 *Europa and the Bull, a limestone relief from Temple Y, Selinus, Sicily, circa 540 B.C.*

FIG. 2.2 *Titian's vision of Europa and the Bull (1559–62), in the collection of the Isabella Stewart Gardner Museum, Boston.*

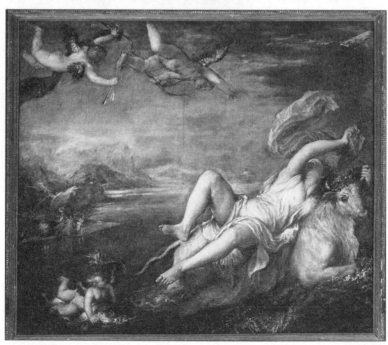

summate her desire. Thus she conceived the Minotaur — the bull *(tauros)* of Minos — a hideous monster, half man, half animal.

This beast had to be hidden, so Minos, advised by an oracle, ordered Daidalos to construct the Labyrinth beneath his palace. At the center of the Labyrinth, the king concealed the Minotaur, whose voracious appetite was fed with seven youths and seven maidens, sent as tribute from Athens. One year Theseus, son of the Athenian king, Aegeus, volunteered to face the peril of the Labyrinth. Minos's daughter, Ariadne, infatuated with the handsome foreign prince, enticed from Daidalos the secret of the perplexing Labyrinth. By holding a thread tied to the entrance, Theseus was able to penetrate the maze, slay the Minotaur, and find his way back out (Fig. 2.4). Victorious, he returned to Athens, abandoning Ariadne en route on the island of Naxos.

The clever Daidalos, meanwhile, was himself imprisoned by Minos as punishment for collusion, but he managed to escape, fleeing Crete with his son, Ikaros, on waxen wings of his own design. The unmindful Ikaros, however, not heeding his father's warning, flew too close to the sun, melted the wax, and plummeted into the sea. A son's negligence also brought about the death of King Aegeus: On returning to Athens, Theseus forgot to change the sails of his ship from black to white to indicate that he had survived his Cretan adventure. When his father caught sight of the dark sails on the horizon, the distraught old man hurled himself from the Acropolis. His name is preserved in the sea named for him, the Aegean.[2]

—⟨⟩—

Was Minos, who ruled the Aegean, a wise king or a merciless tyrant? Is it possible to reconcile these conflicting traditions? Diodoros, a Sicilian writing in Greek in the first century B.C., was interested in this question. Although Minos was thought to have ruled Crete well over a thousand years earlier, in the distant days before the Trojan War, the king was nonetheless an attraction on Sicily: legend had it that in pursuit of the clever Daidalos, Minos had journeyed west to Sicily,

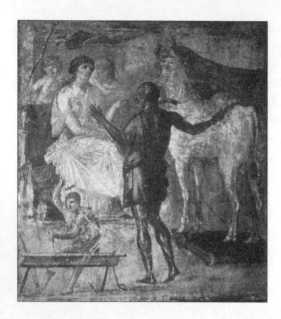

FIG. 2.3 *Pasiphaë's passion:
Daidalos presents his model heifer
to the queen. Fresco from the Casa
dei Vettii, Pompeii, shortly after
A.D. 62.*

FIG. 2.4 *In the Labyrinth:*
Theseus and the Minotaur *by the
English artist Edward Burne-Jones
(1862).*

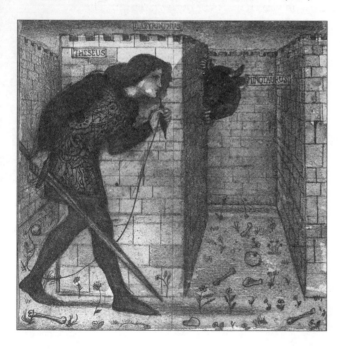

where the daughters of the local ruler murdered him by pouring scalding water into his bath. He was said to be buried on the island. Diodoros, however, was a rationalist, and he distinguished between two kings named Minos who lived three generations apart. Could Minos have been a name favored by Cretan kings, employed sequentially, like the Ramses or Thutmoses of Egypt?

Like Diodoros, Arthur Evans sought to reconcile myth and history. Although early in his career he had warned against "poetical topography," he later came to assert the "truth in myth," claiming that as the result of his excavations at Knossos, "we know now that the old traditions are true." Evans proposed that in antiquity the term "Minos" came to function as a title for the king (rather like caesar, kaiser, and czar) and that "Minoan" might therefore be used in modern times to denote the high culture of prehistoric Crete, in much the way "Pharaonic" refers to dynastic Egypt.[3]

The great civilizations of Egypt and the ancient Near East, whose impressive monuments had been brought to light by archaeologists in the nineteenth century, served alongside the glories of the British Empire, ruled benevolently by Queen Victoria from 1837 to 1901, as models for Evans as he undertook to reconstruct the society being unearthed at Knossos. Midway along the northern coast of Crete, three miles inland, on a large flat hill called *tou tseleve he kephala* ("the headland of the chieftain"), Evans excavated the building that he, like others before him, identified as Minos's palace. Its complex architecture and mazelike storerooms (Fig. 2.5) seemed to recall the legendary Labyrinth, and Evans gave the name "Minoan" to the civilization whose remains he was beginning to uncover. Meanwhile other archaeologists, including Richard Seager and Harriet Boyd Hawes, were finding related ruins elsewhere on the island and along the shores of the Mediterranean. But it was Evans's synthetic vision — the product of great energy, industry, and inspiration — that fundamentally shaped modern views of Minoan culture and art.

Arthur Evans's intellectual vision and imagination were huge,

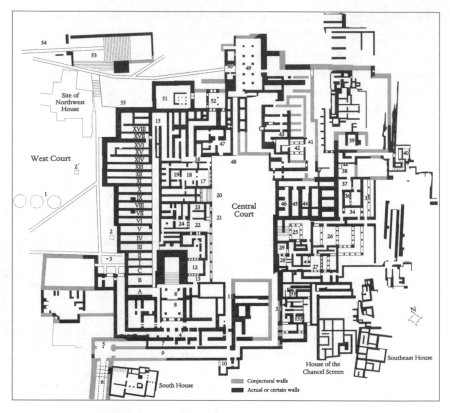

FIG. 2.5 *Plan of the Palace of Minos.*

and he had the discipline and perseverance to match. He first visited Crete in 1894, drawn by the conviction that early Europeans, no less than the inhabitants of ancient Egypt and the Near East, must have employed some form of writing. His father, John Evans, was a prominent British antiquarian and prehistorian, a fellow of the Royal Society, and honorary secretary of the Geological and Numismatic Societies of London. He had made his fortune as a paper manufacturer, thanks to the popularity of letter writing in Victorian England (made possible by cheap postal rates).

Throughout his youth, Arthur, who had no interest in the family

business, was exposed to the world of learning, the excitement of archaeological discovery, and new theories regarding the origins and nature of human civilization.[4] He was an undergraduate at Oxford in 1870, when Heinrich Schliemann began to excavate a hilltop at Hisarlik in northwest Turkey that had been brought to his attention by its English owner, Frank Calvert. There, in a series of seasons, or campaigns, as archaeologists say, the monumental remains of a prehistoric citadel were exposed. These seemed to confirm the historicity of Homer's *Iliad* and the war at Troy.

Six years later Schliemann dug at Mycenae, in the Peloponnesos, where he again caused a sensation, extracting artifacts of fabulous value from tombs he associated with Agamemnon and other legendary heroes of Greek mythology. The material culture of this early Greek civilization, which flourished in the second half of the second millennium B.C. and came to be called Mycenaean, was distinct from that of later, classical Greece, and its origins were (and remain) the subject of intense debate. What was the relation of the Mycenaeans to the inhabitants of ancient Egypt, Anatolia, and Mesopotamia? Were their roots to be found to the east, or to the north, in Europe? So distinctive were the finds at Mycenae that some scholars considered them to be Byzantine or barbarian; still others have gone so far as to suggest that Schliemann commissioned and planted forgeries.[5]

In 1878 Arthur Evans journeyed to London to see an exhibition of Schliemann's Trojan finds. Four years later he met the great man himself in Greece, where he was deeply impressed by the remains of Mycenae, Tiryns, Orchomenos, and other prehistoric sites. The Athenian acropolis and other Greek remains did not move him nearly as much, and throughout his life he rated prehistoric art more highly than classical.

Evans, like Schliemann, was a wealthy amateur, but although he was certainly inspired by his predecessor's discoveries, it would be wrong to think that the privileged Englishman modeled himself closely on the self-made German millionaire. Schliemann excavated with the epic poems of Homer in hand, seeking to demonstrate

their historical veracity and gain personal glory in the process. Evans, though also influenced by ancient myths, had more theoretical goals.

In the nineteenth-century intellectual milieu in which Evans was raised, writing was considered one of the most important marks of a great civilization, for it provided the means for the codification of laws, the accumulation of historical records, and the composition of literature. Greece and Rome were obvious examples of high civilizations that had writing, and in 1822 Jean François Champollion's deciphering of the hieroglyphics on the Rosetta Stone paved the way for the reconstruction of the language of ancient Egypt. In the following decades scholars cracked the cuneiform script of the Assyrians and Babylonians and thus gained new sources for the history of the Near East, while others scoured mainland Greece, the islands, and Anatolia for classical Greek inscriptions on stone. Schliemann, who has rather generously been described as a "rough" excavator, recovered scant evidence for writing at the sites he explored, but Evans, studying the finds after Schliemann's death in 1890, confirmed his own conviction that the Mycenaean civilization of the Aegean, the earliest high culture of the West, was also literate. In search of further physical evidence for prehistoric European scripts, Evans returned to Athens, where he purchased some ancient gemstones engraved with prealphabetic signs. They were said to have come from Crete, as were similar objects that had been acquired by the Berlin Museum. In search of more evidence, he turned his sights toward the island.

Since the fifteenth century, if not before, travelers to Crete had readily linked the remains of ancient monuments there to the stories of Minos and Pasiphaë, Theseus and the Minotaur, Daidalos and Ikaros. A Roman stone quarry some twenty-five miles southwest of Knossos was identified as the fabled Labyrinth by early travelers. The geographer Strabo (writing around the time of the birth of Christ) had, after all, attributed the founding of the nearby city of Gortyna to none other than Minos himself. Knossos, meanwhile, was largely forgotten, though it had flourished in classical antiquity and through the Mid-

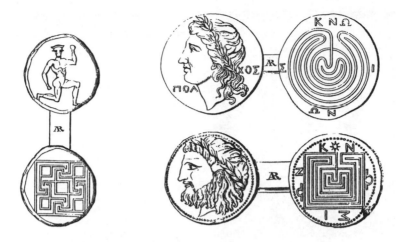

FIG. 2.6 *Roman coins minted at Knossos, showing the Minotaur and his lair.*

dle Ages. Coins featuring both the maze and the Minotaur had been minted there in the Roman period (Fig. 2.6), and Onorio Belli, a doctor from Vicenza serving the Venetian quartermaster-general in the late sixteenth century, recorded ancient remains. When the French scholar Georges Perrot visited the site in 1857, however, he lamented that "Knossos, the oldest city of ancient Crete, one that ruled without rival, supreme over all others, has left no ruins. On the southeastern heights above the small plain where Candia stands is one miserable village whose name, Makrytichos, or the Long Wall, informs the antiquarian that there were once great constructions here; but at most he can detect only the vague, formless debris of mounds of brick."[6]

A citizen of Candia, appropriately named Minos Kalokairinos (Fig. 2.7), nonetheless undertook preliminary excavations at Knossos between December 1878 and April 1879. He made twelve soundings at different points and discovered ancient ceramic vessels as well as symbols inscribed on cut gypsum blocks. The pots were great *pithoi*, "Ali Baba jars" large enough to hold one or two men. The hill therefore came to be called *stà pithária*.

The importance of these finds was recognized by Thomas B. Sandwith, the British consul based in Chania, on the western side of

FIG. 2.7 *Minos Kalokairinos, the first excavator of Knossos.*

the island. Sandwith arranged for one of the Knossian pithoi to be sent to the British Museum, and the pot, as one archaeologist observed, had "a truly royal passage to England" on the flagship of Queen Victoria's son Prince Alfred, the duke of Edinburgh, which was appropriately named HMS *Minotaur.*[7]

Other European museums also obtained pithoi — Kalokairinos even sent one to the king of Greece — but despite the competitive spirit of the age, Sandwith was unable to interest the British Museum in excavating at Knossos. The French, in contrast, actively attempted to gain formal permission to dig, but Cretan patriots, long engaged in a struggle for independence, feared that the finds would be exported to Constantinople by the island's Turkish overlords. Thus further excavations were blocked. Sandwith, nonetheless, was able to extract additional artifacts from diggings carried out "on the sly" in a neighboring field, but these were not Bronze Age objects. They were, rather, terra cotta figurines from a considerably later period, "statuettes from 6 to 18 inches high like those from Tanagra," Sandwith wrote, "but I am bound to say very inferior in style."[8]

Tanagra, a site in Boiotia some twenty-five miles north of Athens on the Greek mainland, has never been properly excavated. Its cemeteries were discovered in 1870 and systematically plundered in

Fig. 2.8 *Ancient or modern? Two Tanagra figurines.*

subsequent years. Thousands of terra cotta figurines, mostly mold-made images of draped women dating from the fourth to the second century B.C., were found there. Other ancient sites, especially in western Turkey, produced similar statuettes, and some came to light on Crete, as Sandwith's letters make clear. Extremely popular among collectors, the so-called Tanagra figurines (Fig. 2.8) flooded the European market, for they appealed to nineteenth-century Europeans as charming, elegant reflections of Greek ladies of the period of Alexander the Great. Heinrich Schliemann acquired a number of them and, social climber that he was, in 1876 offered to send the ten best examples from his personal collection to Queen Sophie of the Netherlands. The British archaeologist Caroline Amy Hutton later explained the reason for their continuing allure: "They are so human in their dainty prettiness that we realise at once that their type of beauty is not the ideal one of the sculptor, but the real one of every-day life." The idea that art should reflect life is a pervasive one, and the recovery, reception, and marketing of Tanagras in many ways foreshadowed the popular response to Minoica just a few years later.[9]

During the last three decades of the nineteenth century, Tanagra

figurines inspired painters and sculptors such as James McNeill Whistler, Jean-Léon Gérôme, and Claude Michel (who used the name Clodion) and were snatched up by museums as well as private collectors. Some of the statuettes fetched extremely high prices. Like the models *(bozzetti)* of Renaissance and Baroque sculptors, they were prized by collectors because they seemed to provide more direct access to the hand of the artist and thus the "spirit of the age" (although they were, in fact, mold made). And when supplies of the genuine Tanagras dwindled, the needs of an enthusiastic market were readily filled by enterprising forgers.

The movement from illicit excavation to forgery, though direct, was not unbroken. As Reynold Higgins, Britain's preeminent expert on ancient terra cottas, has observed:

> From the first, the dealers had found it necessary to improve their damaged wares by glueing together sections which had broken away and by touching up the joins and those parts of the figurines where the paint had come off. As comparatively few figurines came out of the ground complete and undamaged, this treatment was frequently resorted to. Soon, however, as the demand exceeded the supply, the dealers were reduced to assembling fragments — heads, arms, torsos, etc. — which did not belong, adding restorations in plaster, raw clay, or terracotta, and covering the resulting pastiches with white slip, which they painted new colours, usually much brighter than on the original. . . . By 1876 the first out-and-out forgeries were being made. The market was soon so swamped with them that before many years had elapsed the more discerning of collectors began to distrust the whole class of Tanagra figurines.[10]

Thomas Sandwith sent the best of his Cretan figurines — the unbroken pieces — to Charles Newton, keeper of Greek and Roman antiquities at the British Museum, but retained for himself numerous fragments and "200 or 300 heads." Newton was unimpressed with them. The consul defended their authenticity, pointing out that the clay from which they were fashioned was different from that of for-

geries produced elsewhere on Crete. In a letter of 24 February 1880, he wrote, "There is a factory at Candia where antiquities are fabricated, and several pieces have been brought to me which I knew to be false. I bought a few — but they are of a whitish-yellow clay, and all covered with lime difficult to get off without acids." Referring to the illicit excavator who provided him with artifacts from the south side of Knossos, he added, "I never found any of these pieces brought me by my man."[11]

Forged Tanagras appealed directly to the Victorian taste for sentimentality, as well as what art historian Otto Kurz has called "the general propensity to collect decorative figurines and trinkets. Greek terra-cottas were regarded as forerunners of china figurines. The forgers were very quick to exploit this vogue." Indeed, forgers are followers rather than leaders, producing what the market wants. Thus, although forgeries can provide only deceptive "evidence" about the nature of the past, when properly identified they can be quite revealing about the ways in which the past is reconstructed in and for the present. Many alleged Tanagras deviated from genuine pieces in pose, attributes, and drapery but were nonetheless accepted as genuine by museum curators and private collectors who simply "did not want to notice that the figures were far too long and too softly modelled," in keeping with contemporary taste. "They were blind to the ridiculous puerility of all the details." Tanagras, in short, suited what people in the late nineteenth century wanted to see in and make of the past. In fact, comparing these figurines to contemporary fashion in 1899, the French archaeologist Théodore Reinach tellingly wrote, "The Tanagra lady is truly the Parisienne of antiquity."[12] It would not be long before some Minoan art was described in identical terms.

⸻

Though Sandwith failed to arouse the British Museum's interest in Knossos in the early 1880s, the American consul, William James Stillman, a photographer and friend of John Ruskin and Arthur Evans, attempted to investigate the site on behalf of the Archaeological Institute of America. When Minos Kalokairinos showed him around

Knossos in 1881, Stillman drew plans of the ancient walls — which he, too, associated with the Labyrinth — and copied the strange prealphabetic inscriptions on the cut stone blocks. Stillman came to an agreement with one of the landowners to undertake excavations, but his plans were blocked by political problems, for during the bloody rebellions of the late 1860s he had gotten on the wrong side of the Ottoman authorities by supporting Cretan insurgents. There were also concerns about the final disposition of the finds. The Turks would have liked to transfer the artifacts to Constantinople, while most Cretans preferred them to remain underground a little longer rather than see them leave the island permanently.[13]

Minos Kalokairinos continued to give guided tours to foreigners who journeyed to Knossos, and some of them reported his findings in scholarly journals. Schliemann himself came in 1886 and attempted, unsuccessfully, to gain permission to dig. The excavator of Troy and Mycenae returned to Knossos in 1889; "I would like to complete my research with a major undertaking: to excavate the prehistoric palace of the kings of Knossos in Crete," he wrote. But Schliemann lacked the patience to negotiate with the multiple owners of the hilltop, who knew of his wealth and sought to be paid as much as possible. His own shady dealings at Troy further doomed Schliemann's chances of obtaining the permission of Turkish authorities. The French, too, tried various times to gain authorization, but they seem to have been thwarted by what Arthur Evans later called the "almost inexhaustible powers of obstruction" of the "native Mahometans [Muslims]."[14]

Patience, politics, and good fortune, however, favored the Englishman. Evans's friends John Myres and Federico Halbherr had sought permission to excavate Knossos in the early 1890s, but it was not until Evans himself first visited the site in 1894 that any headway was made.[15] He copied the inscriptions, some of which he recognized from gems he had acquired from the local inhabitants, along with other artifacts. More significantly, with the assistance of Halbherr and Joseph Hatzidakis, a local physician, intellectual, and archaeologist,

Evans opened negotiations to purchase the site from its Turkish owners, who soon sold him one quarter of the land. By Ottoman law this did not give him the right to excavate, but it did give him veto power over anyone else who might desire to do so.

Over the next few years he returned to Crete regularly, and he eventually acquired the remaining parcels of the hilltop. Yet the political situation was still not auspicious. In 1898, however, Crete gained de facto independence from Turkey under a protectorate of Western powers. (The island was unified with Greece fifteen years later.) In 1899 new laws favorable to foreign excavators were drafted by Hatzidakis, who was president of the Cretan Syllogos, a learned society whose archaeological collections formed the foundations of the Candia Museum. The museum was to take possession of all artifacts excavated on the island (though some provision was made for the authorized export of duplicates), and Evans and his team were finally given permission to dig.[16]

Ground was broken at Knossos on 23 March 1900. Schliemann had been convinced that excavations could be completed in one week with one hundred men, but Evans spent the remainder of his long life (1851–1941) occupied with the site. His multiple campaigns, funded predominantly out of his father's and then his own private fortunes, were conducted on a massive scale. Most of the site was cleared in the first six seasons. Employing as many as three hundred workmen at a time — pickmen, shovelers, wheelbarrow pushers, shard washers, carpenters, and masons — he eventually uncovered approximately six acres (more than 260,000 square feet; almost 30,000 square meters). "The volume and variety of the relics brought to light," he later wrote, were "unrivalled perhaps in any equal area of the Earth's surface ever excavated."[17]

Like Schliemann, Evans was lucky. It was with good reason that his half sister, Joan Evans, titled her biography of him *Time and Chance*. In the first two weeks of his initial season, Evans unearthed inscribed clay tablets. These remained undeciphered until a decade after his death, but Evans, who knew what he wanted to find, none-

theless associated them with the mythical Law of Minos and suggested that they were the basis for later Greek legal codes (the most famous of which, dating to the seventh century B.C., had been discovered in 1884 by his friend Halbherr at Gortyna). Evans wrote:

> The minute bureaucratic precision revealed by these clay documents, the official sealings and dockings, their signing and countersigning, are symptoms that speak for themselves of a highly elaborated system of legislation. In view of such evidence, the legendary account of Minos, like another Moses or Hammurabi, receiving the law from the hands of the divinity himself on the Sacred Mountain, may well be taken to cover the actual existence of a code associated with one of the old priest-kings of Crete.

These inscribed tablets (Fig. 2.9) were written in one of the two prealphabetic systems that Evans recognized in addition to Cretan pictographic or hieroglyphic writing. The script, known as Linear B, was finally deciphered in 1952, when the young architect Michael Ventris identified it as an early form of Greek.[18] Although the Knossos tablets do confirm the presence of a sophisticated bureaucracy during the Late Bronze Age, when the site was occupied by Mycenaeans from the mainland, these texts have turned out to be inventory lists, not a law code at all.

The first season at Knossos was a great success. In fact, it surpassed all expectations. Evans and his workmen uncovered not only evidence of an advanced European civilization in the form of the inscribed tablets but also the remains of a multistoried architectural complex — thought to be the tangible underpinnings of the legendary Labyrinth — complete with stairways, light wells, and provisions for running water. In what he would later identify as the west wing of a vast palace, Evans recovered multicolored ceramics adorned with vividly painted flora and fauna and fragments of frescoes whose elegant, lithe human figures appealed to contemporary taste. Subsequent campaigns would yield exquisitely naturalistic miniature statuary in diverse materials, finely engraved gems, and still more fresco

FIG. 2.9 *Linear B tablets from Knossos: the first Greek script?*

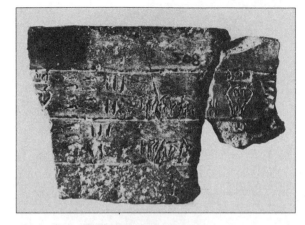

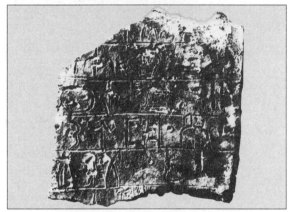

fragments. A hitherto unknown civilization was revealed, one that seemed uncannily modern.

One of the most astounding discoveries of the campaign of 1900 was a "Throne Room" complex (Fig. 2.15, nos. 17–19 on the plans; Figs. 2.10–2.12). Minos Kalokairinos had excavated part of its anteroom, but nothing valuable had come to light, so he had moved on. Removing layer upon layer of earth, Evans's workmen encountered traces, still adhering to walls, of painted plaster panels imitating veined stone; a fragment of a frescoed bull's hoof was also recovered.

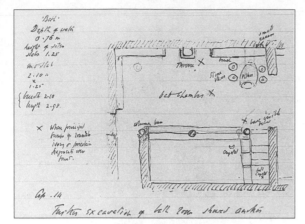

F IG. 2.10 *Evans's sketch of the Throne Room in 1900.*

F IG. 2.11 *Plan of the Throne Room.*

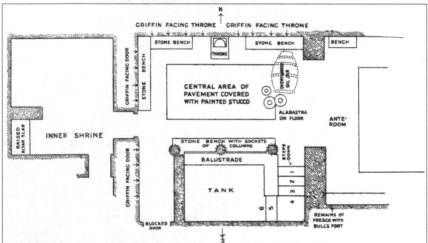

F IG. 2.12 *The Throne Room in the course of excavation. The painted palm frond to the right of the throne disappears in later restorations (compare Figs. 5.12 and 8.1).*

Along the north and south walls they found stone benches, and when they reached the floor, they discovered that it, too, was plastered. Four steps led down from a large court to the east, and here were emplacements for the jambs of four retractable doors. This *polythyron,* or many-doored wall, was a sophisticated architectural innovation. It could be entirely shut to close off a separate room or opened to form a larger hall.

The Throne Room itself was discovered on the west side of the anteroom. On its southern side six steps led down to a large stone-lined tank, which Evans, thinking in terms of the ancient myths, initially called "Ariadne's bath." Similar stone tanks (as well as other *polythyra*) were later discovered elsewhere at Knossos. Their function remains unclear, though Evans, believing that they were used for ritual ablutions, labeled them "lustral basins." (Others have argued that they served as fish tanks or latrines, although there is no provision for drainage.) The basin in the Throne Room contained fragments of rock crystal and other materials, which may have fallen from an upper story, for the basin itself was separated from the rest of the room by a low parapet that preserved sockets for wooden columns in its upper surface as well as the charred remains of the columns themselves. The floor of the Throne Room proper was littered with fragments of fallen fresco, and some traces of colored paintings still adhered to its walls: these depicted papyrus reeds and recumbent wingless griffins, composite beasts with the body of a lion and head of an eagle.

According to detailed daybooks kept by Evans's assistant, Duncan Mackenzie, on 13 April 1900, excavators uncovered "a tall slab in the [north] wall and this on further clearing proved to be the back of a stone chair whose seat was soon brought into view" (Figs. 2.12 and 5.12). This "seat of honor," carved from a single block of gypsum, had originally been covered with painted plaster. Set on a low dais in the middle of the wall, it was flanked by stone benches like those that lined the other walls of this room. The seat's high back had an undulating border, and its front legs were grooved and arched in a

manner Evans initially considered "almost," and later "distinctly," Gothic: he compared the "counter-arch" below it to the architecture of Wells Cathedral in Somerset. Just as he had named the basin after the legendary princess, Evans also initially called this elaborate chair the "Throne of Ariadne," apparently considering its wide molded seat more appropriate for a woman's proportions than for a man's. Later he seems to have changed his mind, publishing it as the seat of the priest-king. Whoever sat there, Evans called this seat, copies of which he commissioned for his home in Oxford, "the oldest throne in Europe."[19]

—◁◁◁◁▷▷▷▷—

The task of making sense of this astounding material was no less challenging than that of excavating on such a monumental scale. Evans published his finds in detailed preliminary reports and numerous scholarly articles and publicized them in popular magazines, newspapers, and public lectures. The great fruit of his labors, however, was a massive book that appeared in four multipart volumes between 1921 and 1935 and that remains a cornerstone of Minoan studies: *The Palace of Minos. A Comparative Account of the Successive Stages of the Early Cretan Civilization as Illustrated by the Discoveries at Knossos*. Here, in well over three thousand profusely illustrated pages, Sir Arthur defined the various stages of building at Knossos. He differentiated among diverse styles of artifacts and elucidated a system of Minoan chronology, largely by means of cross-connections with datable Egyptian material. Following nineteenth-century anthropological models, he distinguished (some might say imposed) three principal periods (Early, Middle, and Late Minoan) along with complex tripartite subdivisions (such as Middle Minoan IIIB), designations that are still used by professionals to this day.[20] On the site itself, Evans's engineers, architects, and conservators rebuilt the palace as it emerged from the earth — a practice that was controversial even at that time — while in the pages of *The Palace of Minos* Evans set about reconstructing Minoan society, tracing the development of Minoan

art, speculating as to the nature of the Minoan economy, civic institutions, foreign relations, and religion — in sum, re-creating the culture.

It is difficult to view the past through any lens other than that of one's own present. Evans, according to his half sister,

> was extremely short-sighted, and a reluctant wearer of glasses. Without them, he could see small things held a few inches from his eyes in extraordinary detail, while everything else was a vague blur. Consequently the details he saw with microscopic exactitude, undistracted by the outside world, had greater significance for him than for other men. . . . Out of an inchoate mass of pottery and stone, metal and faience, clay tablets and seals, walls and pavements, he had to achieve a synthesis. He had set out to find a script; he had found four and could read none of them. But Time and Chance had made him the discoverer of a new civilization, and he had to make it intelligible to other men. Fortunately it was exactly to his taste: set in beautiful Mediterranean country, aristocratic and humane in feeling; creating an art brilliant in colour and unusual in form, that drew inspiration from the flowers and birds, creatures that he loved. It provided him with enigmas to solve and oracles to interpret, and opened a new world for eye and mind to dwell in: a world which served to isolate him from a present in which he had found no real place.[21]

Minoan Crete, for Evans, was both a familiar place and an escape from the demands and constrictions of life back home. He saw it as a peaceful European island nation, led by an enlightened aristocracy, ruling a maritime empire and producing sophisticated, refined artworks — rather like England, he may have believed, before industrialization. And practically from the moment of its discovery, this early civilization was recognized as culturally advanced, complex, and elegant — in short, remarkably modern. "Primitive though they may be," proclaimed an anonymous author in *The Speaker,* a self-proclaimed "review of politics, letters, science, and the arts," in 1903, "Cretan frescoes strike a European note. The Court of Minos must

have been rather a club of gay gentle-folk than the suite of some eastern tyrant. . . . It must have been a free and somewhat democratic society which expressed itself in these bright contemporary sketches."[22]

Evans himself compared Minoan civilization to medieval, Renaissance, and baroque Europe, as well as to ancient Egypt, the Near East, Greece, and Rome. To explain the production of fine Minoan ceramics, for example, he drew analogies with the illustrious factories of the early modern period: "The Palace manufactory of Knossos," he wrote, "is the remote predecessor of Vincennes and Sèvres, of Medicean Florence, of Urbino or Capodimonte, of Meissen and other princely establishments of the same kind." In the architectural remains of the palace, Evans saw evidence that the Minoans had surpassed later European royal residences; their multistoried buildings were equipped with retractable doors, light wells for the circulation of fresh air, paved streets and courtyards, running water, and, it seemed, lavatories. Such features resonated strongly with Evans and his contemporaries, who had only recently begun to enjoy such conveniences. In 1903 Captain T. H. M. Clarke, medical adviser to the British high commissioner on Crete, compared Minoan latrines favorably to "the 'wash-out' closet of the present day" in an article entitled "Prehistoric Sanitation in Crete" in the prestigious *British Medical Journal*.[23]

In fashion, too, the Minoans were likened to contemporary trendsetters. Explaining the images preserved in frescoes, statuettes, and engraved gems, the French scholar Salomon Reinach wrote that "the women of Knossos in 1600 BC shared with the Parisiennes of our day the notion that a dress should cling around the hips and widen toward the hem."[24] And the Orientalist René Dussaud chastised both Minoan and modern women for relying on corsets to shrink their waistlines. Paris, the cultural capital of the day, was the focus of most comparisons, and a particularly attractive Knossian fresco fragment excavated in 1901 was duly dubbed "La Parisienne" (Fig. 2.13). Minoica had replaced the Tanagras as the ancient art most desirable to the present.

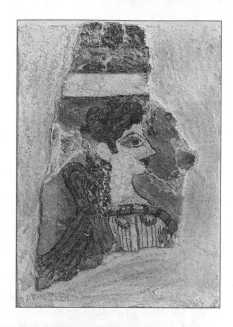

FIG.2.13 *The La Parisienne Fresco from Knossos: a "mixture of naive archaism and spicy modernism."*

FIG. 2.14
The Queen of Valencia?

La Parisienne, though originally part of a larger composition, soon became an icon in and of herself, gracing the pages of art and history books as if she were a sophisticated socialite.[25] More recently she has been transformed into the "Queen of Valencia" on cans of concentrated frozen orange juice "made exclusively from 100% American Valencia oranges" (Fig. 2.14). Soon after the discovery of the fragment, however, the French archaeologist Edmond Pottier cast her as a sultry temptress:

Her disheveled hair, the provocative "kiss curl" on her forehead, her enormous eye and sensual mouth, stained a violent red in the original, her tunic with its blue, red, and black stripes, the mass of ribbons tossed over her shoulder in a "come-hither" gesture, this mixture of naive archaism and spicy modernism, this quick sketch traced by a paintbrush on a wall at Knossos more than three thousand years ago to give us the impression of a Daumier or a Degas, this Pasiphaë who looks like an habitué of Parisian bars — everything about this work conspires to amaze us; in sum, there is something about the discovery of this unheard-of art that we find stunning, even scandalous.[26]

Pottier's remarks reveal little about the Minoans, but his passionate description sounds like nothing so much as the art criticism of the nineteenth-century French poet Charles Baudelaire. In his essay "The Painter of Modern Life," Baudelaire defined "modernity" as "the ephemeral, the fugitive, the contingent, the half of art whose other half is the eternal and the immutable." He wrote of the distillation of the mysterious beauty accidentally present in human life; his ideal painter "gives the eye a more decisive appearance of a window open upon the infinite; and the rouge which sets fire to the cheekbone only goes to increase the brightness of the pupil and adds to the face of a beautiful woman the mysterious passion of the priestess." For Baudelaire the prostitute was a consummate subject for the painter, the "Protean image of wanton beauty. Now she is majestic, now playful. . . . She has discovered for herself a provocative and barbaric sort of elegance, or else she aspires, with more or less success, towards the simplicity which is customary in a better world."

La Parisienne and other Cretan finds certainly suited modern tastes, and many writers compared Minoan artifacts to contemporary art and fashion. Evans likened another Knossian fresco fragment featuring a guinea fowl — stylized yet naturalistic — to the wallpaper patterns of William Morris, who had led a new design movement in England in the second half of the nineteenth century.[27]

For Arthur Evans, Richard Seager, and other enthusiasts of the prehistoric Aegean, it was paramount that the Minoans, whose homeland was "liberated" from Turkish rule in 1898, be not only modern but also as advanced as their "Oriental" contemporaries in ancient Egypt, Anatolia, and Mesopotamia, if not more so. "For the first time," Evans wrote in the opening of volume 1 of *The Palace of Minos,* "there has come into view a primitive European civilization, the earliest phase of which goes back even beyond the days of the First Dynasty of Egypt." Despite the paradoxical use of the word "primitive" here, Evans reveals another longtime preoccupation: that his Minoans be as old as, if not older than, other early peoples; and that as Europeans they function as the predecessors of a great and glorious Western tradition. For he wanted to believe that Crete, a "comparatively small island, left on one side to-day by all the main lines of Mediterranean intercourse, was at once the starting-point and the earliest stage in the highway of European civilization."[28]

Indeed, Evans considered his Minoans superior to their successors, and not just to the Mycenaeans of the Greek mainland, whom he believed were entirely dependent on their Cretan predecessors. At a time when painters and sculptors, as well as entertainers like Nijinsky and Isadora Duncan, were making the classical Greeks fashionable again, the advanced prehistoric society of Minoan Crete seemed to provide an explanation for the roots of the Golden Age of fifth-century Greece. Duncan herself journeyed to Knossos where, on the palace's Grand Staircase, she "could not contain herself and threw herself into one of her impromptu dances."[29] The formative role of the Minoans was promoted in the title of Charles Henry and Harriet Boyd Hawes's short book *Crete: The Forerunner of Greece* (1909) and in Evans's own books and articles as well as in many other publications that have appeared even to the present day.

For Evans and others, Minoan civilization at its height marked an earlier Golden Age recalled in later Greek myths that cast Minos as a "beneficent ruler, patron of the arts, founder of palaces, stablisher of civilized dominion." As for the cruel Minos and the Labyrinth, it

was "reserved for Athenian chauvinism," Evans wrote, "so to exaggerate the tyrannical side of that early sea-dominion as to convert the Palace of a long series of great rulers into an ogre's den." Minoan priest-kings, Evans believed, were prosperous and beneficient, as revealed in "the uniform prosperity . . . the great diffusion of wealth . . . the spacious villas and town-houses, in the many signs of domestic comfort and cultured tastes."[30]

As material testimony to such high culture, Evans could produce not only the writings and monumental architecture of Knossos, but also small finds of terra cotta, plaster, faience, carved stone, precious metals, and exotic imported ivory. In May 1902, excavating in what he called the "Domestic Quarter" of the palace, Evans and his crew discovered the remains of a series of gold and ivory statuettes (Figs. 2.15 and 2.16). Approximately one-sixth life size, the separately carved ivory heads, limbs, and torsos had originally been mortised together and adorned with gilded bronze hair and clothing of gold foil to form technically sophisticated composite sculptures. The best-preserved components were reassembled into the figure, now well known, of an agile acrobat participating in the Minoan sport (or ritual?) of bull leaping. (The restoration was apparently executed by the Swiss-born artist and restorer Émile Gilliéron, whom Evans had hired during the first season of the excavations.) The workmanship of the ivories is remarkable, and Evans repeatedly praised their exquisite anatomical detail. Indeed, he elevated them above better-known classical Greek works, for he had long rebelled against that standard. In a letter to his father written soon after the discovery, he wrote: "Our last find here is the remains of extraordinarily fine statuettes of ivory. Part of the surface and some limbs are wanting, but there is a good part of two figures. The carving goes beyond anything that could have been imagined and is more like good Renaissance work than anything classical." Evans expressed similar sentiments in the December 1902 *Circular of the Cretan Exploration Fund* and drew on myth in describing the quality of the figures. His remarks were paraphrased the following year in the *American Journal of Archaeology:* "The exquisite ivory fig-

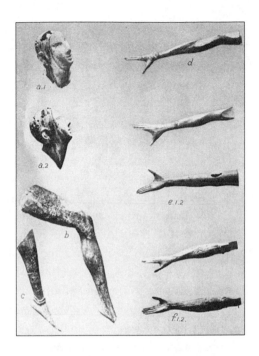

FIG. 2.15 *Components of statues from the Ivory Deposit at Knossos, excavated in 1902.*

FIG. 2.16 *"The 'art of Daedalus' in its highest perfection": the Leaper (restored) from the Ivory Deposit.*

ures of youths showed the 'art of Daedalus' in its highest perfection, displaying naturalistic details not found again in such work till the age of the Italian Renaissance."[31]

Evans was not alone in making such comparisons. Although he did not publish these ivories fully until the third volume of *The Palace of Minos*, twenty-five years later, he made no secret of his spectacular finds. He showed slides of them in public lectures and preliminary reports, and his remarks were widely repeated in the popular press. He also generously provided other writers with information as well as photographs. Thus the archaeologist Jean Charbonneaux, who did not share Evans's anticlassical bias, related the naturalism of the figurines to that seen in Greek statues of the fourth century B.C., and in a similar vein John Pendlebury specifically compared them to the works of Lysippos, the court sculptor of Alexander the Great, celebrated by Greek and Roman authors for creating particularly lifelike images. M.-J. Lagrange likened the Cretan statuettes to the idealized sculptures of the Parthenon, universally recognized as a high point in Western art, and even to the works of Michelangelo.[32] It was, of course, with the figures from this Knossian "Ivory Deposit" that Evans and others later associated the Boston Snake Goddess.

The immediate desire to elevate Minoan art to canonical status was part of a wider trend, evident in the analysis of exquisitely carved statuary in precious materials and even in descriptions of architectural fragments. According to an unnamed author in *La revue de l'art ancien et modern*, whose comments were translated in a 1902 *Scientific American* supplement:

> The molding of the petals and the pleasant curves of the corollas are rendered on the stone with a delicacy which suggests the best works of classic Greece. Were this fragment found in the vicinity of the Erechtheum it would not disgrace the collection of magnificent fragments strewn around the Athenian citadel. One understands how much the Ionic order owes to its archetypes, which, in Crete and elsewhere, drew from the plant and flower the classic elements of stone decoration.

In 1903 David G. Hogarth, who, like Evans, had been a newspaper correspondent before turning to archaeology, could write that a life-size bull rendered in high relief found at the north entrance passage of the Palace at Knossos was "hardly inferior to Myron's," referring to a lost statue of a heifer by the celebrated classical sculptor of the *Discus Thrower*. That same year Duncan Mackenzie traced to Crete the origins of Athenian vase painting.[33]

For Evans and his contemporaries, the art of the Minoans helped to explain not only the origins of the material Schliemann had discovered at Mycenae but also the marvels of the classical period. Crete replaced the Orient as the cradle of European civilization, and classical Athenian art of the Golden Age could now be traced back to a Minoan high point in the middle of the second millennium B.C.

—⁂—

Arthur Evans was not one for half measures. His excavations were vast, and his publications aimed to be comprehensive. On the title page (Fig. 2.17) of the first volume of *The Palace of Minos* he presented his credentials: Doctor Litterarum, Fellow of the Royal Society, Fellow of the British Academy, Honorary Vice President of the Society of Antiquaries, Royal Gold Medallist of the Royal Institute of British Architects, Foreign Member of the Royal Academy of the Lincei, of the Bavarian, Royal Danish, Swedish, and Serbian Academies, of the Göttingen Society of Sciences, of the Royal Academy of Sciences, Amsterdam, of the German, Austrian, and American Archaeological Institutes and the Archaeological Society of Athens, Correspondant de l'Institut de France, Extraordinary Professor of Prehistoric Archaeology, Honorary Keeper of the Ashmolean Museum and Fellow of Brasenose College in the University of Oxford.

Opposite this impressive litany (to which further accolades were added in subsequent volumes), two color images served as the frontispiece to the entire work. It was here that Arthur Evans enshrined the Minoan Snake Goddess (Fig. 2.17).

THE
PALACE OF MINOS

A COMPARATIVE ACCOUNT OF THE SUCCESSIVE
STAGES OF THE EARLY CRETAN CIVILIZATION
AS ILLUSTRATED BY THE DISCOVERIES

AT KNOSSOS

By SIR ARTHUR EVANS

VOLUME I
THE NEOLITHIC AND EARLY AND MIDDLE MINOAN AGES

MACMILLAN AND CO., LIMITED
ST. MARTIN'S STREET, LONDON

FIG. 2.17 *Frontispiece of Evans's* Palace of Minos, *vol. 1, showing the faience Snake Goddess excavated in 1903. Restorations to the face, left arm, skirt, and snake atop the headdress are rendered in lighter tones.*

This was not the Boston statuette, however. For as singular as it is, that gold and ivory figurine is not the sole representation of the Minoan Snake Goddess. In July 1914 Arthur Fairbanks had told Mrs. Fitz of statuettes in a museum on Crete that were "hardly as interesting" as the Boston Goddess, referring presumably not only to the ivory leapers recovered in 1902 but also to some faience figurines unearthed at Knossos in 1903. To Sir Arthur, however, the faience statuettes were extremely interesting, and it was one of these that he featured as the frontispiece to *The Palace of Minos.*

Exploring an area just south of the Throne Room (Fig. 2.5, no. 23) in late May 1903, toward the end of his fourth campaign, Evans and his workmen encountered two rectangular stone-lined pits, or cists, sunk beneath the floor. These large, well-built chambers measured approximately two meters long and one and a half meters wide and deep (Fig. 2.18). Because Evans thought their precious contents had been transferred from a damaged shrine and deliberately buried in antiquity, he called the pits "Temple Repositories." As he later wrote, "for beauty and interest [their contents] equalled, and in some respects surpassed anything found during the whole course of the four seasons' excavations."[34]

When the gypsum paving stones that sealed the repositories

FIG. 2.18 *The Temple Reposi-tories at Knossos.*

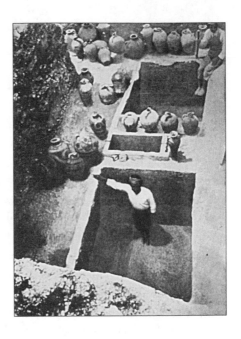

were lifted, Evans and Mackenzie found a layer of red earth, which they considered to have been affected by the heat of fire through the floor. Mixed in were broken pots, scraps of gold foil, and "a good deal of rubble." Deeper down lay more gold, fragments of worked ivory and rock crystal, bronze and stone implements, numerous bones and shells, clay sealings bearing the impressions of numerous sealstones, and the remains of inlays, plaques, and statuettes of faience, which the excavators initially called porcelain.

When the material was sorted, it became clear that the fragments of at least five faience statuettes had been recovered. Two were soon restored: the one Evans enshrined on his frontispiece and a smaller female with arms outstretched to the sides, holding a small, writhing snake in each hand (Figs. 2.19 right and 2.20). The smaller figure wears a horizontally layered skirt, a short apron, a scalloped belt, and a close-fitting, short-sleeved bodice, open in front, exposing her high, full breasts. Colorfully painted patterns adorn her garments,

providing contrast to her white flesh. This statuette immediately became famous and is to this day one of the most frequently reproduced pieces of ancient art. Replicas are sold throughout Greece and are easily obtained elsewhere. This piece is so popular, in fact, that it is regularly copied in other media: paintings, large-scale sculpture, even earrings (Figs. 2.21 and 2.22). But familiar as this figure has become, it is rarely noted that the "original," now on display in the Herakleion Archaeological Museum, is badly damaged: it was discovered without its head and most of the left arm (Fig. 2.19 right; 2.22). These missing parts (as well as the head of the single surviving "snake," whose stripes twist like those of a candy cane) were fashioned and attached by Halvor Bagge, a Scandinavian artist whom Evans employed alongside Émile Gilliéron as a conservator in the early seasons at Knossos. The crouching feline perched atop the head of the reworked figurine, unlike the face, is original, though it was not found with the statuette. Bagge, deciding that a small dowel hole on its underside matched another on a fragmentary beret adorned with rosettes, incorporated both cat and beret in the reconstruction.[35]

Although slightly less dramatic in appearance than the snake handler with outstretched arms, other fragmentary faience statuettes from the Temple Repositories were larger, and the one Evans selected for the frontispiece to his *magnum opus* (Figs. 2.17; 2.19 left) was restored to 13 1/2 inches (34.2 cm) tall. She resembles the Boston Goddess more closely than her counterpart, for her arms extend forward, with her hands at about hip level. She grasps the head and tail of a long spotted snake that zigzags up her arms, passes over her shoulders, and drapes down her back. Two thicker, undulating serpents, knotted at her waist, frame her bare breasts and cinched waist. The head of one is visible at her abdomen, and its tail loops over her right ear. The head of the other rises above the top of her high, purple, spiral tiara, a feature that reminded Evans of the *uraeus* (serpent headdress) of the Egyptian goddess Hathor. She has a painted necklace and, like her companion, wears a close-fitting, short-sleeved yellow bodice, open in front, revealing her breasts.

The painted frontispiece to *The Palace of Minos*, more than any

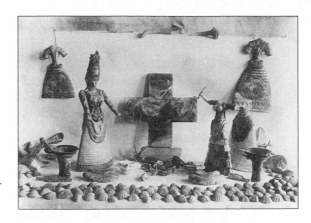

FIG. 2.19 *The contents of the Temple Repositories as reassembled by Evans. The faience Snake Goddess (left) has been restored, while the Snake Priestess (right) lacks the head and left arm. Note the large lower part of another statuette (far right) and coiled "snake bones" in the center. (Compare Figs. 3.3 and 3.4.)*

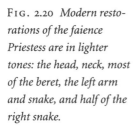

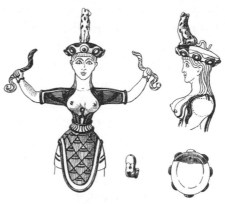

FIG. 2.20 *Modern restorations of the faience Priestess are in lighter tones: the head, neck, most of the beret, the left arm and snake, and half of the right snake.*

FIG. 2.21 *This monumental statue modeled on the Knossian Snake Priestess was erected on the campus of the University of California at Berkeley in the 1980s.*

FIG. 2.22 *An earring representing the Knossian Snake Priestess, the insignia of a powerful, independent woman.*

more recent photographs (and many of those that appear in books are actually of replicas!), deliberately reveals just how much this figurine, too, has been restored, for the modern components are clearly distinguished from original material by their lighter tones. The ancient statuette, in fact, is preserved only to the hips, which are covered by a short apron with a border of interlocking running S-hooks, only part of which remains. The lower portion of the figurine is entirely modern, and the reconstruction is based not on the figure with outstretched arms but on the remnants of a third, slightly larger statuette with horizontally flounced skirt and a decorated apron, preserved only up to the waist (see Fig. 2.19 far right). On the restored figure the left arm and hand grasping the serpent's tail are also modern, as is the neck, most of the face, and the snake's head atop the headdress.

Arthur Evans's handwritten notes on the Temple Repositories, recently rediscovered in the archives of the Ashmolean, indicate that he immediately identified this statuette (the one that most closely resembles the Boston figurine, which did not surface at the Museum of Fine Arts until twelve years later), as a "Snake Goddess." Noting her "matronly bosom," he also called her a "Mother Goddess," and in a preliminary report he referred to her "milky white" flesh. The smaller restored figure with outstretched arms, in contrast, he considered to represent the Goddess's "Priestess," "Votary," "Double," or "attendant." The third faience figure, originally larger than the other two, but surviving only in the fragment of a skirt and upper laces of the bodice, preserves no evidence of snakes. However, one of a series of stray faience arms found in the Repositories is overlaid by an undulating snake and may have belonged to this or a similar statuette. In *The Palace of Minos* Evans treated this larger figure, which his conservators did not restore, as another "Votary or attendant" rather than "an actual Goddess"; unlike its now more complete companions, it has largely been forgotten.[36]

The destruction of the palace at Knossos and the fall of Minoan civilization resulted in an irretrievable loss of information. All but one of

the prehistoric Cretan scripts Arthur Evans identified remain undeciphered, and the only one we can read, Linear B, postdates the Minoans; the examples from Knossos derive from a later phase of the palace, circa 1450–1350 B.C. according to standard chronologies, when Crete seems to have been dominated by the Mycenaeans. Modern attempts to unravel the belief systems of the Minoans are therefore dependent on comparisons to contemporary material elsewhere (Egypt and the Near East), reliance on later written sources, and the reading of the archaeological record.

In the retelling of Cretan myths by Greek and Latin authors, Europa, Pasiphaë, and Ariadne are all significant and colorful figures, but the roles they play are subordinate to those of their male counterparts: Zeus, Minos, and Theseus. This certainly fits the patriarchal structure of later Greek and Roman societies. In Minoan imagery recovered from Knossos and other Aegean Bronze Age sites, however, female figures seem preeminent. Males, to be sure, appear on frescoed walls, engraved sealstones, and gold rings and in small-scale statuary, but by and large these are not the bearded kings and warriors of Egypt and the ancient Near East. They are youths, who often, though not always, attend a dominant female, seemingly a goddess. Although later authors emphasized the importance of male gods and of Zeus in particular, Olympian goddesses, too, were worshipped in post–Bronze Age Crete: Hera, Demeter, Athena, Artemis, Leto, and Aphrodite. Classical texts also mention other, obscure female deities — Eileithyia, Britomartis, and Dictynna — who seem to have Minoan roots. But how are we to determine whether the later Greek polytheism derived from a Minoan pantheon? Or whether the Minoans worshipped a single goddess or many? For that matter, how can we determine the identity and significance of the faience figures recovered by Evans and restored by his workmen? Who or what is the gold and ivory Snake Goddess in Boston?

As we shall see, the standard answers to these questions over the years have themselves been the products of their own ages. They, too, are historical artifacts, which makes them at once less satisfactory and more fascinating.

3
THE DIVINE MOTHER

> The "making of a goddess" is always a mystery, the out-
> come of manifold causes of which we have lost count.
>
> — Jane Harrison, *Prolegomena to the*
> *Study of Greek Religion* (1903)

WHEN ARTHUR EVANS WAS SIX years old, his beloved mother died. Arthur knew she was very ill. He and his younger siblings had been sent away from home, and he had overheard that if she died, someone would throw gravel against the night nursery window. According to his half sister Joan, "He tried to stay awake, and listen every night; and on New Year's night he heard the sound he dreaded. Later he was taken to see his mother, where she lay so white and still. He knew that he would never see her again, and studied and studied the features that were so familiar and so changed; he was determined that if he never saw her again he should remember her all his life."

Harriet Evans's death at age thirty-four from an infection following the birth of her fourth child marked a turning point in the life of her eldest son:

> On Arthur the blow fell at an evil time. He was still in virtue of his childhood dependent on his mother; she was the active centre of his world. With her loss the world fell to pieces, and no one, least of all his father, realized the depth of his bewilderment and grief as he stood among its ruins. When the children came home from Abbot's Hill, John Evans wrote in his wife's diary that they did not seem to feel her loss; more than seventy years later Arthur Evans was to write an indignant *NO* in the margin. Arthur

was only six, and could find no escape in action; no thought or deed of his could set the world going anew.[1]

Although his mother's death scarred him for life, it would be facile to suggest that Evans's devotion to the Minoan Mother Goddess as an adult stems entirely from this significant childhood event. His reconstruction of prehistoric Cretan religion and the notion that peaceful, egalitarian, matriarchal societies had once existed on the island and elsewhere were rooted in ancient myths and also reflected prevalent intellectual trends of his time. During the Romantic movement of the late eighteenth and early nineteenth centuries, the rationalism of the Enlightenment began to be questioned, and the natural — even irrational — qualities conventionally associated with the feminine ceased to be disparaged and feared but instead came to be admired and enshrined.

This shift in attitudes has been tracked, for example, through the changing connotations of Olympian goddesses in classicizing poetry: Ronald Hutton has noted that between 1350 and 1800 the goddess most favored by writers was Venus (Aphrodite), followed by Diana (Artemis), Minerva (Athena), and Juno (Hera). These deities functioned as embodiments of love, chastity, wisdom, and majesty, respectively. Only Diana ever had any connection with the natural world, and in those rare cases she was represented as the patroness of hunting, the principal pastime of the European nobility. After 1800 Minerva and Juno were demoted and supplanted by Proserpina (Persephone) and Ceres (Demeter), both of whom are closely associated with the earth, the seasons, and agriculture. Venus, symbol of love, retained her primacy, but was now seen in relation to natural surroundings, while Diana came to be associated with the moon, forests, and animals more than with chastity or the chase.[2]

The trend toward naturalism in literature reflected larger shifts in thought. In 1849 the German scholar Eduard Gerhard suggested that behind the various goddesses of the classical pantheon stood a single Great Goddess. Twelve years later the Swiss jurist Johann Jakob

Bachofen published *Das Mutterrecht: Eine Untersuchung über die Gynaikokratie der alten Welt nach ihre religiösen und rechtlichen Natur* (Mother Right: An Inquiry into Female Power in the Ancient World According to Its Religious and Juridical Nature), in which he theorized a matriarchal phase in the development of all cultures. Far from being a feminist, Bachofen considered this matriarchal stage, which he called "Demetrian" (after the Greek goddess of agriculture), merely transitional, a necessary intermediate step on the path to a more spiritual, "Apolline" patriarchy, which constituted the culmination of human social evolution. Gathering "survivals" of matriarchy from ancient myth and legend and reading them as reflections of history, Bachofen argued that the Demetrian stage arose in response to a still earlier period of promiscuity, when marriage did not exist and women lived entirely at the mercy of men. He dubbed this phase "Aphroditian hetairism," *hetaira* being a Greek term for "courtesan." Women, he thought, rebelled against such unacceptable circumstances, instituted marriage, and established Mother Right, meaning not only matrilineal family descent (the mother's bond with her child always being stronger than the father's), but also matriarchy, the rule of women.[3]

Bachofen and his followers found evidence for these developments in the myths of Anatolia, India, and central Asia as well as of Italy, Greece, and Crete. These theorists linked the advent of matriarchy to the birth of agriculture in the belief that early peoples throughout the world necessarily correlated the ability of women to engender new life with that of the earth. Because they considered religious attitudes crucial to the formation of social structures, and women to be fundamentally more religious than men, they posited a universal cult of a female deity associated with the earth. It did not matter to them that in some cultures the earth was thought of as male, with a female deity ruling the heavens. The earth, after all, was fertile; to bring forth life it had to be plowed or at least "impregnated" by the rain, and its mountain peaks and deep crevasses seemed to some to suggest female anatomy. Early historians of religion parsed

the name of Demeter into *De-Meter,* with *De* being taken as a doublet of *Ge* (the Greek goddess Earth) and *meter* meaning mother.[4] It made little difference to them that Greeks of the Classical Age distinguished Demeter from Ge and various other goddesses from one another. In their view the ancients apparently suffered from what today might be called "false consciousness": living under patriarchy, they did not recognize the "earlier truths."

The relatively new discipline of archaeology seemed to provide support for these theories. During the long and prosperous reign (1837–1901) of Queen Victoria, prehistoric female figurines came to light throughout Europe and the Levant. The most famous of these, known as the Venus of Willendorf, was not discovered until 1909, but similar statuettes discovered earlier, conspicuous for their obesity and often called steatopygous (literally "fat-buttocked"), were recognized as belonging to the dawn of history. Now dated to the Upper Paleolithic (about 26,000–10,000 years ago) and Neolithic periods (about 7000–3500 B.C.), these figurines have long been interpreted in light of contemporary aesthetic, erotic, and even pornographic views of women. Their large stomachs and pendulous breasts were (and often still are) thought to depict pregnancy and lactation, even though pregnant women tend to have rounded bellies — tight as a drum — rather than sagging flesh. The figurines are frequently viewed as archetypal fertility figures that represent the desire for the successful births that any culture needs to maintain and increase its population. They have also been understood as projections of the sheltering, protecting, and nurturing character of the prehistoric Mother Goddess. Such views, however, are entirely conjectural. Stone Age depictions of males have also been recovered, as have animal figurines, but the nude female figures have received far more attention. Indeed, those seeking the antecedents of the present patriarchal order (or alternatives to it) have been attracted to the idea that every one of these statuettes is a cult figure that originally promoted a positive view of female qualities. Thus the figurines have been taken as evidence of the central importance of woman's biological powers in prehistoric soci-

FIG. 3.1 *The "Aphrodite of Knôsos" (no. 1) and other Neolithic figurines excavated by Evans.*

ety, notwithstanding the vast geographical, chronological, and physical differences among the artifacts themselves.[5]

Raised on the cutting edge of archaeology and having studied in Germany as well as at Oxford, Arthur Evans was certainly aware of these ideas. When he unearthed Neolithic figurines himself, he dubbed one the "Aphroditi of Knôsos" (Fig. 3.1) and linked the large-bottomed "Mother idols" to the Oriental Mother Goddess. "In Crete itself," he wrote in the first volume of *Palace of Minos*, "it is impossible to dissociate these primitive images from those that appear in the shrines and sanctuaries of the Great Minoan Goddess." Thus he compressed history by millennia. Although Evans does not cite Bachofen explicitly, he writes repeatedly of "the older matriarchal stage of social development" and "the matriarchal stage of society, to which the Minoan religious system owes its origin."[6]

He was also in close contact with two British scholars who engaged Bachofen's work directly. In her influential *Prolegomena to the Study of Greek Religion*, first published in 1903, the Cambridge classicist Jane Harrison extolled Bachofen's writings as the fullest collection of "ancient facts," although she recognized the "wildness" of some of his theories. Harrison jettisoned Bachofen's early phase of Aphroditian promiscuity but fully embraced the idea of a matriarchal stage as well as Gerhard's notion of the original unity of diverse goddesses prior to their separation and demotion in the classical period, the result, she believed, of the advent of patriarchy. Perhaps a victim

of false consciousness herself, Harrison considered the shift from matriarchy to patriarchy "[in] spite of seeming a retrogression . . . a necessary stage in a real advance." Bachofen thought this change liberated the human race from earthbound materialism and brought it to a higher spiritual plane, but Harrison believed patriarchy superior because "matriarchy gave women a false because magical prestige. With patriarchy came inevitably the facing of a real fact, the fact of the greater natural weakness of women. Man the stronger, when he outgrew his belief in the magical potency of woman, proceeded by a pardonable practical logic to despise and enslave her as the weaker."[7]

Harrison wrote these words in the first decade of the twentieth century, just as Evans was digging. And she occasionally incorporated into her arguments references to his finds, which he communicated to her personally. Projecting backward from later Greek religion, she suggested that the recently discovered faience Snake Goddess "may prove to be the prototype of Athene, of the Erinyes [avenging Furies] and of many another form of Earth-goddess."[8]

Another member of the Cambridge School, or "Cambridge Ritualists," who was familiar to Evans was Sir James George Frazer. Trained as a classicist, Frazer compiled learned commentaries on the writings of the ancient Greek traveler Pausanias and the mythographer Apollodoros. He is best known, however, for his massive publication *The Golden Bough*, which first appeared in two parts in 1890 and was subsequently expanded into twelve volumes and a supplementary *Aftermath*. It has since been abridged into numerous popular editions and, unlike Evans's *Palace of Minos*, is still in print. In *The Golden Bough* and his less well known *Adonis, Attis, and Osiris* of 1906 (both of which Evans cited with approval), Frazer, like Bachofen, sought to trace the primitive modes of thought common to mankind across diverse cultures. To this end he systematically collected, studied, classified, and coordinated magical and religious practices recorded in the myths and folk tales of numerous peoples, believing that the parallels he found were manifestations of our common humanity. Frazer was especially interested in tracing the Great Mother

and her younger male consort, the Dying God, exemplified by Ishtar and Tammuz in Mesopotamia, Isis and Osiris in Egypt, Kybele and Attis in Anatolia, Gouri/Isnai and Iswara in India, Astarte/Aphrodite and Adonis in Cyprus and Greece, Selene and Endymion, and even Mary and Jesus.

Evidence that the Minoans fit this pattern was readily found in the imagery preserved on Cretan artifacts, and Evans promulgated Frazer's ideas. Such pairings, apparently, were the way of major civilizations. Carl Jung and Marija Gimbutas also saw in the Mother Goddess a universal archetype existing deep within the human psyche and present in all cultures, whether or not attested by written sources. Such ideas remain potent to this day.[9]

Gerhard, Bachofen, Harrison, Frazer, Evans, and many others compiled, organized, and compared seemingly analogous manifestations of shared human culture to reveal the universal roots of civilization. According to Professor John MacEnroe, the "theoretical backbone of the emerging disciplines of archaeology and ethnology [in the nineteenth century] was a form of evolutionism: the idea that human history was essentially the story of progress from simple, primitive beginnings to an advanced present, with the promise of a Utopian future beyond."[10] This idea had arisen even before Darwin published *On the Origin of Species* in 1859. The Danish archaeologist Christian Jürgensen Thomsen (1788–1865) had already divided human history into three progressively more advanced periods, which he named for the raw materials used to fashion tools: the Stone Age, the Bronze Age, and the Iron Age. (Around 700 B.C. Hesiod had written of the Ages of Gold, Silver, and Iron, but this dyspeptic poet was charting degradation rather than progress.)

Evans's father was active in a circle of intellectuals who, as MacEnroe has observed, accepted a series of canonical precepts evident also in the work of Bachofen and the other scholars mentioned above:

1. A belief in the psychic unity of all humanity.
2. The assumption of unilinear progress in universal stages. Pro-

gressive evolution involved not only matters of technology, but also intelligence, emotional life, and morality.
3. The use of "survivals" to predict earlier stages of development. "Survivals" are cultural traits that appear out of place in a society and are explained as having their origin in more "primitive" stages of society.
4. The "time-machine" approach: the belief that "primitive societies" could be studied as representing stages of our own past. Ethnology and archaeology were linked.
5. The use of numerous, global comparisons as a means of explanation and proof.[11]

The Minoan Mother Goddess, however, was not fashioned entirely out of modern attitudes toward the development of gender relations in prehistoric societies, any more than she was simply the embodiment of Arthur Evans's boyhood desires. There is indeed ample archaeological evidence for a predominant female deity (or deities) on Crete, and not just in the form of the Snake Goddess or Votary or Priestess figures. Evans and other early explorers of the island's past recovered fresco fragments, carved gemstones, and engraved seal rings with female imagery. And in some cases, where the miniature intaglios themselves have not survived, impressions or sealings have been preserved.[12]

Knossos yielded several broken impressions of one seal that restorer Émile Gilliéron was able to reconstruct by drawing the overlapping fragments (Fig. 3.2). Here the familiar figure of a long-haired, bare-breasted female figure wearing a flounced skirt stands atop a mountain. In this and most other seals the images are too small for us to determine whether the figure is also wearing the open bodice sported by the statuettes, but women in Minoan art, both mortal and divine, were regularly depicted in such attire in a variety of media. Of course, the fact that they are represented wearing such elaborate costumes and exposing their breasts does not necessarily mean that most Minoan females went about their daily business in such outfits. The imagery could well represent special celebratory attire or the clothing

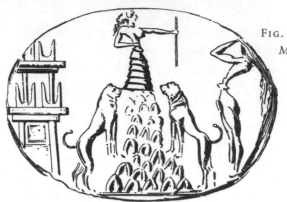

FIG. 3.2 *The Mother of the Mountains, as drawn by Émile Gilliéron* père, *after fragmentary sealings excavated at Knossos.*

particular to one social class. Such imagery appears not only in statuettes and small-scale objects of gold and semiprecious stones but also in the frescoes that adorned the walls of monumental buildings of the elite.

The female figure on the fragmentary sealings is certainly no ordinary woman. Flanked by two rampant lions, she stands on a mountain peak extending a scepter or staff toward a male wearing a Minoan kilt, who salutes her from below; behind her stands a building adorned with horns, evidently a shrine. For Evans she "is clearly the Minoan Mother Goddess." He also called her the "Minoan Rhea," a prototype of the mother of Zeus in later Greek mythology. Rhea came to be associated with the Anatolian goddess Kybele, who was attended by lions and worshipped on Mount Dindymus. The Romans, who worshipped a number of other female divinities, called this one Magna Mater, Great Mother.[13]

Mountains and caves played a major role in Minoan religion, as did other natural forms frequently depicted in Cretan artworks: animals, trees, flowers, and marine life. Depending on the surroundings in which she appeared, or the attributes with which she was associated, Evans identified the Cretan goddess as the "Mountain Goddess," "Snake Goddess," "Dove Goddess," "Earth Goddess," "Goddess of the Caves," "Goddess of the Double Axes," "Goddess of the Sports," and the "Mother Goddess." For Evans, however, these were not different

goddesses but different aspects of a unitary divinity, not unlike local variations of the Virgin Mary. Thus he did not consider the Snake Goddess, whether the faience version he had excavated or the chryselephantine statuette in Boston, to be a "separate religious entity, but rather . . . a chthonic version of the same matronly divinity worshipped" throughout the Aegean and even beyond, "the Underworld form of the great Minoan Goddess."[14]

Unable to read Minoan texts, Evans naturally looked for parallels elsewhere: in ancient Egypt and the Near East, Greece and Rome, and even in more recent cultures. In his notes, as we have seen, he linked one of the faience figures to Hathor, the Egyptian goddess of love and fertility, because of the snake on its high spiral crown.[15] The snake's head, however, had not survived, and Hathor, in any case, is not the only Egyptian deity that wears a serpent crown. Though she is often called a Mother Goddess, her particular symbol is the cow, not the snake.

Evans considered the smaller of the restored faience snake handlers from Knossos to represent a priestess rather than the Goddess, but he nonetheless argued that the spots of the feline Halvor Bagge had restored atop her beret, "taken over, perhaps through analogy with the snakes, need hardly stand in the way of the identification of the animal with the lioness, sacred, as we know, from other pieces of evidence, to the Great Minoan Goddess, later identified with Rhea." This connection of the Goddess with the lion, he further noted, was also found in other early civilizations: it "recalls the Egyptian representations of the Semitic Goddesses assimilated to Hathor. The Moon Goddess, Qetesh, stands on a lioness. Ashtoreth has a lion's head. As the great goddess of Dendera, Hathor assumes the form of a lioness with an uraeus on her head."[16] Ashtoreth is one of the names of Astarte, the Phoenician goddess of fertility, who is usually represented naked, holding her breasts with her hands. Like Hathor and many other Near Eastern divinities, she also often has horns on her forehead.

As he prepared his finds for publication, Evans arranged the ar-

tifacts from the Temple Repositories (Fig. 2.19). In the center of the assemblage, between the reconstructed faience snake handlers, he placed a Minoan marble cross, which he associated with the primary symbol of Orthodox Christianity and whose "special religious significance," he wrote, "can hardly be a subject of doubt."[17] In front of the cross he placed bones found in the Repositories, which he believed to be the head and vertebrae of a snake, arranged in coils (Fig. 3.3). From ruined fragments he carefully staged a ritual scene.

These bones, unfortunately, are now lost and thus unavailable for further study, but Evans himself seems to have determined that the disks were, in fact, fish vertebrae and the skull that of a weasel. When he published the photograph, he doctored the image. In his preliminary report he blotted out the bones and in *Palace of Minos* he pasted a small offering table over the "snake" skeleton and also added the now restored head of the smaller "Snake Priestess" (Fig. 3.4).[18]

—⁘⁘⁘—

Evans and others spilled much ink attempting to determine whether one or more of the faience figurines represented the Goddess herself or her priestess(es). (Some writers have effectively solved this problem by blurring the distinction, seeing the statuettes as images of priestesses imitating the Goddess.)[19] Whether or not the viewer is meant to think of them as divine beings, the Minoan snake handlers, like their counterparts in other societies, clearly had some form of supernatural power. Female snake handlers, however, are rare in Minoan art, despite their ubiquitous reproduction in recent times. The faience figurines from Knossos, in fact, are the only excavated examples from palatial Crete, though some later terra cottas have been recovered archaeologically. There are no Snake Goddesses in surviving Minoan frescoes, engraved gems, or seal rings. Yet Evans selected the Goddess for the frontispiece of the first volume of *Palace of Minos,* and she remains one of the most, if not *the* most, emblematic images of Minoan civilization. Why should this be so?

The answer lies, at least in part, in a certain universality and timelessness of the imagery. Snakes bear symbolic connotations in

FIG. 3.3 *Fish vertebrae: the true nature of the coiled "snake" in the Temple Repositories (detail of Fig. 2.19).*

FIG. 3.4 *Improvements: Evans's retouched version of the assemblage shown in Fig. 2.19, as published in* The Palace of Minos, *vol. 1. Evans pasted a small stone altar over the "snake bones" and added the restored head of the Snake Priestess (right).*

many cultures, be they beneficent or ominous. In conjunction with female images, as in the numerous depictions of the Gorgon Medusa (Fig. 3.5), Eve, or even Sin, the results are especially powerful, for they combine in disturbing ways the comforting and familiar with the terrifying and repellent. Linking desire with fear, and attraction with re-

FIG. 3.5 *The Gorgon Medusa, with snaky belt, hair, and wings, from the west pediment of the Temple of Artemis at Corfu, circa 580 B.C.*

FIG. 3.6 *A nineteenth-century snake charmer.*

THE FAIR CIRCASSIAN LADY.
THE ORIGINAL SNAKE CHARMER.

pulsion, such images, often highly erotic, exercise a strong hold on the imagination.[20]

Snakes evoke different associations for different people. For Freud they were phallic symbols, but the Pueblo Indians, who associated the long, zigzag form of the snake with lightning, employed them in rainmaking rituals. In 1896 the German cultural historian Aby Warburg visited New Mexico to investigate the "psychology of the American Indians." Like his contemporary Arthur Evans, Warburg recognized parallels in the practices of cultures separated widely by time and place and asked to what extent these "remnants of pagan cosmology" might help one understand the evolution from primitivism through the highly developed cultures of classical antiquity to modern civilization. Warburg was especially interested in the magic practices adopted by primitive pagans "to coerce the hostile forces of nature." In the case of the Pueblo Indians, he was told, the scarcity of water led people to practice the arts of prayer and necromancy, and his native informants led him to understand that the Pueblo believed in a "relation of magic affinity" between snakes and rain. Thus Warburg came to contrast the serpent as fetish in this primitive religion with its symbolic role in "the pure religion of redemption," citing numerous examples from ancient Greece and Rome, as well as the Old and New Testaments.[21]

Snake charmers have long been featured in circuses and freak shows (Fig. 3.6), and around 1910 an American named George W. Hensley was inspired by the Gospel of Mark to practice snake handling as proof of his Christian faith and divine favor. After the Resurrection, Jesus addressed his apostles: "And these signs shall follow them that believe: In my name they shall cast out devils, they shall speak with new tongues, they shall take up serpents" (Mark 16:17–18). When Hensley and his followers felt "the power," they handled poisonous snakes. Mishaps were not uncommon. Many snake handlers died from snakebites, and Hensley himself endured more than four hundred before he was bitten fatally by a diamondback rattler in 1955. Despite laws seeking to curb them, such practices continue to this day.[22]

Because they live in the earth, snakes frequently function as chthonic symbols — symbols of the underworld. Seen as passing readily from the nether world to the earth's surface, they are also considered intermediaries between the living and the dead. Their seasonal shedding of skin has caused them to be associated with rebirth as well as with menstruation and thus fertility. In one Cretan myth, snakes revealed to a soothsayer how to revive Glaukos, the infant son of Minos and Pasiphaë, who had chased a mouse into a pithos of honey and drowned. Snakes have positive connotations in other myths as well, appearing as the familiars of the Goddess Athena, her father, Zeus, and the healing god Asklepios; hence snakes appear on medical insignia to this day.[23]

To illuminate the function of the Snake Goddess in Minoan Crete, Evans assembled parallels not only from Egypt, the Near East, and ancient Greece, but also from the contemporary Balkans, where he had lived and worked as a journalist in Bosnia, Herzegovina, and Serbia in the 1870s and early '80s. There, he observed, "it is not an uncommon thing for snakes . . . to be fed with milk and be treated as domestic pets." Extrapolating back more than three millennia from this contemporary ethnographic evidence, he posited the existence of an indigenous Aegean tradition of the snake as a protective household divinity, a "domestic genius." As snakes were also wrapped around the hips of the larger faience Snake Goddess, he linked her even more closely with the Divine Mother: "It may be added," he wrote elsewhere, "that the sacral value of the girdle, emphasized here both by the plaited snakes that encompass the loins of the divinity and by the appearance of the girdle as a separate votive object, points to a Goddess of Maternity." He even considered the Snake Goddess to be "the Lady of the Underworld" and attributed responsibility for Crete's many earthquakes to her "infernal powers."[24]

—⊶⊷—

Although the Snake Goddess is relatively rare in Minoan imagery, Evans ascribed to her a wide sphere of influence, for he believed in the

essential unity of all manifestations of prehistoric feminine authority. The visual evidence, however, is ambiguous, and little else suggests that the Minoans worshipped a single unitary Mother Goddess. Unable to read the Minoan texts, we are left to "read" the artistic representations, but we cannot be certain how well we understand their visual language or how much we might superimpose our own meanings on their "words."

In *The Palace of Minos*, Evans introduced the supreme Minoan Mother Goddess on the third page of volume one. There he suggested that Minos's mother, Europa, was "perhaps, an Earth-Goddess," and went on to translate the names of the mythical king's wife, Pasiphaë, and daughter, Ariadne, as "the all illuminating" and "the Most Holy," respectively. For him, Minos was a "Priest-King," not unlike the Pharaohs: simultaneously child, consort, and father of the Mother Goddess in her various manifestations. Minos "was coupled with alternative forms of the Mother Goddess of pre-Hellenic Greece." But unlike the Snake Goddess, Dove Goddess, Mountain Goddess, and others, the Cretan Mother Goddess has no definitive imagery that sets her apart. In Minoan art, unlike that of Egypt and the Near East, one sees no nursing mothers, and depictions of children are rare. The bare breasts of Minoan females, of whatever status and whether or not such depictions reflect any reality, form part of a standard costume. Along with the flounced skirt, they distinguish women from men and goddesses from gods. There is no indication that bare breasts connote fertility or maternity, as Evans and others have assumed. Nor can we know whether the Minoans considered exposed breasts to be erotic, as some modern commentators have asserted, no doubt influenced by a long line of serpent-wielding femmes fatales, from Eve to Cleopatra.[25]

While most modern interpreters have assumed that the faience figurines had some sort of religious significance and have frequently called them "cult statues," René Dussaud (who disapproved of women in tight corsets) suggested in 1905 that they represented not goddesses, priestesses, or even votaries but rather snake charmers

(*charmeuses de serpents*). His idea was seconded by the German classicist Hermann Thiersch, who considered the faience figurines to represent Egyptian entertainers imported to Crete for palace amusements. He called them *Schlangenzauber*.[26] Most scholars have not agreed with this explanation (which if correct would certainly reduce the importance of the statuettes as central documents of Minoan religion), but it serves to illustrate how interpreters of Minoan civilization have been able to construe the Snake Goddess figurines in light of what was familiar to them.

The anachronistic cultural baggage that influences interpretation is illustrated in quite a different way by Francis Bramley Warren's painting *Egyptian Girl with Snakes* (Fig. 3.7). The resemblance of this long-haired, nubile, bare-breasted female snake handler in a heavy skirt to Evans's faience Snake "Priestess" is striking. She was, however, painted in 1889, thirteen years before the excavation of the Temple Repositories! The degree to which exotic images such as this might have influenced Dussaud or Thiersch, or even Evans and his restorers, is unknown, but there can be little doubt that when Evans produced the Minoan Snake Goddess, Europe was ready to receive her.[27]

—————

The Boston Goddess, naturally, was interpreted in light of earlier theories, but she nonetheless provided a separate canvas for those who wished to reconstruct a lost world. For Lacey Caskey, snake goddess/priestess and snake charmer were not mutually exclusive categories. Nonetheless, he accepted Evans's identifications of the two restored faience figurines and concluded that "our ivory figure, with her elaborate crown and stately pose, is more probably the central figure of the cult rather than one of her ministrants." Mariana Griswold Van Rensselaer, who in the *Century Magazine* praised the gold and ivory statuette as "the most remarkable work of art that the world of to-day possesses," admitted that she did not know "what the snake typified in Cretan mythology" and that the statuette might seem "very unlike a goddess . . . to eyes accustomed to the deities of Egypt and Greece."

FIG. 3.7 Egyptian Girl with Snakes
by Francis Bramley Warren (1889).

But because "no other that we know compares with it in the preciousness of the material, in the beauty of the workmanship, or in the impression of stateliness and power which, despite its small size, it conveys . . . We feel that this determined, dominating air — an air that is also singularly proud and aristocratic — befits no mere votary or temple attendant."[28]

The following year, 1917, saw the publication of *Myths of Crete and Prehistoric Europe,* by Donald MacKenzie (apparently no relation to Evans's assistant), which showcased several color illustrations by John Duncan that depicted the bare-breasted Minoan Goddess and her attendants with snakes, lions, doves, and mountains (Figs. 3.8 and 3.9). Some of the drawings were based on actual finds, such as the fragmentary seal impressions from Knossos mentioned above (Fig. 3.2), but they are nonetheless misleading: the artist recombined distinctive elements of diverse Cretan images to create charming com-

FIG. 3.8 *Lovely Cretan ladies: the title page of Donald MacKenzie's* Myths of Crete and Pre-Hellenic Europe *(1917).*

FIG. 3.9 *John Duncan's conflation of the Mother of the Mountains, Snake Goddess, and Dove Goddess, from Donald MacKenzie's* Myths of Crete and Pre-Hellenic Europe.

FIG. 3.10 *All things to all people? The Boston Goddess as "Eve . . . or Guen-ever, as Serpent-Priestess of Eden before Marriage with King Her Thor, Arthur or Adam."*

positions of ladies in their boudoirs or surrounded by various animals.

Others, too, have interpreted the Snake Goddess in light of their own desires. Perhaps the most extreme instance occurred in 1930, when L. A. Waddell employed the Boston statuette as the frontispiece to his book *The British Edda* (Fig. 3.10). According to the title page, Waddell rendered into English "the great epic poem of the ancient Britons on the exploits of King Thor, Arthur or Adam and his knights in establishing civilization reforming Eden & capturing the Holy Grail about 3380–3350 B.C. reconstructed for [the] first time from the medieval mss. by Babylonian, Hittite, Egyptian, Trojan & Gothic keys." The Boston Goddess, dated by Waddell to circa 2700 B.C., was identified as "Eve or Ifo, Gunn-Ifo or Guen-Ever, as Serpent-Priestess of Eden before marriage with King Her-Thor, Arthur or Adam." Laboriously tracing King Arthur back, via Troy and elsewhere, to Eden, the author explicitly rejected the attribution of the gold and ivory statuette to Crete, associating it instead with Sumerian and Hittite prototypes as well as with "figures on old Gothic cathedrals."[29]

As times have changed, so too have interpretations of the Goddess, apparently in response to evolving conceptions of the proper role of women in contemporary society as much as to any new information about the Minoans. In 1943, when Crete was occupied by the Germans, and American women faced new responsibilities at home, their men having departed to fight in World War II, the Boston Goddess was no longer compared to delightful snake charmers or Parisian dancing girls. Seeking to capture the spirit of the "important woman of affairs," the fashion designer Madame Eta (Eta Valer Hentz) created an evening dress inspired by the gold and ivory Snake Goddess (Fig. 3.11). The gown is décolleté but, in keeping with contemporary mores, not so revealing as the garments worn by the statuette. More recently the Boston Goddess has been interpreted as a powerful independent female, a fitting model for modern women. In 1993 she was featured as the frontispiece of Asia Shepsut's *Journey of the Priest-*

FIG. 3.11 *Fashion for the "important woman of affairs": a divinely inspired dress by couturier Madame Eta (Eta Valer Hentz), circa 1943.*

ess, in which the "priestess traditions of the ancient world" serve as guides on a "journey of spiritual awakening and empowerment."[30]

Other authors, meanwhile, remain concerned with antiquity. In *Lady of the Beasts: Ancient Images of the Goddess and Her Sacred Animals*, Buffie Johnson found distant parallels for the Boston Goddess's imagery in northern Europe: "The nipple on the right breast is indicated by a golden nail that serves, like the exposure of the breasts, as a reminder of her precious nurturing role and suggests that the Goddess sometimes suckles the serpent." She adduced the parallel of "Tenau of the Golden Breast, a Celtic goddess . . . so called because a snake clung to her nipple so tenaciously that the breast had to be cut off and replaced with one of gold."[31]

Whether or not one accepts such distant parallels as valid depends, at heart, on the degree to which one believes that humans living in different cultures vastly separated by time and space share basic

underlying beliefs. Or, to focus on the particular rather than the general, on whether the gold pin in the Boston Goddess's right breast (the left one is split) was part of the original. For, although many people seem unaware of the fact, it cannot be proven that the Boston Goddess came from Knossos. Also, like the faience statuettes that were indisputably excavated there, she is heavily restored. In her 1994 book *Sanctuaries of the Goddess: The Sacred Landscapes and Objects,* for example, Peg Streep writes of the faience figurine holding snakes in her upraised arms (Evans's Priestess, Figs. 2.20; 3.4 right) that "the sternness of her expression reminds us that if she is the source of all life, she is equally the repository of all death." Yet the entire face of this statuette was fashioned by Halvor Bagge, as were the "snakes," except for the lower half of one. In fact, the objects she holds could well have been something else, such as the sheaves of grain or necklaces held by other Bronze Age females (Figs. 3.12 and 3.13). The larger faience figurine (Evans's Goddess, Figs. 2.17; 3.4 left), whose original face is barely preserved below the eyes, is for Streep "the sacred energy incarnate. Her face betrays none of the other Goddess' stern power but is, instead, almost serene, reflecting her ability to harness the snake's sacred power." Others, meanwhile, have written of these figures' "trance-like, almost mask-like expression [which] composes a meditation upon [the] theme of regeneration." The statuettes have simultaneously been thought to embody "a culture of joyousness, grace and elegance centred for hundreds of years around the worship of a great goddess."[32]

—⁓⁓—

Arthur Evans and others erred, not in admitting the existence of a Minoan Mother Goddess but in presupposing it. There is ample evidence for the worship of female deities on Crete, but we cannot determine its precise nature. Excavation has revealed that the Minoans enacted rituals at sanctuaries on Cretan mountains and deep in clefts and caves, but there is no conclusive evidence as to the gender of the god or gods they worshipped there.

Evans, as we have seen, was far from alone in reading his finds in

FIG. 3.12 *Did the Priestess hold snakes? A seated female in Aegean dress holds sheaves of grain on an ivory pyxis lid from Minet-el-Beida, Syria, circa 1300 B.C.*

FIG. 3.13 *A woman (goddess?) holding a necklace on a fresco fragment from the Cult Center at Mycenae, circa 1250 B.C.*

light of preconceived notions about early human culture and religion. In fact, as ideas about the proper role of women in society have evolved in the past one hundred years, so too have the Minoans been reinterpreted. For the past is constantly reshaped to suit the needs of the present. The unsubstantiated nineteenth-century idea that the numerous goddesses of classical Greece were descended from a single

prehistoric divinity gained increasing popularity in the twentieth. Feminists and others seeking alternatives to an oppressive, patriarchal, Judeo-Christian tradition have embraced the idea of a kinder, gentler, matriarchal world, in which humans peacefully coexisted with nature as well as with one another in a loving, egalitarian society protected by an all-powerful female deity. Evans did not take things so far. He believed that patriarchy was the ultimate social development and that males — Minos and his descendants — ruled Crete and its peaceful empire. Adherents of the modern Goddess movement, for whom the Snake Goddess evokes "the solemnity of Minoan ritual" and serves as a symbol of "strength and fecundity" have come to assume that Minoan Crete was a matriarchy, but there is little to indicate that women in cultures whose religions focus on female deities necessarily enjoy particularly high status (consider Athena at Athens, Kali in India, and Mary in Rome).

Likewise, while it is *possible* that the diverse individual goddesses of classical Greece — Athena, Artemis, Aphrodite, Hera, Demeter, Persephone, Hestia, and others — all developed out of a single Great Minoan Mother Goddess, it hardly seems *probable.* Nonetheless, the later deities, clearly distinguished by Homer, Hesiod, and other ancient sources, have been conflated retroactively into a primeval Great Mother by adherents of the Goddess movement. To explain the tradition that many of the classical goddesses never gave birth and some remained perpetual virgins, moreover, the Goddess movement has viewed them as distinct manifestations of *the* Goddess in different stages of female development — as Maiden, Matron, and Crone. The individual cults and rituals of the Olympian goddesses and the attributes that distinguish them (Athena's owl, Artemis's bow, Aphrodite's swan, and so forth) are posited as developments of aspects of the Great Goddess that are evident in Minoan female figures (snakes, doves, axes). But such reasoning is circular. Why should we believe that the Minoans, unlike their successors in Greece and contemporaries in Egypt and the ancient Near East, were monotheists rather than polytheists?[33]

The Linear B tablets from Knossos, although inscribed about 1375 B.C., at least two hundred years later than the material from the Temple Repositories and characterizing a Mycenaean rather than a Minoan phase, mention numerous deities: Mistress Athana, Paiaon (Apollo?), Enyalios (Ares), Poseidon, Eleuthia (a birth goddess in later periods), and, apparently, Zeus. Later tablets from Pylos, on the Greek mainland, also mention Poseidon, Hera, Artemis, Hermes, and Dionysos, as well as other divinities that seem not to have parallels in later Greek religion. In both the Cretan tablets and those recovered on the mainland, the term "mistress" *(Potnia)*, which was applied to Athena at Knossos, is used for individual, differentiated goddesses. We read of a Mistress of the Labyrinth and a Mistress of the Horses, a Grain Mistress, and others. At Pylos a "Divine Mother" seems to be just one of many female divinities.[34]

It appears that the Minoans, like the Mycenaeans and their classical Greek successors, may well have worshipped a pantheon of gods and goddesses rather than a single multifaceted divinity. But until Minoan writing is deciphered, the precise nature of early Cretan religion must remain uncertain.[35] And the greater the certainty with which moderns explain ancient belief systems, the more we must suspect that their convictions reflect present desires rather than past realities.

4

ℬoy-Gods, ℬull Leapers, and Corseted Goddesses

> In the course of time the slow advance of knowledge,
> which has dispelled so many cherished illusions, con-
> vinced at least the more thoughtful portion of mankind
> that the alternations of summer and winter, of spring and
> autumn, were not merely the result of their own magical
> rites, but that some deeper cause, some mightier power,
> was at work behind the shifting scenes of nature. They
> now pictured to themselves the growth and decay of veg-
> etation, the birth and death of living creatures, as effects
> of the waxing or waning strength of divine beings, of
> gods and goddesses, who were born and died, who mar-
> ried and begot children, on the pattern of human life.
>
> — James G. Frazer, *Adonis, Attis, Osiris* (1907)

THE EXCITEMENT over the Boston Goddess, combined with the in-
creasingly popular notion of a prehistoric Mother Goddess, ensured
that when other "Minoan" statuettes of gold and ivory as well as stone
came to light in the 1920s and 1930s, they would be enthusiastically
received. These objects streamed north through Europe and across
the Atlantic into the eager hands of museum curators and private col-
lectors, Evans included. As in the case of the Boston Goddess, ques-
tionable stories surrounded their origins, but they were, for the most
part, readily accepted. Like the Boston Goddess, almost all were said
to have come from Knossos. Sold on the international art market,
usually in Paris, they fetched exorbitant prices. Admired and praised
by experts, they too have been featured in academic journals and

popularized in newspapers, magazines, and books. They have been extolled as extraordinary works of art in their own right and employed as valuable evidence of prehistoric Cretan religion and culture. Most of these statuettes represent some manifestation of the Goddess; two, however, have been interpreted as "Boy-Gods" who worshipped her.

In the early twentieth century the art market was a secretive place, just as it is today. Details of the dates, places, and prices asked and paid for these statuettes were often concealed and can be as difficult to determine as the objects' provenience. Publications, museum archives, and personal letters yield some information, but these repeat rumors as often as they provide reliable data. Art dealers, especially those in the antiquities trade, are a slippery lot, for their wares are frequently obtained illicitly, so important contextual information is lost. The erasure of provenience is necessary not only for looted and smuggled objects but also for forgeries, and in both cases the need for plausible stories of origin engenders particularly imaginative narratives. Customers have to be satisfied, and astute salesmen rise to the challenge, offering accounts tailored to their clients' desires.

Consider the two "Minoan" ivory statuettes purchased in the 1920s by Henry Walters, a Baltimore art collector and philanthropist. They were found languishing in a desk drawer after his death in 1931, accompanied by an undated certificate from the Paris firm of Feuardent Frères (Fig. 4.1), which proffered the following optimistic assessment of their origins:

> I certify that the two objects in ivory (1st snake goddess covered with a gold network 2 crowned goddess with the head crowned and a pleated dress) were found on Crete at Knossos. They come from around the palace of King Minos, from the information which I was able to gather.
>
> The objects date back to a legendary epoch which should be placed around the 15th century before Christ.
>
> G. Feuardent[1]

FIG. 4.1 *Guaranteed genuine: an undated certificate from the Parisian dealer Feuardent authenticating two Minoan ivory statuettes from the Palace of Minos (Figs. 4.2 and 4.5).*

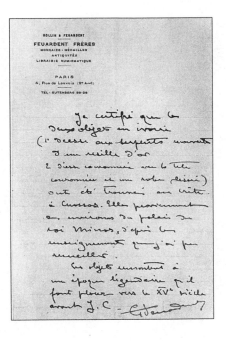

The larger of the two, a Snake Goddess, has been restored (Fig. 4.2). Slightly taller than the Boston Goddess at 21.5 centimeters, her atrophied arms are outstretched to the sides like those of Evans's faience priestess. Carved separately and inserted into square mortises at the shoulders, the arms are enveloped by gold snakes, one of which remains. The surface of the ivory has deteriorated, but the Goddess's heavy, cut-out and incised gold ornaments are quite well preserved (Fig. 4.3). The flounced skirt is represented by thin gold strips decorated with geometrical patterns, like those of the Boston Goddess, as well as by wide bands with rectangular cut-out panels. The figure also wears a short gold apron with cut-out triangles that form the outer curves of two heraldically arranged repoussé snakes. Like the Boston Goddess and the faience figurines from Knossos, the narrow-waisted figure is belted. Her open, sleeved bodice, however, is much better "preserved" than that of the Boston statuette. When the figure was found — in Walters's desk drawer, that is (Fig. 4.4) — the cut-out

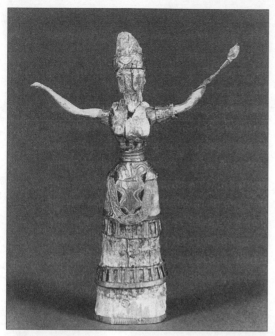

FIG. 4.2 *Gold and ivory Snake Goddess, restored, Walters Art Gallery, Baltimore. Height 8 1/2 in. (21.5 cm).*

FIG. 4.3 *Bits and pieces: gold and ivory elements of the Baltimore Snake Goddess (Fig. 4.2) in the course of restoration.*

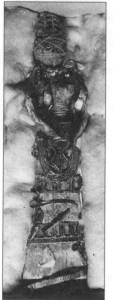

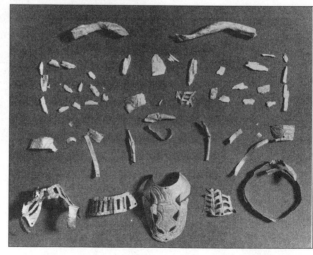

FIG. 4.4 *Found in a desk drawer: the Baltimore Snake Goddess as discovered in 1931. Some of the gold garment pieces are tied to the head with string.*

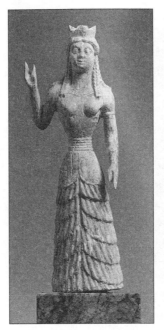
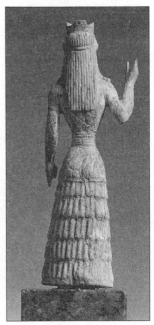

gold bodice was wrapped around the figure's high tiara, the base of which is further adorned with a gold band with repoussé spirals.

The tension of the Goddess's pose and the proportions of the figure show clear resemblances to the Boston Goddess and other Cretan statuettes, but the deterioration of the original ivory surface prevents any comparison of anatomical detail and style. Her face has been obliterated, and the piece is badly weathered overall.

The second figure purchased by Walters (Fig. 4.5) is considerably smaller (10.4 centimeters) and extremely well preserved. Carved from solid ivory, it has no gold, nor does any ever seem to have adorned it. The flounces of the dress, which rise at center front, are carved rather than applied, as are the figure's ringed belt and the bands encircling her forehead and left hand, held at her side. Her right arm is bent sharply with the hand turned forward, as if in some sort of benediction. Twisted locks fall over her shoulders in front and on the sides,

but her hair is straight at the back. Her round eyes are blank and she smiles slightly. On her head is a low crown with four crenelations.

Dorothy Kent Hill, curator of ancient art at the Walters Art Gallery, who published both figures in 1942, recognized the smaller Goddess as a forgery: "the costume is misunderstood, the head-dress typically Greek, the crown unprecedented in ancient times and the general impression, too, like a chess queen." But she also concluded that "the fact that it was purchased with the other does not, I think, argue against the authenticity of the first piece. In fact, it is not only possible, but quite probable that someone, finding himself the possessor of a genuine but frightfully mutilated statuette, made a companion piece for the trade." For Walters, who purchased both, the well-"preserved" details of the smaller figure may have made up for the terrible losses in the larger.

As for the trade in Cretan objects, it was thriving in the years after World War I, and Feuardent Frères (formerly Feuardent & Rollin) seems to have had particularly profitable connections with Crete. The firm, which was reputable — although it, like many other dealers in the late nineteenth century, sold fake Tanagras — can be traced as the source of other unprovenienced Cretan statuettes.[2] In these cases, too, exact sale dates are difficult to determine. An ivory Boy-God (Figs. 4.6 and 4.7), for example, was apparently introduced to the world in February 1924, by Evans in a lecture at the Royal Institution entitled "Recent Light on the Minoan Art of Crete." Sir Arthur compared the statuette to the "famous ivory Goddess now in Boston — so modern in its expression that many had doubted its genuineness." But in Evans's opinion, the new figurine, "apparently by the same hand and unquestionably genuine," proved the authenticity of the Boston Goddess. The Boy-God, who "seems to be in the act of adoring his Lady Mother . . . shows a delicate and sympathetic execution more suggestive of Leonardo than of any ancient models."[3]

Evans did not admit publicly that the statuette was part of his personal collection, but a year later he mentioned the dealer from whom he had acquired it, "a mutual friend," in a letter to Charles

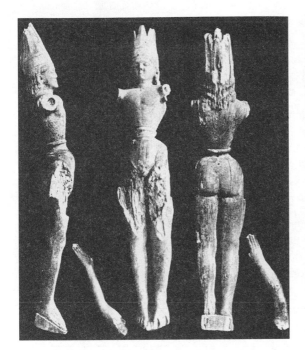
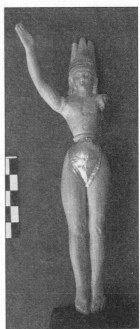

FIG. 4.6 *Ivory Boy-God in "the condition in which it was found." Seattle Art Museum, formerly in the collection of Arthur Evans. Height 6 7/8 in. (17.5 cm).*

FIG. 4.7 *Evans's favorite Boy after restoration. This plaster cast, owned by Evans, has an added gold loincloth and headband.*

Seltman, a fellow of Queen's College, Cambridge, and university lecturer in classics. Some months earlier Seltman had shown Evans a female figurine in stone that had "probably been removed from Crete" and offered to sell it to him.[4]

Seltman was asking £2750 for this stone image of the Goddess (Fig. 4.12). Even for a man as wealthy as Evans, this price was high. Sir Arthur nonetheless had the stone Goddess sent to him on approval and suggested to Seltman that it be repaired by William Young at the Ashmolean Museum, for "it really is painful to look at it in its present state." When Evans eventually decided against buying the stone God-

dess, Seltman offered it to the Fitzwilliam Museum in Cambridge. The director, Sydney Cockerell, sought Evans's opinion on the piece, and on 12 January 1926, Sir Arthur responded:

> I never saw the stone figurine of the Goddess till Seltman showed it to me and left it with me to consider. There is no doubt about its genuineness but Seltman's idea as to the price seemed to me to be beyond all bounds. For all I know, he may now be abating his demands, but they amount to about four and a half times what I paid Feuardent a little time since for what is after all a more unique and beautiful Minoan figure — the boy God in ivory. As to what he paid Feuardent I know nothing, but I guess that he is trying to get a high price for which he will receive a Commission of 10%. After due consideration, and taking advice, I refused to think of it at his price.
>
> Whether it ultimately reposes at Cambridge or Oxford does not much matter — but meanwhile I doubt even if an American Millionaire Collector would give Seltman's price!

Whether Sir Arthur knew of Walters's purchase of two ivories from Feuardent, or whether that purchase had even taken place at that time, is not clear. Evans's letter, nonetheless, does indicate that he, like Seltman and Walters, had bought his Minoan statuette from Feuardent and had paid approximately £600 for it. Sir Arthur, moreover, was correct in his suspicion, expressed elsewhere, that Seltman was "sporting the market." Seltman had paid Feuardent £2500 for the stone Goddess and was later involved in other transactions involving Minoica.

Evans treasured his Boy-God, and although he later acquired another ivory boy for a price and from a source unknown, he seems to have been more fond of the first one. In 1938 he donated the second boy to the Ashmolean, but the first one remained in his possession until his death. In fact, of all the pieces in his vast personal collection, this was the one he chose to hold when, late in life, he sat for a portrait executed in his study by Francis Dodd in 1935 (Fig. 4.8). The

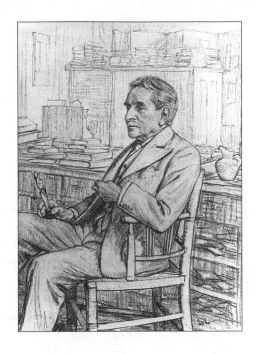

FIG. 4.8 *Sir Arthur Evans in his study, Boy-God in hand. Drawing by Francis Dodd (1935).*

figurine was later acquired from the executor of his estate, the dealer Jacob Hirsch, by the Seattle Art Museum for $6000.[5]

Sir Arthur shared news of his acquisitions with friends. In another letter to Cockerell concerning the stone Goddess (which the Fitzwilliam Museum did purchase), Evans again mentioned his favorite "boy God": "[The Goddess] is a very wonderful little work. Some day I may show you my ivory boy God, smaller than the other but very exquisite and a fellow to the Boston Goddess." This ivory may also be the statuette that Evans showed to the young Kenneth Clark. The renowned art historian recalled in his memoirs seeing what he thought was the Boston Goddess when, as an undergraduate in the 1920s, he visited Evans's large house on Boars Hill outside of Oxford. Evans, he wrote,

> was lively and intelligent, with an impressive range of interests; I remember that we talked about Caravaggio. After tea he said

"Something has just arrived that I must show you — I haven't even unpacked it properly." He took me into his study and produced a shoe box full of cotton wool and tissue paper, from which there emerged the ivory snake goddess of Boston. (I cannot swear that it was the Boston figure, but it was one of the same series.) It was a thrilling moment. I could not help saying (with no *arrière-pensée*, of course) "What an extraordinary modern face she has." He agreed, and pointed out how similar all Cretan decoration is to art nouveau. When I saw the goddess in Boston a year or two ago she looked more modern than ever; and when I saw the frescoes at Knossos their likeness to the *style dix-neuf cent* was easily explained.[6]

Clark had a keen eye, and the figurine he saw might have been a copy of the Boston Goddess. Although that statuette had by then been in Boston for some time, Evans had at a date unknown acquired a plaster replica for his personal study collection, which is now displayed in the Ashmolean Museum. However, it is unlikely that he would have been so enthusiastic about a copy. He might have shown Clark the Fitzwilliam Goddess, which he had on approval from Seltman from October to December 1925, but that statuette is of a dark, brownish stone, and Clark remembered the figurine he saw as being of ivory. Perhaps it was the Boy-God that is now in Seattle.[7]

In any case, Evans seems to have kept the Boy something of a secret prior to its full publication in volume 3 of *The Palace of Minos* in 1930. He alluded to the figure in the second volume, published in 1928, and that same year the Egyptologist H. R. Hall, a friend of Richard Seager, referred vaguely to the "young god" in a "private collection" while discussing the Boston Goddess. But the statuette was apparently still under wraps in November 1929, when the archaeologist Robert Carr Bosanquet wrote to his daughter from Boars Hill, where he was studying other objects in Sir Arthur's collection:

Last night we went over much Cretan ground, and he showed me the Ivory Boy, of whom I hadn't heard a hint: not to be talked about publically, perhaps, even now. Thee remember the gold

and ivory goddess in the Boston Museum? This is the companion figure, which came into the market later, tho' no doubt found with her: the young god stands before his mother on tip toe, raising both hands in adoration . . . Gold loin cloth is lost.[8]

Evans repeatedly advanced the idea that the ivory Boy had originally been associated with the Boston Goddess. In volume 3 of *The Palace of Minos* he noted that the statuettes were approximately the same height and concluded that "it is impossible not to regard [the Boy] as a companion piece to the Goddess." He even provided the Boy with a Knossian provenience: "It seems probable indeed that this had fallen to the share of a partner in a group of stolen ivories belonging to the same deposit, but that it had been 'released' after a somewhat longer interval — a not infrequent occurrence in such cases."[9]

Later authors have occasionally reported that the Boy was excavated at Knossos, but it, like the Goddess, has no secure archaeological context. Evans apparently purchased the statuette from Feuardent sometime in the early 1920s, but only elaborated on its nonarchaeological findspot in 1930:

> The figurine migrated to Paris a few years after the War where it made its appearance amongst a series of objects said to have been discovered by a Cretan miller. But the boy was in bad company. Of the numerous associated objects — all said to be Minoan and to have been found at the same spot — it was hard to recognize any genuine relic beyond one or two fragments. The whole lot seemed to have been the result of a peaceful and "sheltered" industry, carried out during that stormy time. The output was in part of a highly expert nature, but tempered with the usual ignorance that dogs the forger's footsteps.[10]

Sir Arthur had no doubt about the authenticity of the Boy, however, and he rejoiced in its fine state of preservation: "the main part of the figure was preserved in one piece, — a very different fate from that of the [Boston] Goddess! The chief damage that it had suffered was the

disintegration of the front part of the two thighs from the groin to the knees."[11] (The missing material was filled in, with wax and paraffin, by William Young at the Ashmolean.)

Sir Arthur thought that "the artist's intention was clearly to represent a child not more than about ten years of age," and he sometimes called him the "Divine Child." Evans's interpretation of the figure's role in Minoan cult followed a lengthy disquisition on the disproportionate width of the thighs as compared to the waist, which he attributed to the "forcible constriction of the internal organs imposed by the narrow, apparently metal ring" of the belt. He examined this body shaping in light of the apparel and form of other Minoan statuettes and adduced further parallels: Chinese foot binding and "the binding of boards to their babies' heads by the Indian 'Flatheads.'"[12]

The Boy-God stands on his tiptoes, his heels supported by a wedge, his back arched. Like the faience figurines from the Temple Repositories and the Boston Goddess, the upper body is thrown back, "in this case sufficiently somewhat to uplift the profile of the face, as if the figure were looking towards another of slightly higher stature." Evans further compared the "lively naturalistic perception" in the execution of the Boy's feet with other Cretan works, but for him the "beauty of the feet as a whole transports us rather to Renascence times," a comparison that recalls his description of the composite ivory leapers he excavated in 1902 (Figs. 2.15 and 2.16).[13]

The following section of Evans's description of the Boy is worth quoting in full:

> Even more modern is the feeling that has inspired the long waving locks that fall so gracefully from the Divine Child's head and hang down over the shoulders and the upper part of his back. The face itself, compared with the mature features of the ivory Goddess, shows less expression, as is natural to his tender years. The nose is decidedly snubby and broad, and the eyelids here, though adumbrated, indeed — as appears in certain lights — are not well defined as in the face of the "Boston Goddess." All

the same, when the two heads of the Goddess and of the boy-God are compared, it is impossible not to be struck by a great similarity in style. The modernness of treatment is shared by both, and the mere fact that what we have before us in the latter case is just the head of a young child only confirms the impression. Unfortunately the back of the head and shoulders of the Boston statuette have suffered a great deal of abrasion, but enough remains to show that the locks fell down behind in wavy tresses comparable with those that contribute such a graceful feature to the boy's head.

Can it be doubted that both works are by the same artist?

Both works were chryselephantine, both were crowned by tiaras, and, so far as the arms are concerned, both are of the same composite kind. To this may be added the fact that the history of both points to the neighbourhood of Candia as their source.

The conclusion seems more and more to impose itself that both the "Boston Goddess" and the boy-god formed part of the same ivory treasure — connected with a Palace Shrine of Knossos — as that to which the leaping youths and other associated remains belong. All are of approximately the same date, the closing M. M. III phase, when Art was at its highest level.

But the connexion between the Goddess and the Divine child seems to be even more intimate. It is a highly suggestive circumstance that the height 166 millimetres or exactly 6 1/2 inches corresponds, within a small fraction, to that of the "Boston Goddess." This remarkable agreement, indeed, best explains itself if we regard them as having been contained in the same frame and as forming part of the same group. They are thus reproduced in the sketch [Fig. 4.9] executed for me by Monsieur Gilliéron, fils.

What, indeed, can be more beautiful and natural than the relationship which the attitude of the boy-God itself suggests? Standing on tiptoe with his face slightly upturned he has the appearance of actually gazing at the slightly higher figure, and the obvious restoration of the right arm as lifted to the level of the peak of his tiara is only needed to supply the act of salutation. It is the Divine Child adoring the Mother Goddess.

FIG. 4.9 *The Boy-God ador-*
ing the goddess. Drawing by
Émile Gilliéron fils, *published*
by Evans in The Palace of
Minos, *vol. 3.*

The relation of this youthful male to the mature female fig-
ure, the divinity of both of which is here marked by the elabo-
rate tiaras, brings us face to face with the most interesting and,
in some respects, the most difficult problem in Minoan Reli-
gion.[14]

At this point Evans shows himself to be a true heir of Bachofen:
"It is certain that, however much the male element had asserted it-
self in the domain of government by the great days of Minoan Civili-
zation, the Religion still continued to reflect the older matriarchal
stage of social development." And Evans produced an unprove-
nienced sealstone, said to be from Thisbê in Boiotia (Fig. 4.10) and a
bronze statuette allegedly from Crete (Fig. 4.11) to demonstrate that
the Minoan Goddess was accompanied by a "Young Male Attendant,"
as in the numerous ancient traditions examined by Frazer in the
Golden Bough and in *Adonis, Attis, and Osiris.* Thus he employed four
unprovenienced objects to confirm the authenticity of one another
and to build a picture of ancient Cretan religion.[15]

FIG. 4.10 *"Minoan Goddess helped to rise from the Earth by a young male attendant." Drawing of a gold bead-seal, said to be part of a treasure found at Thisbê on the Greek mainland. Ashmolean Museum, formerly in the collection of Arthur Evans.*

FIG. 4.11 *A "youthful male adorant," said to be from Crete. National Archeological Museum, Athens. Height 9 in. (23 cm).*

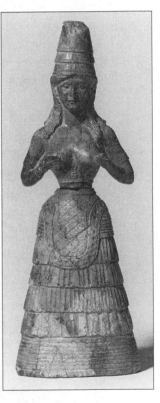

FIG. 4.12 *The Fitzwilliam Goddess: "the earliest piece of true sculpture to be found on Greek soil," said to be from the harbor town of Knossos. Height 8 7/8 in. (22.7 cm).*

Evans may have considered Seltman's stone Goddess (Fig. 4.12) infe-
rior to his "exquisite" ivory Boy-God, but the Fitzwilliam Museum
was eager to obtain its own relic of Minoan civilization. The museum
purchased the female figure in 1926 despite her high cost and despite
knowing that if she was genuine, she must have been smuggled out of
Greece illegally. The maneuvering that surrounded her acquisition
has been carefully researched by Kevin Butcher and David Gill, and I
have drawn on their account. Like her gold and ivory cousin in
Boston, the Fitzwilliam Goddess was viewed by those who sought to
obtain her not only as a rare survival of a legendary culture miracu-
lously brought to light but also as a vehicle to bring renown to their
institution. When Winifred Lamb, the museum's honorary keeper of
Greek and Roman antiquities, learned that the Goddess was avail-
able, she wrote immediately to Cockerell: "Something must be done.
She'll make my our dept. world famous." Lamb was so eager to obtain
the Goddess for her new Prehistoric Gallery that she and her mother
offered to underwrite half its cost. In the end, this proved unneces-
sary, as other officials agreed that the museum's funds, albeit limited,
would be well spent, as one of them wrote, "in obtaining objects of
outstanding interest which raise the position of the Museum in a way
in which no accumulation of objects which can be seen elsewhere,
can do." The Goddess was considered unique, and the fact that Evans
had contemplated buying her seems to have added to her perceived
importance.[16]

The Fitzwilliam's acquisition was duly announced in the press.
The *Times* of London declared the figure to be of first-rate significance,
"the earliest piece of true sculpture to be found on Greek soil." Just
as the Boston Goddess was lauded as the precursor to the great gold
and ivory statues of Pheidias, the Fitzwilliam Goddess was promoted
as the forerunner of Greek marble statuary. The *Illustrated London
News* went further still, extolling the statuette — in terms formerly
reserved for the Boston statue — as "the most perfect known exam-
ple of Minoan art of that period." Alan J. B. Wace, a former director of
the British School at Athens, who, like Evans, had advised the mu-

seum to purchase the Goddess, in a lecture at the Hellenic Society emphasized that the statuette was "of the highest importance" and called it "the most valuable Minoan sculpture yet discovered." He later wrote an entire book about it.[17]

It was only after the museum purchased the Goddess that "information" about its provenance became more widely known. According to the *Times* the Goddess was "said to have been discovered in Crete some little distance to the east of Candia, and found its way to a dealer in Paris, whence it was secured for Cambridge." There was no mention of its sojourns with Seltman and Evans.

In his 1927 book *A Cretan Statuette in the Fitzwilliam Museum*, Wace provided a recent findspot for the statuette — the harbor of Knossos. This information seems to have been obtained through local inquiries made by Evans or on his behalf. Wace went further, however, positing an archaeological provenience from the Goddess's damaged condition: because the figure was broken and appeared to be burned, he suggested that it was found in the ruins of a shrine destroyed by fire. This is clever deduction but hardly reliable. Indeed, in a letter to Cockerell Evans later said that he "only heard in a vague manner that the statuette was said to have been found 'East of Candia.'" But he added, "It is inherently probable however since the site was occupied by the flourishing harbour town of Knossos, where there was certainly a lapidaries' quarter and where fine bronze figurines were also produced." Thus the Goddess, acclaimed as a unique find — "the only example of an entire Minoan figure carved in stone" — was provided with a findspot that was precisely where one might expect to encounter such an object, near ancient stone-working installations. Evans commented that the statuette showed "the most perfect modelling of the human face," and he naturally related it to the faience Snake Goddess and the votaries from the Temple Repositories: "In this case the artist has concentrated himself on the maternal aspects of the divinity and has omitted the snakes that symbolize her Underworld dominion. Otherwise the tiara and the dress are practically the same, including the sleeved jacket and the

pattern of the apron and of the flounced skirt." There were, however, no Minoan parallels for the figure's grasping her breasts, a pose common in the ancient Near East.[18]

The Fitzwilliam Goddess was further enshrined by being reproduced as the frontispiece to the authoritative *Cambridge Ancient History*, by none other than Charles Seltman. As Butcher and Gill observe, this put the statuette "in a significant position in the development of Western Art." In his monograph Wace compared its construction — in two pieces joined at the waist — to prehistoric Cretan terra cottas, and he found much more modern parallels for the Goddess's apparently "boned" bodice: "The 'bones' cannot of course have been whalebone, but may have been of wood or perhaps even of bronze, in which case they would be analogous to the European iron corsets of the XVIIth century."[19]

Like the Boston Goddess, the unprovenienced Fitzwilliam figure quickly entered the art historical mainstream. Despite the doubts of some experts, she was repeatedly presented as an example of prehistoric Cretan art and employed to support various arguments about Minoan religion, fashion, and culture.

———

Considerably less is known about the acquisition of Evans's second ivory Boy-God, the one he eventually donated to the Ashmolean Museum (Fig. 4.13). He published it only in 1935, in the fourth volume of *The Palace of Minos*, which suggests that he had not acquired it by 1930, when he unveiled its counterpart in volume 3. It was, he wrote, a "happy chance" that made it possible to illustrate this "fresh specimen of a youthful chryselephantine figure." For "this specimen too had crossed the Atlantic, but in this case it has re-crossed it. . . . All that can with certainty be said about its provenance is that it was found some years since in the Southernmost region of Crete." Just where in southern Crete, or how he knew, Sir Arthur does not say, but unlike other statuettes, this boy was not said to come from Knossos. Nonetheless, Evans praised it in the highest terms. Despite its some-

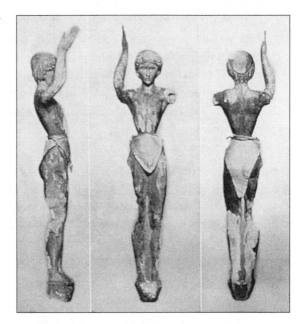

FIG. 4.13 *The other Boy. Ashmolean Museum, Oxford, formerly in the collection of Arthur Evans. Height 4 7/8 in. (12.5 cm).*

what rubbery arm and sketchily incised ribs, he wrote that "the skill of this little figure is worthy of the Italian Renaissance."[20]

Like the slightly larger Boy-God now in Seattle, this figure stands on a plinth (though not on his tiptoes) and raises the one arm that remains. (Here too the left arm is lost and the legs are damaged.) This boy, however, has somewhat different proportions and firmer muscles. Rather than a tall, tripartite tiara worn over long, flowing locks, he has hair cut short at the back, with the crown tonsured, a style that led Sir Arthur to associate him with ritual offerings of hair and rites of passage recorded by various ancient sources and practiced in diverse cultures worldwide. In fact, Evans thought the boy had originally worn some sort of beret to cover a bald patch. He adduced "similar usage in the Roman Church" and also considered that the

> alternation in these two chryselephantine images — the religious character of which may in both cases be assumed — of the

tiara and *biretta* suggests an interesting reflection. Have we not here in truth a much more ancient parallel to the contrast visible between the public and private head-gear of the Roman Pontiff himself? From the early Middle Ages onwards the *biretum* — in that case of linen — was included, like the triple "mitre," among the pontifical insignia and was worn by bishops and abbots as a sign of investiture.[21]

Unlike its counterpart now in Seattle, this statuette came to light with a golden loincloth covering his genitals — another indication, for Evans, of his greater age. Sir Arthur nonetheless concluded that this Boy-God should be recognized as "standing in the same, probably filial, relation to the Minoan Goddess."[22]

––––

The year after the publication of the final volume of *The Palace of Minos*, the Royal Academy of Art hosted an exhibition, British Archaeological Discoveries in Greece and Crete 1886–1936, to celebrate the jubilee of the British School at Athens. Sir Arthur arranged the Minoan Room and enshrined both of his ivory boys in the same case as the Fitzwilliam Goddess. Although neither the Boston Goddess nor the ivory and faience figures he had excavated at Knossos were present, replicas of them were exhibited. The Baltimore Snake Goddess (Fig. 4.2), though discovered in 1931, seems not to have been known to Evans, and in any case, it had not yet been restored. But another gold and ivory statuette of the Minoan Mother Goddess that had crossed the Atlantic was represented at the London exhibit: viewers could examine a photograph of the remarkable "Lady of the Sports" in Toronto's Royal Ontario Museum (Fig. 4.14).[23]

Charles T. Currelly, the founder of that museum, acquired this figure in 1931 "on the English Market." Preserved from head to knee, the statuette was said to have been taken from Crete and sold in Athens. From there it made its way to Feuardent in Paris, where Seltman acquired it; he later sold it to Currelly for £2750. Like Cockerell and Lamb, who had paid Seltman the same amount for the

FIG. 4.14 *"Our Lady of the Sports": a Mother Goddess and bull leaper in one. Royal Ontario Museum, Toronto. Height 7 in. (17.8 cm).*

Fitzwilliam Goddess five years earlier, Currelly, who had excavated in East Crete before moving on to Egypt, was eager to purchase a rare Minoan relic that would bring prestige to his new institution. And the Lady is certainly unique: with both arms upraised as if in benediction, she combines the open bodice and matronly anatomy of the Cretan Mother Goddess with the codpiece worn by Minoan males. Although her legs below the knees and her right arm, except for the hand, are lost, the figure is relatively well preserved. Estimated to have originally stood about 25 centimeters high, she is decked in heavy gold foil. She wears a diadem, a wide necklace, and two bands at her shoulders that appear to be the very short sleeves of the bodice that encircles her high, round, gold-nippled breasts. Her narrow waist is bound by a wide belt, which, like all of her golden raiment, is further adorned with embossed decorations. But where we have come to expect the customary flounced skirt (with or without

an apron), the Toronto statuette sports the stiff "Minoan sheath" or codpiece.[24]

The enterprising Currelly considered the acquisition of this spectacular Minoan chryselephantine figure one of the significant events of his great career. In his memoir, *I Brought Home the Ages,* he observed that the statuette seems to represent a female bull leaper ready to catch a colleague. He and others have compared her to the well-known images of bull leapers in frescoes from Knossos (Fig. 4.15). For Evans, however, she was the Great Goddess. He published her photograph in the *Illustrated London News,* and the imposing image was the color frontispiece to the fourth volume of *Palace of Minos.* Section 91 of that volume is entitled "The Minoan Goddess as Patroness of the Palace Bull-ring — New Chryselephantine Image of her as 'Lady of the Sports': Sacrifice of *Corrida* Bulls and its Survival." Evans provided a synopsis of the twenty-eight-page section:

> Bull-sports of Palace Arena as illustrated by the wall-paintings and reliefs; Pillar Shrine of Goddess depicted overlooking Bull-ring; Sexual transformation of girl performers — their male

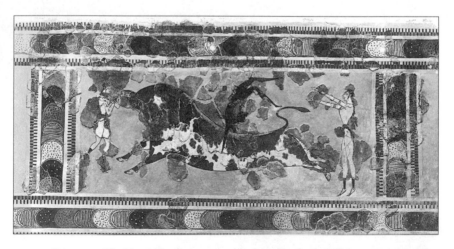

FIG. 4.15 *The Taureador Fresco as reconstructed by Émile Gilliéron* père. *The light-skinned figures with "very slight pectoral development" have long been considered female, but are they?*

"Sheath"; Anatolian source of bull-sports — divinity there male; Varied aspects of Minoan Goddess; Her interest in Games; Her Sacred Swing — terra-cotta model; Doves perched on its side-posts — emblems of divine possession; Swinging as magical and religious rite — *Aiora* festival in Athens; Swinging in Modern Greece and Crete; Normal impersonations of Goddess, in fashionable dress, unfitted for Sports; New Chryselephantine figure of Goddess in garb resembling Taureador's; With matronly corset, however, combined with male loin clothing and masculine "cod-piece" attached — Minoan adaptation of "Libyan Sheath"; Facial features of figurine: Classical profile, like Cambridge Goddess; emergence of new statuette with similar features; Diadem and coronal of Chryselephantine figure; Its broad necklace — sign of rank; Height and girth of statuette — comparisons with adult male figures; Comparison with "Boston Goddess"; "Lady of the Sports," still a Mother Goddess; Her aid constantly invoked by her protégés of the Bull-ring; A Vision of comfort in direst need; Sacrifice of bull of Corrida on Thisbê seal-type — a priestly *Matador;* Gem-types showing sacrificed bull on Table; Sacrificed bull on Table in H. Triada Fresco; Funeral sacrifice of bulls; Offertory animals depicted as coursing in Arena: Survivals of Minoan bull-sports — Thessalian *Taurokathapsia;* Artemis *Tauropolos* and *Taurobolos;* Survival of Minoan bull-sports as religious function at Miletos, an old Cretan foundation; Bull sacrifice at the *Boegia.*[25]

In this fascinating chapter, Evans traced Cretan bull sports back to rituals first enacted in Anatolia in honor of a male divinity. But when transferred to Crete, these games underwent "a characteristic transformation. Could the female votaries of the great native Goddess who naturally took precedence in her cult be excluded, indeed, from the acrobatic feats in her honour?" The answer, obviously, was no. But the open bodice and flounced skirt, the customary garments of Minoan women, which Evans illustrated by means of the Boston and Fitzwilliam Goddesses, were not amenable to such activities. As he wrote in the *Illustrated London News:*

It might have been thought that if they were to take part in the feats of the arena, the difficulty would have been met by the substitution of some simple form of "shorts" adapted to the female sex in place of this somewhat cumbrous fashionable dress.

It was not so, however. Religious conservatism seems to have demanded, as the condition of the entry of female participants in the ceremonial sports thus originally connected with a male divinity, that they should actually assimilate their attire to that of the male performers. What took place was, in effect, a real sexual transformation, analogous to that of the ancient Queens of Meroê, who asserted their titular kingship by wearing false beards. A still nearer illustration is to be found in the ritual assimilation to the male sex of the wives of Libyan chiefs by the adoption of the *penistasche* that distinguishes the men. This sexual feature — the "Libyan sheath" — which still survives in the Congo, seems to have itself been taken over through the early Libyan contact — of which we have so many proofs — by the Cretan men and was now shared by the female acrobats in the bull-sports.[26]

In proposing that Minoan Goddess worship was based on an *earlier* rite dedicated to a male divinity, Evans seemed to reject Bachofen's thesis but without recognizing the contradiction. Although he did admit that "these female performers travestied in men's attire do not appear in connexion with other forms of sacred sports, such as boxing and wrestling bouts," he was keen to see Minoan females engaged in athletic activities, as women were in his own day.[27]

Sports, until quite recently, were widely viewed as an exclusively male realm. Strength, speed, power, sweat, aggression, and competition were traditionally considered unsuitable for and even harmful to women, and spurious physiological and psychological claims were employed to justify and reinforce such prejudices. In the reign of Victoria, however, gradual but serious inroads were made. The queen herself practiced archery, but it, like croquet and golf, did not threaten feminine decorum. More vigorous activities, including calisthenics, gymnastics, cycling, and skating, soon followed, and to en-

gage in these sports some women donned clothes resembling those of males, such as the wide pants invented by Amelia Bloomer in 1851. Women of all ages began to take up sports, and in 1912 an article in *Good Housekeeping* praised "the new athletic girl" for her "rosy glow, healthful appearance, and easy movements." Although women did not compete in the inaugural modern Olympics of 1896, they were admitted in 1920.[28]

Crete in the second millennium B.C., however, was not twentieth-century Europe, and evidence for female Minoan bull leapers, familiar as they have become, is slim. Evans identified as female an inverted figure attempting to capture a bull on one of two gold cups recovered in 1888 from a tomb at Vapheio, near Sparta, on the Greek mainland (Fig. 4.16). He based this assumption on "her" long hair and what he perceived to be a slightly larger bosom, an observation that had eluded earlier scholars, who considered the figure male. In fact, examining the cups in Athens soon after their discovery and long before he recovered fragments of the Taureador Fresco at Knossos, Evans himself wrote, "The position of the bull charging behind with its body is not happy. Nor is the position of the *man* in its horns well judged" (emphasis added). Evans also suggested that some of the ivory components he had recovered in 1902 (Fig. 2.15) belonged to female bull leapers. These assertions, however, seem to have been based more on his own ideas of female athleticism and his confidence that the Minoans adhered strictly to ancient Egyptian color conventions in depicting gender (dark skin for men; light for women) than on any unequivocally female representations in excavated Minoan imagery. In fact, when Émile Gilliéron restored the Taureador Fresco, he added nipples to the white-fleshed figures, making them appear more like females.[29] Numerous subsequent reconstructions of the sport erase any doubt (Fig. 4.17).

For Evans, in any case, the Toronto statuette

at once strikes the eye as of a very different character from that of the girl performers in the Minoan bull-sports as portrayed for us in the frescoes and small reliefs, notwithstanding the fact that she

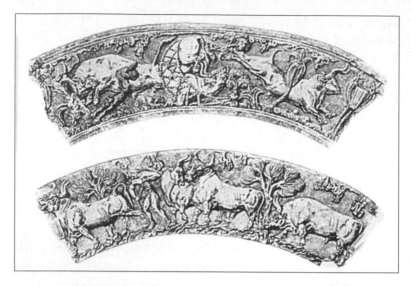

FIG.4.16 *Figural scenes from two gold cups excavated at Vapheio in the Peloponnesos, shown in an extended drawing by Gilliéron père. When Evans first examined these, he described the fallen figure between the horns of the charging bull (upper left) as a man. After he had identified female bull leapers in Minoan art, he perceived a "slightly larger bosom" and saw this figure as a woman.*

FIG.4.17 *A modern depiction of Minoan bull leaping, published in 1921. The flat-chested figures of the Knossian fresco (Fig. 4.15) are now fully female.*

shares with them the most distinctive article of the male apparel. The girl performers — whether they display their acrobatic skill in the Palace Circus or the open field — are consistently depicted with a very slight pectoral development; so much so, that in the wall-paintings, were it not for the convention of the white skin colouring, it might be difficult to distinguish them from the youthful male toreadors who take part in the same scenes. But the figure before us presents the full breasts of a more matronly stage, and their decidedly prominent contours have brought with them as a corollary the need for artificial support. This is supplied by the stays, of which we find the representation in open gold-work, somewhat suggestive of the whalebones of more recent feminine attire . . .

In the loin-clothing, where this wealth in gold-plating is most conspicuous, we recognize an assimilation with the male costume that the girl performers in the sports had borrowed from the Minoan "cowboys" and toreadors. But the transition to true femininity is here marked by the elaborate stays and corset, as well as by the full womanly development of the bosom.

This, surely, is no actual participant in such acrobatic feats, but rather the Minoan Goddess herself in a novel aspect, as patroness of the arena. The attitude in which the figure itself is presented, with both hands raised and the palms turned forward has nothing to do with that of the attendant female performer (seen on the Knossian fresco) who stretches forth her arms as if to seize the leaping boy. The attitude here, as seen with only the forearms raised, is really the traditional posture that recurs on a series of cult images of the divinity, either receiving the adoration of her votaries or conferring on them her benediction. We have here, in fact, "Our Lady of the Sports" — though still the Mother Goddess in one of her numerous interpretations.

It was not enough that her pillar shrine should merely overlook the palace arena. The Minoan bull-sports, as practised either there or in the rock-fringed glens of the country beyond might well be thought to call at every turn for the personal inter-

vention of the Goddess. For it was, in truth, a dangerous profession. . . . For those connected with these dangerous acrobatic feats, there was constant need to invoke the aid of a divine patroness, who, as in the image before us, combined with her sporting garb the essential attributes of motherhood. In this little gold and ivory image, thus restored to the light of day, we may recognise a Goddess always still a Mother, but one who, it may be, in some more celestial scene, had herself shared the most risky turns of the sport in which her votaries engaged themselves in her honour. Some such glittering vision as it presents to us may well have comforted of old the strained eyes of her followers in the moment of their direct need.[30]

Specific features of "Our Lady" were naturally compared to those of the Goddesses in Boston and Cambridge. Evans saw in the Toronto figure's "rather long" nose a "faint tendency to aquilinity" that contrasted with the "tip-tilted profile" of the Boston Goddess but was nearer to the "Classical outline" of the Fitzwilliam statuette. The "undulated flow" of the Lady's "luxuriant tresses to below the level of the shoulders" recalled the hair of the Boston Goddess and her "pendant," the Boy-God now in Seattle. Sir Arthur even went so far as to suggest that, along with the "delicate rendering of the small of the back," her hair "may be legitimately regarded as a mark of the same 'Knossian School.'" Like Wace before him, he deftly sought to provide a provenience for a statuette that had none, writing that "it is also a significant fact in this connection that the original height of the figure, as nearly as possible 25.6 centimetres, practically corresponds with that of the 'Leaping Youth' from the Palace Ivory Deposit" (Fig. 2.16).[31] The Toronto statuette, however, is not preserved below the knees, so Evans was making a guess at its original height. And the Knossian leaper, though it measured 25.6 cm when first restored, was damaged in 1926 in an earthquake that also pulverized some of the frescoes in the Herakleion Museum. Subsequently *re*-restored, it measures 29.9 cm.

On account of her unusual dress and imposing physique, the Toronto statuette, like the Boston Goddess, has appeared not only in scholarly journals but also in fashion histories and New Age publications. She was featured in David Kunzle's 1982 book, *Fashion and Fetishism: A Social History of the Corset, Tight-Lacing and Other Forms of Body-Sculpture in the West* as well as in the Style section of the *London Sunday Times* fifteen years later. There, above the caption "Baring it: a Cretan goddess," she was produced as evidence for the long history of female toplessness in an article entitled "Treasured Chests." And as recently as 2000, in Lyn Webster Wilde's *On the Trail of the Women Warriors: The Amazons in Myth and History,* the Lady was described as a "lithe athletic young woman." Although not directly linked to the Amazons, she was included as an example of "strength and athletic power combined with erotic beauty." Today, as when she first appeared, "Our Lady of the Sports" continues to serve the agendas of those who look to the past to satisfy modern needs and desires.[32]

5

\mathcal{E}VANS AND THE \mathcal{G}ILLIÉRONS:
MAKING AND MARKETING THE PAST

I accompanied a party of fellow passengers to the museum to admire the barbarities of Minoan culture. One cannot well judge the merits of Minoan painting, since only a few square inches of the vast area exposed to our consideration are earlier than the last twenty years, and their painters have tempered their zeal for reconstruction with a predilection for covers of *Vogue*.

— Evelyn Waugh, "A Pleasure Cruise in 1929" (1930)

THE RECONSTRUCTION of Minoan religion, society, and culture took place not only in the pages of newspapers, journals, and books but also physically, on the site of Knossos and in the workrooms of the Cretan Museum. Arthur Evans's personal wealth allowed him more latitude than was available to most archaeologists, and he strove to protect the excavated remains of the Palace of Minos from disintegration and to make the ruined civilization intelligible to visitors through extensive restoration and rebuilding or, as he called it, "reconstitution."

In addition to Halvor Bagge, who pieced together the faience statuettes found in the Temple Repositories in 1903, Evans employed other artists, as well as architects, engineers, carpenters, and masons, to reconstruct Knossos and the artifacts recovered there. Chief among them was one of the foremost artists in Greece. As soon as the first fragments of painted plaster emerged from the Throne Room in 1900, Evans sent to Athens for Émile Gilliéron (Fig. 5.1), a painter who

had long been employed by archaeologists. Born in Villeneuve, Switzerland, on 26 October 1850, Gilliéron studied at the *Gymnasium* at Neuveville, where his father was assistant master, and from 1872 to 1874 at the *Gewerbeschule* in Basel. He trained further at the Academies of Fine Arts in Munich and Paris, and from 1875 to 1876 he worked in the atelier of the Academic painter Isidore Pils, which at that time was engaged in the decoration of the Paris Opera. In 1876 Gilliéron immigrated to Greece, where he worked as a draftsman for Heinrich Schliemann and other archaeologists. It was he, in fact, who made the often reproduced extended drawings of the gold Vapheio cups (Fig. 4.16), found in 1888. At least as early as 1885, Gilliéron journeyed to Crete, where he made drawings of bronze finds from the Idaean Cave, the alleged birthplace of Zeus, in the collection of the Cretan Syllogos. Gilliéron's work was not just archaeological, however. He was commissioned to design the postage stamps commemorating the first modern Olympics, held in Greece in 1896 (Fig. 5.2), and other stamps ten years later. He was also engaged as art tutor to the children of the Greek royal family and to the young Giorgio de Chirico. On 10 April 1900, Evans recorded in his notebook that as soon as the highly experienced Gilliéron arrived at Knossos he "began immediately to sort the fresco fragments like jigsaw puzzles."[1]

Bits of painted plaster and other small finds were eventually removed from the site for reconstruction, but the palace itself, which had long been protected and held in place by tons of overlying earth, also required conservation. The gypsum floor, benches, and throne of the Throne Room (Fig. 2.12), for example, were now exposed to the elements, and after one winter Evans recognized that some sort of covering had to be erected to safeguard them, for the stone expanded and cracked when exposed to the summer sun and tended to dissolve in the winter rains. To support a modern roof, new columns made of plastered and painted wooden slats were placed in the positions of the original columns, whose charred remains had been discovered *in situ*. Additional brick pillars were erected along the sides to support a timber framework (Figs. 5.3 and 5.4). To prevent entry by unwelcome

FIG. 5.1 *Émile Gilliéron* père *(second from left), with local workmen in front of the Villa Ariadne, Evans's house at Knossos, circa 1910.*

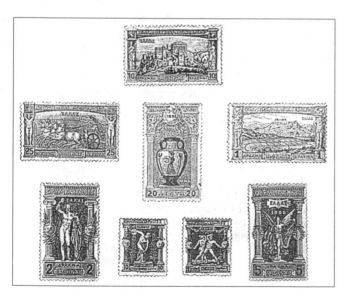

FIG. 5.2 *Postage stamps designed by Gilliéron* père *to commemorate the first modern Olympic Games, held in Athens in 1896.*

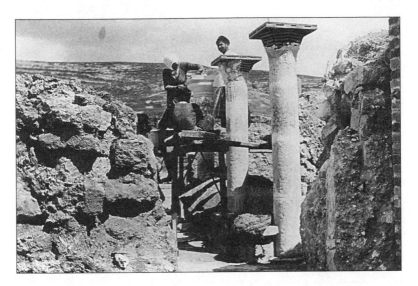

FIG. 5.3 *Modern columns erected in the Throne Room at Knossos, 1901.*

FIG. 5.4 *Modern piers and roof beams erected in the Throne Room, 1901.*

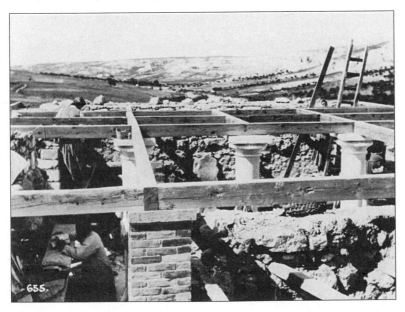

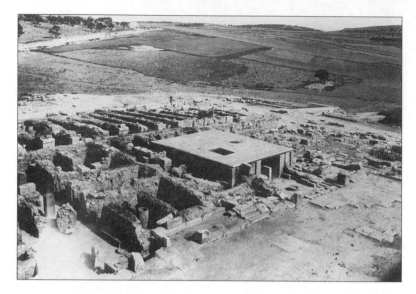

FIG. 5.5 *A general view of the first restoration of the Throne Room, 1901.*

FIG. 5.6 *The second restoration of the Throne Room, circa 1904.*

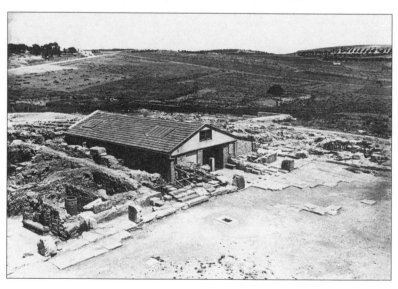

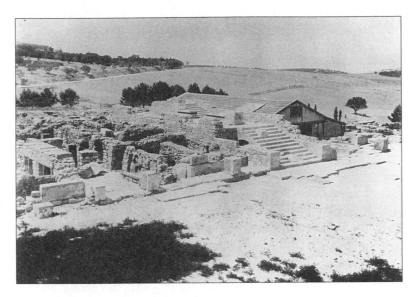

FIG. 5.7 *The Stepped Portico alongside the Throne Room, circa 1923.*

FIG. 5.8 *The third restoration of the Throne Room, with two upper stories, completed in 1930.*

visitors, Evans was "reluctantly obliged" to commission a "native smith of Candia to make scroll-work railings of wrought iron of the kind that it is usual here to place before Mahometan shrines, the spiral designs of which at least are curiously in harmony with Mycenaean patterns." All of this work was supervised by Theodore Fyfe, the architect at the British School at Athens, who assisted Evans for the first five seasons and returned to Knossos intermittently in subsequent years.[2]

"Reconstitution" at Knossos, a German colleague of Evans's observed, "passed through three 'periods' of conservation, marked respectively by the use of wooden supports, of iron girders, and of ferro-concrete."[3] Although the initial flat-roofed covering of the Throne Room (Fig. 5.5) provided adequate protection from the elements, it was soon deemed insufficient, and in 1904 it was replaced, at considerable personal expense to Evans, by a structure with a pitched roof supported by imported metal girders (Fig. 5.6). The roof extended back to cover the Inner Sanctuary as well as the Throne Room and had an upper story or loft, fitted with shelving and used for storing shards and other finds, which functioned "as a kind of reference Museum."

Evans became dissatisfied with the appearance of this peaked edifice too. It jarred with his conception of Minoan architecture, a conception derived in large part from the buildings depicted on fragments of miniature frescoes, engraved gems, and other small finds, which he optimistically believed represented the building he had found. To provide visitors with a better view of the palace as he thought it might have appeared in its original state, he reconstructed the Throne Room complex for the third time in 1930 (Fig. 5.8). Using the relatively new technology of reinforced concrete, he extended the covering to the anteroom and added two new stories: a "lantern" atop a "loggia," which served as a picture gallery for the display of replicas of frescoes from various parts of the palace, produced by Gilliéron père and his homonymous son and successor, Émile *fils*. The massive ferroconcrete reconstruction was laid directly on the original fabric

of the palace, thus rendering the underlying remains inaccessible to further study. Evans also rebuilt a monumental staircase, dubbed the Stepped Porch, immediately to the south (Fig. 5.7), although here, as with the upper stories of the Throne Room, the foundations he had excavated gave little indication of the details of the original structure.

Similar interventions, which Evans admitted might shock "the lover of picturesque ruins," were undertaken elsewhere on the site. The so-called Hall of the Double Axes was also rebuilt, as were the Lobby of the Wooden Posts, West Court Façade, North Passage Entrance, North Lustral Basin, and the multistory Grand Staircase. This last feature (Fig. 2.5, no. 25; Figs. 5.9 and 5.10), discovered in 1901, presented the excavator with "extraordinary difficulty," as Evans wrote in an initial report, "owing to the constant danger of bringing down the stairway above. It was altogether miners' work, necessitating a constant succession of wooden arches."[4] Fortunately, two of his workmen had previously worked in the mines at Laurion, southeast of Athens, and thus were able to advise on tunneling and shoring up the walls and roofs with wooden props.

Such interventions, however, were not entirely effective, and in 1902:

A very serious problem was presented by the upper dividing wall of the Grand Staircase . . . it had heeled over and threatened ruin, not only to itself, but to the outer staircase and the rising balustrade above it. Professional guidance ceased at this point but, as the case seemed desperate, I took upon myself the responsibility of what might be thought a very risky operation. A slit was first cut along the base of the mid-wall on either side, the whole wall was cased with planks and roped round, a block of timbering was constructed to stop the movement of the wall at the point where it became perpendicular, and, these preparations having been made, a body of sixty workmen on the terrace above, under the skilled direction of Gregori, was harnessed by ropes to the casing of planks round the masonry and at a given signal pulled as one man. It was a moment of breathless excitement, but the

FIG. 5.9 *The Grand Staircase under construction, circa 1905.*

FIG. 5.10 *Evans, in white suit and pith helmet, with workmen on the Grand Staircase, circa 1905. Next to him stand Duncan Mackenzie, in a dark suit, and the architect Christian Doll, wearing a wide-brimmed hat.*

great mass moved all together, righted itself, and stopped on the line fixed for it. The slit on the inner side of the wall was thus closed. That on the outer side was filled in at once with rubble and cement, and the work was done.[5]

This, however, was but a temporary solution. In spring 1905 the excavators returned to the site to find, in Duncan Mackenzie's words, that "heavy winter rains which had done much damage in the villages in different parts of Crete had also left their mark in different parts of the Palace of Knossos," and that "it was at once apparent that unless strenuous measures were taken at once the whole upper fabric to the stair might collapse." In fact, Evans wrote in the *Times:*

> An exceptionally rainy season led to the falling in of the second landing of the Grand Staircase. The wooden props inserted at the time of the excavation to support the upper structure of this —— which, in default of the original wooden pillars, simply rested on indurated *débris* —— had given way at this point and the whole of the upper flights and balustrades together with the adjoining upper corridor, were threatened with ruin. To avert this demanded nothing less than heroic measures. The tunnel below the third flight of stairs . . . being rendered insecure, it was necessary to remove provisionally the steps and balustrades above belonging to the third flight —— to be subsequently replaced at their original level when properly re-supported. The upper structures once removed, and the remaining *débris* that had underlain them could now be cleared away, an operation which resulted in a most illuminating discovery. Below the stepped balustrade that accompanied the upper flight of stairs, and separated from it by an interval of fallen and carbonized materials, there came to light . . . another similar ascending balustrade with sockets for columns like those above and even the charred remains of the actual wood shafts.[6]

Evans replaced the inadequate wooden props with columns set into the original sockets. Inspired by fresco fragments discovered

elsewhere in the palace, he gave the columns a distinctive downward taper and had them plastered and painted red. In place of the original wooden architraves and beams, he imported iron girders set in cement "at great expense and with considerable difficulty" — many were lost in the harbor during the unloading at Candia. When the staircase was entirely rebuilt, Evans had great confidence in the accuracy of his reconstruction, for he had recorded the dimensions of the charred beams and carefully numbered the blocks so that they could be returned to their original positions. He also, in his imagination, re-peopled the structure with figures taken both from the frescoes and from later myths:

> The result achieved by this legitimate process of reconstitution is such that it must appeal to the historic sense of the most un-imaginative. To a height of over 25ft. there rise before us the Grand Staircase and columnar hall of approach practically un-changed since they were traversed 3 1/2 millenniums back by kings and queens of Mino's [sic] stock on their way to the more private quarters of the Royal household. We have here all the materials for the reconstruction of a brilliant picture of that remote epoch . . . as in the miniature frescoes from the North Hall of the Palace, we seem to see the Court ladies in their brilliant modern costume with pinched waists and puffed sleeves seated in groups and exchanging glances with elegant youths in the court below — dark-eyed these, with dark flowing locks, sinewy, bronzed, and bare of limb save for the tightly-drawn metal belt and orna-ments, and their richly embroidered loin-clothes. A note of mys-tery is added by the window, now freed from *débris,* in the wall to the right. . . . Here surely — if fancy indeed may transport her to a sublunary scene — at times may have looked out that Princess of most ancient romance whose name is indissolubly linked with the memories of Minoan Knossos.[7]

Frescoes such as the one nicknamed La Parisienne and others re-stored by the Gilliérons brought such fantasies out of the realm of the imagination and into visible reality, for replicas were mounted not

only in the Candia Museum but also on the walls reerected by Evans's workmen at Knossos. Today these early reconstructions are crumbling and are themselves in need of restoration. Still, Knossos is far and away the most popular attraction on Crete and, with well over half a million visitors a year, it is the most heavily frequented archaeological site in Greece after the Athenian Acropolis. This popularity is in large part due to Evans's "reconstitutions," for, as archaeologist John Papadopoulos has noted, "the site was transformed from poorly preserved ruins into a multistoried concrete vision of the past."[8] Modern material was placed directly on ancient remains, and spaces were drastically altered. What had begun as a program to preserve the original fabric of the palace evolved into a full-scale recreation.

Inside the Throne Room, for example, brightly colored paintings were installed on all the walls and were even superimposed on the fragmentary fresco of a griffin discovered *in situ* in 1900. The appearance of the room was thus dramatically transformed (compare Figs. 5.11 and 5.12). Modern renderings of other frescoes were mounted elsewhere in the reconstituted palace, which, as Papadopoulos observed, "were restored according to the architectural fashion of the day" and thus "are considered by some to be the best-preserved and finest examples of Art Deco and Art Nouveau architecture in Greece."[9] These new frescoes were painted by the Gilliérons, father and son, after the highly fragmentary, complex compositions they had painstakingly reassembled.

The younger Gilliéron (Fig. 5.13), was not quite fifteen years old when his father began working for Evans. Born in Athens on 14 July 1885, he too was a citizen of Switzerland, though he lived most of his life abroad. (His son, Alfredo, and grandson Émile Gilliéron III still reside in Athens while maintaining Swiss citizenship. The former, having trained with *his* father, had a successful career fashioning replicas and other souvenirs for tourists, as well as other imitations, which, he told me proudly, have fooled archaeologists.) Émile Gilliéron *fils*, following early training with his father, studied in Paris at the Académie des Beaux Arts and the Académie de la Grand

FIG. 5.11 *The Throne Room as excavated.*

FIG. 5.12 *The Throne Room as "reconstituted" in 1930. Papyrus leaves replace the original palm fronds (seen in Figs. 2.12 and 5.11).*

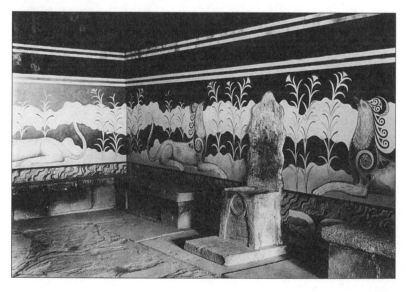

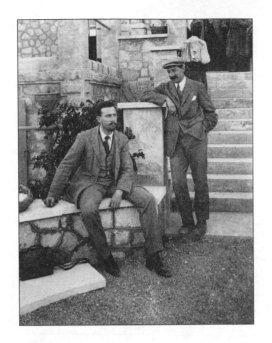

FIG. 5.13 *Émile Gilliéron fils, seated on a balustrade at the Villa Ariadne. Behind him stand Christian Doll and, at the top of the stairs, Duncan Mackenzie with local workmen, circa 1910.*

Chaumière from 1905 to 1908 before returning to Greece to work as an archaeological draftsman and restorer of Bronze Age, Greek, and Byzantine artworks. Working alongside his father until his father's death in 1924, Gilliéron *fils*, too, did much work for Evans and eventually served as artistic director of the National Museum at Athens. He also designed Greek coins and banknotes and arranged the display of the Mycenaean collections of a number of foreign museums. He died in 1939.[10]

As Evans's principal restorers, the Gilliérons were responsible, perhaps more than anyone other than the excavator himself, for the romantic vision of Minoan society evident on the site and promulgated in diverse publications. For they skillfully, heavily, and often tendentiously restored many of the Knossos finds. Often working with only a handful of fragments, the Gilliérons re-created entire compositions, fashioning a picture of Minoan life that conformed to contemporary tastes. Scenes were occasionally misinterpreted and fragments of different paintings joined together; in one case a monkey gathering saffron was restored as a "Blue Boy" (Fig. 5.14), while the fa-

FIG. 5.14 *The Blue Boy Fresco, excavated in 1900 and restored by Gilliéron père (right). Subsequent study of the fragments (below) suggests that the figures gathering saffron are monkeys, not humans.*

mous Taureador Fresco (Fig. 4.15) is, in fact, a series of separate scenes conflated into a single composition.[11]

Working with fragments, the Gilliérons filled in what was missing according to Evans's vision as well as their own. Sir Kenneth Clark, like Evelyn Waugh, compared Minoan painting to *art nouveau* and the *style dix-neuf cent*. Still, the degree of restoration often goes unnoted. Very little of the famous Procession Fresco (Fig. 5.15), for example, is preserved above the ankles of the figures, yet the composition is widely reproduced. The fragments of the "Ladies in Blue" (Fig. 5.16), which Evans compared to the "beautiful designs on white Athenian *lekythoi*," were first restored by Gilliéron *père*, but suffered in the earthquake of 1926, when some of the original plaster was

FIG. 5.15 *The Procession Fresco, excavated in 1900. The drawing, by Gilliéron* fils, *shows the extent of restoration undertaken by Gilliéron* père.

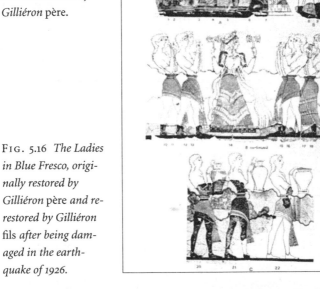

FIG. 5.16 *The Ladies in Blue Fresco, originally restored by Gilliéron* père *and re-restored by Gilliéron* fils *after being damaged in the earthquake of 1926.*

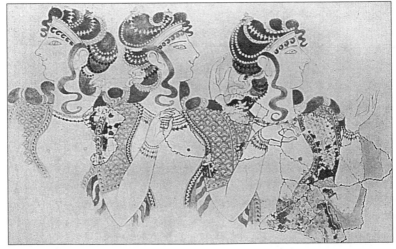

pulverized. The entire composition was nonetheless replicated by Gilliéron *fils*, who replaced the lost original fragments. Thus the familiar image of this "ancient" fresco is, in fact, the restoration of a re-creation — or a re-creation of a restoration.[12]

The Gilliérons also embarked on a lucrative business selling reproductions of Bronze Age frescoes and artifacts. Around 1906 *A Brief Account of E. Gilliéron's Beautiful Copies of Mycenaean Antiquities in Galvano-Plastic* was printed, along with a catalogue of replicas of material from Schliemann's excavations and other sites. Gilliéron and Son also issued at least two editions of a multilingual catalogue, *Galvanoplastic Copies of Mycenaean and Cretan (Minoan) Antiquities* (Fig. 5.17), in which they offered replicas of finds recovered in Richard Seager's 1906–8 excavations at Mochlos and Pseira as well as in Evans's campaigns at Knossos. In fact, the finds from Knossos were being copied for specialists and study collections at least as early as November 1901.[13]

Most of the Gilliérons' replicas were made by the galvanoplastic technique, a variation of electroplating that had, at the turn of the century, recently been adapted to fashion precise copies of metal objects. These objects were manufactured in cooperation with the Würtembergische Metallwarenfabrik, a leading producer of nickel-plated tableware in Geislingen, Germany.[14]

In the introduction to the second edition of the Gilliérons' Cretan catalogue, Dr. Paul Wolters, director of the Munich Glyptothek and former secretary of the Imperial German Archaeological Institute at Athens, informed prospective customers that the reproductions, although made "with the help of exact mouldings . . . as now presented to us, are not in the bent, crushed or broken condition in which they were found, but have been reset in their original forms so far as these could be ascertained with certainty. Even the needful restorations are throughout founded on reliable traces, or trustworthy analogy."[15] Most of the products offered for sale were of metal, but "coloured plastic and painted reproductions" in plaster could be obtained directly from the Gilliérons in Athens. Today one can purchase

FIG. 5.17 *The multilingual catalogue* Galvanoplastic Copies of Mycenaean and Cretan (Minoan) Antiquities, *offered for sale by E. Gilliéron and Son from their Athens atelier.*

GALVANOPLASTISCHE
NACHBILDUNGEN

MYKENISCHER UND KRETISCHER
(MINOISCHER) ALTERTÜMER

VON E. GILLIÉRON & FILS
RUE SKOUFA 43
ATHÈNES

AUSGEFÜHRT UND ZU BEZIEHEN DURCH DIE
WÜRTTEMBERGISCHE
METALLWARENFABRIK
ABTEILUNG FÜR GALVANOPLASTIK
GEISLINGEN-ST. (WÜRTTEMBERG)
ODER AUCH DIREKT
VON E. GILLIÉRON & FILS
ATHÈNES, RUE SKOUFA 43

copies of the faience snake handlers on the Internet, but in the early twentieth century they had to be specially ordered, as did the reconstructed ivory leaper, one of which, rendered in "dental stone," was bought from the Gilliérons by the Metropolitan Museum (Fig. 5.18). Evans acquired another for the Ashmolean. Full-scale watercolor replicas of the frescoes could also be purchased, and in 1914, through the generosity of Mariana Van Rensselaer, Harvard University acquired a set (now displayed in Sackler Auditorium, the main lecture hall for art history classes), as did the Winckelmann Institute in Berlin and many other institutions.

The Gilliérons also produced painted plaster versions of Minoan stone vessels, and despite Wolters's assurances of accuracy, pieces like the famous Harvesters' Vase from Hagia Triada, on the southern coast of Crete, were offered both in their actual, damaged state and fully restored, with the lost portions re-created entirely (Fig. 5.19). As Evans was to remark in another context, "Happily, in Monsieur E. Gilliéron,

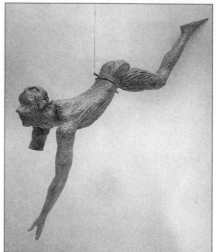

FIG.5.18 *Replica of the ivory Leaper (compare Fig. 2.16) purchased from the Gilliérons by the Metropolitan Museum of Art.*

FIG.5.19 *The Harvesters' Vase from Hagia Triada as reproduced by the Gilliérons. The upper half accurately copies the original. The lower portion is pure invention.*

fils, I had at hand not only a competent artist, but one whose admirable studies of Minoan Art in all its branches had thoroughly imbued him with its spirit."[16] As we shall see, the Gilliérons may well have exploited this spirit more than Evans realized.

The Gilliérons' creations sold well, despite their high cost, and were once widely displayed in museum and university collections; today they are for the most part relegated to storerooms. Their high quality was touted in the sales literature, but it should be noted that although the damaged areas of the ivory leaper's head, torso, and legs closely resemble those of the original (compare Figs. 2.16 and 5.18), the finely carved veins and tendons of the preserved left arm are less evident; the incised fingernails have been delineated, but the wrinkled skin of the knuckles has not. This, however, seems to have

mattered little to purchasers, for the Gilliérons' replicas, though expensive, were considerably more affordable — and more available — than Cretan material being sold on the international art market. Before the outbreak of World War I, gilded copies of the Vapheio cups sold for 75 marks each (recently estimated to be the equivalent of $2250 today) and the "complete" version of the Harvesters' Vase in plaster was priced at 100 marks. Replicas of Mycenaean swords might cost as much as 160 marks, but the most expensive items were the bulls' heads from Myccnac, reproduced in silver plate with gilded horns, and that with glass eyes from Knossos, each of which fetched 300 marks. The South Kensington (now the Victoria and Albert) Museum, the Metropolitan Museum of Art, University College Dublin, the Winckelmann Institute, Harvard University, the University of Montpellier, the Ashmolean, the Fitzwilliam, and many other institutions acquired these objects, and Arthur Evans even used illustrations of some of these pieces in *The Palace of Minos,* as did other scholars elsewhere.[17]

Boston's Museum of Fine Arts also acquired the Gilliérons' products. As early as 1901 it purchased approximately seventy replicas of Mycenaean goldwork, and in 1911, three years before the mysterious advent of the Snake Goddess — perhaps in the soap tin from Karlsruhe, just seventy miles from Geislingen — twenty-two of the Gilliérons' "Minoan" creations arrived in Boston.[18]

6

THE ROAD TO BOSTON

No one knows — that is, those who must know do not
say — just when or where this figure was found or how
it escaped from under the watchful eyes of the Cretan
authorities.

— Mariana Griswold Van Rensselaer,
"A Cretan Snake Goddess" (1916)

THE EXCITEMENT GENERATED by Minoan art in the early twenti-
eth century, the effort and money expended in acquiring it, and the
production and marketing of replicas all demonstrate its great desir-
ability. Copies of statuettes were made not only by the Gilliérons, but
also by William J. Young, the son of William H. Young of the Ash-
molean Museum, whom Arthur Evans had commissioned to restore
his ivory Boy-God as well as the Fitzwilliam Goddess. The younger
Young immigrated to Boston in 1929, and at age twenty-three founded
the Museum of Fine Arts' Research Laboratory for the conservation
and study of works of art. It was he who took the Boston Goddess
apart and pieced her back together in the early 1930s when Paul
Hoffmann's restoration began to come unstuck.[1] And he fashioned
replicas of the Goddess not only for Evans's private collection but also
for the Boston museum, which put its copy on exhibit during World
War II, when the Goddess herself was removed to western Massachu-
setts for safekeeping. The replica was displayed again more recently,
when the Textile Department mounted Madame Eta's evening gown
in a temporary exhibition.

The Youngs were not the only father-son restoration team

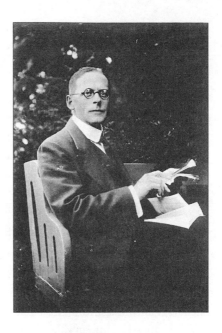

FIG. 6.1 *Georg Karo. Gilliéron* père *offered him a gold and ivory statuette from Knossos.*

through whose hands the Goddess passed. Although it is not known just how the Baltimore Snake Goddess, Evans's Boy-God, the Fitzwilliam Goddess, or Toronto's "Lady of the Sports" reached Paris, where Feuardent sold them to their later owners, the Boston Goddess can, despite the misinformation promulgated about her since 1914, be traced all the way back to the Gilliérons on Crete, even if not into the ground at Knossos.

As we saw in Chapter 1, the charming tale of a shipboard encounter between a museum friend and a Goddess-bearing Cretan peasant traveling steerage cannot be trusted. But there was another story, related by the German archaeologist Georg Karo (Fig. 6.1), excavator of Tiryns, friend of Evans, and a specialist in Aegean archaeology who served as the director of the German Archaeological Institute in Athens from 1905 to 1916. In his memoirs, published in 1959, he recalled that he had been offered a Cretan chryselephantine statue by Gilliéron *père:*

Now it can be told. In the Autumn of 1914, soon after the outbreak of the First World War, I received in Athens a letter from the elder Gilliéron: He offered me a Minoan statuette of ivory and gold found at Knossos. I replied that I could not purchase it; but considering that I was very anxious to investigate such a rare piece at leisure, I asked him about allowing a temporary loan and offered him a sure tempting fee for it. An answer did not follow. Instead, a few weeks later my old friend Lacey Caskey sent to me photos of the statuette in the condition in which it had been offered to him. He had immediately acquired it for his Museum of Fine Arts in Boston. In addition to a number of bigger pieces there were also many tiny little splinters.[2]

Karo's account is problematic, however. He remembers receiving Gilliéron's letter in the autumn, just after the outbreak of the war, but the Goddess was then already in Boston. The first of the preserved letters between Fairbanks and Mrs. Fitz was written on 28 July 1914, the very day that Austria-Hungary declared war on Serbia. But if the Goddess was already in Boston in the summer, what did Gilliéron offer Karo in the autumn? Did Evans's restorer have another Minoan gold and ivory statuette, or was Karo's recollection merely a bit hazy?

Karo left Athens in 1916 but kept in touch with his friend Evans during the war. Afterward he enjoyed a distinguished academic career in Germany and returned to Athens for a second term as director of the German Institute in 1930. But Karo was Jewish, and passage of the Nuremberg Laws forced his retirement in 1936. Three years later, shortly before the outbreak of World War II, he emigrated to the United States, where he spent the duration of that conflict, ironically, as an enemy alien. Karo was eighty-seven when he published his recollections of receiving Gilliéron's letter, an event that had taken place forty-five years and two world wars earlier, so his sense of chronology may have been off by a few months. It is, however, difficult to believe that anyone could distinguish the unreconstructed fragments of the Boston Goddess from, say, those of its less well known counterpart in Baltimore (compare Figs. 1.11 and 4.4). Nonetheless, Karo came to

know the reconstructed Baltimore statuette during his American sojourn and thought Gilliéron had offered him the Boston figure. And the letter and photographs he received from Caskey seem to confirm this.[3]

So how did the Goddess get from Gilliéron in Athens to Caskey and Fairbanks in Boston? The traditional story that she was transported by a Cretan peasant, as we have seen, is riddled with inconsistencies. The crucial lead was provided by Ron Phillips. In his investigations of Richard Seager he came across some letters in the archives of the American School of Classical Studies at Athens, which, along with other material I discovered there later, reveal that it was Seager who transported the statuette to the United States in June 1914. (The archaeologist had previously supplied the Museum of Fine Arts with legally exported "duplicate" artifacts in exchange for partially funding his excavations at Mochlos in 1908.) Seager's precise itinerary is not clear, but on 22 June he arrived in New York from Naples on Cunard's *Ivernia*. There he passed the statuette to the archaeologist Bert Hodge Hill (Fig. 6.2), with whom he had long been in close contact. In fact, they had crossed the Atlantic on the same ship. Hill served as director of the American School in Athens from 1906 to 1926, and in 1914 he was engaged, among other business, in procuring building materials for an addition to the school. As a favor to Seager, it seems, Hill took the statuette to the Boston museum, where he himself had been employed from 1903 to 1906 as assistant curator in the Classical Department. Hill negotiated the sale with Fairbanks and Caskey, who had served under him as secretary of the school in Athens from 1905 to 1908, immediately before being hired by the museum. The relationship between the two men was closer still, for Hill was the godfather of Caskey's son John.[4]

Hill's datebook (Fig. 6.3), preserved in the archives of the American School, indicates that on Thursday, 25 June 1914 — more than a month before Mrs. Fitz agreed to pay for the statuette — Hill traveled on the sleeper train from New York to Boston "taking [a] cast of [the] Corinth Lady and the Cretan ivory Snake Goddess." In an undated

letter apparently written two days later on the stationery of the Hotel Belmont in New York, an apprehensive Seager asked Hill about the outcome of his journey:

> Saturday.
>
> Dear Hill,
>
> I find you tried to see me here but I have just asked at the office and they tell me that you have left for Vermont. I wonder if you have any news for me as to the lady. If they have turned her down I must arrange to get her back. Perhaps I could arrange to motor ~~off~~ over from the White Mts. if my parent proved agreeable to such a plan.
>
> I am going over to Philadelphia this afternoon and leave for New Hampshire on Monday . . . Do drop me a line . . . and let me know if you have any news.
>
> Yours ever,
> R. Seager

Another letter (or draft) in Hill's handwriting (Fig. 6.4), though unsigned and undated, seems to have been written in response. Hill and Seager had dined together on Monday, 22 June, on the evening of their arrival in New York, and Hill was noted for his wit and insouciance, so the opening seems to be ironic:

> My dear Seager—
>
> You doubtless remember the Minoan ivory statuette we saw together in New York Monday evening. The ivory statuette, wh[ich] as you know I was authorized to offer to Boston, was shown the Director of the Museum + the Curator of Classical Antiquities on ~~Thur~~ Friday. I told them that it had appeared in N.Y., seemed probably to be on its way to the Metropolitan, that I had ~~secured~~ brought the refusal of it to ~~for~~ Boston, that you had seen it with me and with full expert knowledge of the Minoan world had pronounced the ivory one of the very most important pieces ~~ext known~~ extant outside of Greece ([illegible] ~~greater~~ Greece). Fairbanks was astonished at the moderateness of the

FIG. 6.2 *Bert Hodge Hill. "They agreed not to let my name appear in the business."*

FIG. 6.3 Right: *Hill's datebook for 25 June 1914.*

FIG. 6.4 *Hill to Seager: "Do you recall how the man who had the ivory said he wanted the $920?"*

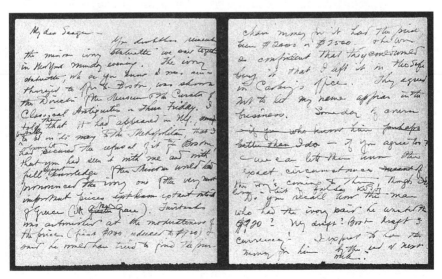

price (first $1200, reduced to $920) + said he would have tried to find the purchase money for it had the price been $2000 or $2500. + he was so confident that they ~~could~~ would buy it that I left it in the safe in Caskey's office. They agreed not to let my name appear in the business. Some day of course ~~if you who know him perhaps better than I do~~ — if you agree too we can let them know the exact circumstances mean of the ivory's coming to them though I'll have [?] a bit of false κυδόs.

Do you recall how the man who had the ivory said he wanted the $920? My draft? Boston draft? Currency? I expect to have the money for him by the end of next week.

Hill's mention of the Metropolitan Museum to Fairbanks and Caskey in Boston was a clever gambit that must be seen in light not only of the usual competition between museums but more specifically of the resignation late in 1905 of Edward Robinson, Fairbanks's predecessor as curator of the Classical Department and director of the Boston museum, and his subsequent appointment as assistant director and then director of the Metropolitan. The MFA's Classical Department had flourished under Robinson, but soon after his departure the Metropolitan quickly began to outstrip Boston as the premier collector of antiquities in America.[5]

Although they must have known that it had been exported illegally, Caskey and Fairbanks jumped to acquire the Goddess, which, as Fairbanks soon wrote to Mrs. Fitz, he considered to be an object of "extreme importance." Indeed, according to Hill, he was willing to pay twice the asking price.

The acquisition of ancient artifacts, however, has long been controversial. Arthur Evans, as noted earlier, understood the damage caused by loss of context occasioned by looting, but his own desire to possess antiquities often overrode such concerns. Harriet Boyd Hawes, in contrast, appears to have worried about issues of patrimony as much as about science.

For their part, Hill and Seager seem to have been ambivalent.

They delivered the statuette to Boston but did not wish their names to be associated with it (although Hill admitted that he would not have minded "a bit of false *kudos*" within a narrow circle). As active excavators, they might have feared how news of their involvement in the affair would be met in Greece. Hill's relationship with Greek officials was good enough that in 1910 he had been authorized to dig *inside* the Parthenon, where he determined the plan of the temple's unfinished predecessor. In 1914 he was excavating at Corinth. His contemporaries noted his exceptional political and diplomatic instincts, and in 1922 he was instrumental in securing for the American School land for the construction of the Gennadeion Library; he later facilitated the expropriations necessary for American excavations of the Athenian Agora. With reference to the political wrangling surrounding the Gennadeion, the chairman of the school's Managing Committee wrote: "Probably no other person, Greek or foreigner, could have succeeded in the circumstances."[6]

Whether Hill, who has also been praised as "the first American archaeologist to appreciate and to make his own the new methods introduced by the Germans at Olympia" and to apply "scientific thoroughness and accuracy" to the examination of the smallest pieces of evidence, had moral or scientific scruples about the export of the Goddess, we cannot know.[7] In this case, worries about the loss of context might have been mitigated by the *belief* that he knew the Goddess's provenience. For it is clear that neither he nor Seager, despite their desire to remain anonymous, had any doubts about her authenticity. Nor were they interested in personal profit. Hill's letter to Seager and Seager's response (Fig. 6.5), written on 29 June, again from the Hotel Belmont, make it clear that both archaeologists were acting for a third party, "the man who had the ivory," whom Seager refers to as "Mr. Jones":

Dear Hill,
 I am just back from Philadelphia and was very pleased to get your letter. How nice the lady was so well received. I hope

June 29th 1919.

Dear Hill,

I am just back from Philadelphia and was very pleased to get your letter. How nice the lady was so well received. I hope she will like her new surroundings as in my possession she was rather a worry and you never know about goddess their temper is so uncertain and she might have thought fit to visit her displeasure, at being so dragged about, on my head. I see now why antiquity dealers become millionaires. Isn't it a pity we can't take up the trade - Goddesses at $920. worth two thousand odd would be paying investments. I am so glad Boston took her as I should rather have had her there.

As to the cash I think Mrs. Jones would like it in either a N.Y. draft or a London draft whichever is most convenient - I don't really think he would mind much if his identity was revealed to Fairbanks and Caskey as I fancy museums know how to keep secrets as it must be part of their trade. Of course Mr. Jones does'nt care to be taken for a dealer but as they seem to think they got it fairly cheap I don't think they will suspect Jones of trying to make a bit. Only of course it must not go further than the two mentioned or Jones might suffer. Do as you like about this. If you think best to keep the truth dark for the present you can leave it as it is. I wonder if you could arrange to let Jones have a couple of pictures of the lady when they get her ready.

FIG. 6.5 Seager to Hill: "You never know about Goddess[es] their temper is so uncertain and she might have thought fit to visit her displeasure, at being so dragged about, on my head."

She will like her new surroundings as in my possession she was rather a worry and you never know about Goddess [*sic*] their temper is so uncertain and she might have thought fit to visit her displeasure, at being so dragged about, on my head. I now see why antiquity dealers ~~hav~~ become millionaires. Is'nt it a pity we can't take up the trade — Goddesses at $920 worth two thousand odd would be paying investments. I'm so glad Boston took her as I should rather have had her there.

As to the cash I think Mr. Jones would like it in either a N.Y. draft or a London draft whichever is most convenient. I don't really think he would mind much if his identity was revealed to Fairbanks and Caskey as I fancy Museums know how to keep secrets as it must be part of their trade. Of course Mr. Jones does'nt care to be taken for a dealer ~~b~~But as they seem to think they got it fairly cheap I don't think they will suspect Jones of trying to make a bit. Only of course it must not go further than the two mentioned or Jones might suffer. Do as you like about this. If you think best to keep the truth dark for the present we can leave it as it is. I wonder if you could arrange to let Jones have a couple of pictures of the lady when they get her ready. I am sure he would like something to remember her by but of course he would not attempt to publish them as you know.

It has been very kind of you to take all this trouble and I am duly grateful. I know so little about the value of antiquities I was rather afraid they might think the price was too high in spite of my opinion to the contrary . . .

Who was this mysterious "Mr. Jones"? Seager's letter, like Hill's, suggests that Fairbanks and Caskey were not apprised, at least initially, of the source of the Goddess. Indeed, it is unclear whether they were ever told of Mr. Jones. The name is probably a pseudonym, for no such archaeologist was then active in Greece. Everything points to Gilliéron. Though best known for his work with Evans at Knossos, Émile *père* also worked for other archaeologists. Seager employed him on various occasions and, in fact, commissioned drawings from

him in 1914. As a member of the archaeological community, Gilliéron was in a position to publish photographs of the Goddess. He would not wish to be taken for a dealer, although he might not mind his identity being revealed to the curators. (He had offered Karo a Knossian gold and ivory statuette.) But he certainly would have suffered if it had been widely known in Greece that he was involved in the export of Minoica.[8]

As for the $30 discrepancy between the $950 paid by Mrs. Fitz and the $920 to be passed on to Jones, it eventually made its way into the American School building fund, for Seager, writing from New Hampshire on 10 July, declined to accept any part of it:

> Dear Hill,
>
> Thank you for yours from New York. Of course I can't take the extra $25 [$5 was deducted to cover Hill's travel expenses] so put it to the building fund or use it in any way you choose. Very kind of the Museum to be so generous and I wish it might have been more if the School could have benifited [sic] by it.

Seager's desire to benefit the school was genuine: he later offered funds to underwrite excavations at Zygouries in the Argolid, and he bequeathed his residuary estate jointly to the American and British schools.[9] Thus on 15 July Hill reported to James R. Wheeler, chairman of the school's Managing Committee, a "mixed anonymous contribution of $30" to the building fund. At a date unknown he also sent Seager a check for $920, which Seager, still in New Hampshire, duly acknowledged (Fig. 6.6):

> July 21st 1914.
>
> Dear Hill,
>
> Thanks very much for the check which came safely. I am afraid it gave you a good deal of trouble and I am most grateful to you for carrying out the transfer for me. . . .
>
> I must go through Boston on my way back to have a look at the Lady as I supposed they may have doctored her up a bit by

hope I shall find you in
residence —
I must go through Boston on
my way back to have a look
at the Lady as I suppose they
may have doctored her up a
bit by them. Mr. Jones had better
keep away from Crete as I
expect he won't be a bit popular
there when she is made known
to the world. Thanks once more,
Yours ever
R. B. Seager

July 21st 1914.
JEFFERSON HIGHLANDS
NEW HAMPSHIRE

Dear Hill,
Thanks very much
for the check which came safely.
I am afraid it gave you a good
deal of trouble and I am most
grateful to you for carrying
out the transfer for me.
I have heard from Mrs. MacGiffert
so that's all right too.

FIG. 6.6 *Seager to Hill: "Mr Jones had better keep away from Crete."*

then. Mr. Jones had better keep away from Crete as I expect he won't be a bit popular there when she is made known to the world. Thanks once more,

> Yours ever,
> R. B. Seager

That Hill, Seager, Caskey, and Fairbanks were not the only American archaeologists who knew of the transaction is evident from a letter Hill wrote ten days later to Carl W. Blegen, then secretary of the American School, later Schliemann's successor as excavator of Troy. Most of the letter concerns Hill's attempts to procure construction materials for the American School, but it also contains a reference to the Goddess:

Thursday night after we landed I traveled to N.Y. Boston with the cast for Mrs. [Sarah] Sears [a benefactress of the school] + the ivory lady you once saw. The Museum took her with much joy

and astonishment at the small cost. The Building Fund gets $30 towards my hotel + railway bills out of the transaction since the Museum allowed me that sum for ~~traveling~~ the expenses of my trip to Boston. I came straight back the Friday night.

Blegen probably saw the statuette in New York when he met with Hill on the morning of Hill's journey to Boston rather than in Greece.

In any case, these documents, along with Karo's (mis?)recollections, seem to confirm Caskey's statement that the Goddess came originally from Crete. The provenance of the statuette is thus confirmed, but because it passed through the hands of the Gilliérons — expert restorers, reproducers, and creators of Minoica — its provenience remains uncertain.

7

SNAKE GODDESSES,
FAKE GODDESSES?

> The prevalence of fakes is the venereal disorder of the illicit art market — the punishment for excessive desire and bad judgment.
>
> — Karl E. Meyer, *The Plundered Past: Traffic in Art Treasures* (1973)

JUST THREE MONTHS after Caskey first presented the Boston Goddess to the world in the museum's *Bulletin*, Professor Ernest Gardner at the University of London questioned the authenticity of the gold and ivory statuette. But he reasoned away the possibility that the Goddess might be a modern forgery on account of the poor condition of her materials and his belief that models for imitation would not have been available at so early a date. He concluded that "so exceptional a work does not easily lend itself to comparison, and may be a freak of individual genius."[1] Others were not so easily convinced, and doubts about the Goddess were widespread. In February 1915 Richard Seager wrote to Arthur Evans from Crete defending her:

Feb. 10th 1915

Dear Evans,

I hear from Hall at the B.M. [British Museum] that you are one of the few people who are disposed to stick up for the Boston Snake Goddess. I am very glad to hear this as it is rather a shame to give her a black eye. She is quite alright and a very fine thing too. In fact the work very much resembles your ivory figures from Knossos especially the hand and the arm. If one had'nt got

your ivories to judge by she would seem almost too good to be true. When bought she was in very bad shape. One arm was reduced to mere chips of ivory and the lower part of the skirt was very bad. I personally don't see why any one should doubt her as she bears all the characteristics one would expect of a Minoan work of the first class and I am sure if you could see her you would feel the same. I have'nt seen the plate in the Bulletin by which they are all judging her. It may be the Boston people have restored her badly and given her a dubious appearance. All this is in confidence, please don't quote me too much as I don't want to get my name mixed up with her. Officially I have'nt seen her yet and shan't have done so until I get to America this summer.[2]

This letter is revealing in a number of ways. Because Seager thought he *knew* where the statuette came from (perhaps having been told by Gilliéron), he adduced parallels to the Goddess in the material excavated at Knossos, attributing her "dubious appearance" to the museum's restoration work. Caskey's original report in the *Bulletin,* however, did not illustrate the reconstructed Goddess, and restoration, in any case, consisted largely of piecing the fragments of the statuette back together, with additions to the bottom of the skirt and replacement of the badly damaged right arm. Even the attachment of the tip of the nose did not greatly alter the appearance of the face, as is evident from comparison of pre- and postrestoration photographs (frontispiece, Figs. 1.1, 1.11, and 1.12). For his part, Seager seems not to have been bothered by the Goddess's pouty mouth and deep-set eyes, "sunk to their natural depth below the brow, a method of treatment practically unknown to ancient art of any kind before the fourth century B.C." as Gardner pointed out and Evans later mentioned. Rather, Seager compared her preserved left arm and hand to the limbs of the leapers unearthed at Knossos. But the Goddess's arm and hand lack the fine subcutaneous anatomical rendering of veins and tendons present in limbs of the leapers (Figs. 2.15 and 2.16) and many of the other unequivocally genuine Minoan chryselephantine statuettes that have been excavated since, such as the composite figures unearthed along the Royal Road at Knossos in the late 1950s and

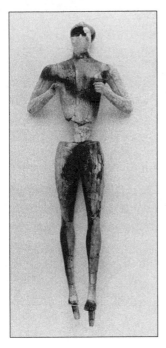

Fig. 7.1 *Gold and ivory youth excavated at Palaikastro in eastern Crete. Though burned and broken, its fine carving rivals that of the Knossos Leapers (Figs. 2.15 and 2.16), and its composite construction, including a stone coiffure and rock crystal eyes, is even more complex. Height about 20 in. (50 cm).*

the remarkable youth recovered more recently at Palaikastro on the eastern tip of Crete (Fig. 7.1).[3]

The absence of such features in the Boston Goddess and other unprovenienced statuettes might be explained as the results of weathering or of the fact that all of the excavated ivories that can be assigned a gender are male. It is a curious fact that although females appear frequently in other media in Cretan art, no demonstrably female Minoan composite ivory statuettes have ever been excavated. To be sure, the ancient Cretans may have depicted women with less defined anatomy than men, as later Greeks seem to have done.[4] Seager, however, did not address these and other differences between the Boston Goddess and the excavated material known to him. Rather, he could

not "see why any one should doubt her." After all, "she bears all the characteristics *one would expect* of a Minoan work of the first class" (emphasis added). Indeed, as the Boston Goddess combined the materials of the gold and ivory leapers and the subject and pose of the largest and most important of the restored faience figurines (Fig. 2.17), she met expectations and fulfilled desires. What could be better than a chryselephantine version of the Knossian Snake Goddess? Without the Knossos ivories, Seager argued, the Boston statuette "would seem almost too good to be true," but the truth of the matter is that without the ivories and the faience figures excavated by Evans the Boston Goddess would be inconceivable.

<center>⎯⎯⎯⎯</center>

The excitement engendered by the unearthing of Minoan civilization is difficult for us to imagine. Occurring at the beginning of a new century, the discovery stretched the history of European culture back by millennia. In the preface to Charles H. and Harriet B. Hawes's 1909 book, *Crete: The Forerunner of Greece*, Evans wrote:

> The recent discoveries in Crete have added a new horizon to European civilization. A new standpoint has been at the same time obtained for surveying not only the Ancient Classical World of Greece and Rome, but the modern world in which we live. This revelation of the past has thus more than an archaeological interest. It concerns all history and must affect the mental attitude of our own and future generations in many departments of knowledge.[5]

This 3500-year-old world seemed fresh to observers, immediate and vital. A quarter of a century earlier, in his inaugural lecture as keeper of the Ashmolean, Evans had declared, "We are no mere relic-worshippers. Our theme is history — the history of the rise and succession of human Arts, Institutions, and Beliefs." But following his discoveries at Knossos, Minoica of all sorts became the rage because of their breathtaking *élan* and uncannily "modern" spirit. Private collectors and museum curators competed to possess works attrib-

utable to this newly unearthed civilization and were willing to pay huge sums for Minoica in various media. Just as the late-nineteenth-century Tanagra figurines were first illicitly excavated and then forged to meet enthusiastic demand, so too in the early twentieth century did enterprising dealers and craftsmen strive to fulfill the craze for Minoan artifacts.[6]

Modern Minoica appeared on Crete at least as early as July 1903, when Evans's letters mention a fake terra-cotta Zeus head. A decade later, Seager wrote to fellow archaeologist Edith Hall about a suspect bronze that Evans had "decided must be a fraud." Seager's letter continued apologetically: "I am sorry about the seals. I am afraid Crete is getting much too adept at turning out frauds and one will have to be very careful."[7] Fake Cretan intaglios, as well as statuettes, were becoming more and more common. Evans himself purchased numerous unprovenienced objects, including a gold seal ring that he reported had allegedly been found

in a large beehive tomb at "Nestor's Pylos" by a peasant in quest of building material there, somewhat previous to the investigation of its remains by the German explorers in 1907. The discovery, however, was kept dark, and on the death of the original finder the ring passed into the possession of the owner of a neighbouring vineyard. Thanks to the kindness of a friend, I saw an imperfect impression of the signet at Athens which gave me, however, sufficient idea of the importance that it might possess. I at once, therefore, undertook a journey to the West Coast of the Morea, resulting in the acquisition of this remarkable object.[8]

Although in recent years some scholars have attempted to rehabilitate this "Ring of Nestor" (Fig. 7.2), it is widely considered a forgery, and Gilliéron *fils* is reported to have claimed in the 1930s that he fashioned it himself. Evans also purchased a group of fake signet rings and bead seals said to have formed part of "a Sepulchral Treasure" found "in a Mycenaean rock tomb near the site of Thisbê in Boiotia" (Fig. 7.3). The discovery was purportedly made by a peasant in 1915, "at a time when war conditions diverted the course of dis-

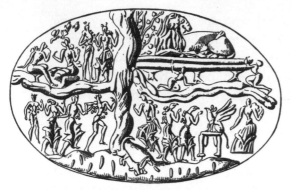

FIG. 7.2 *The Ring of Nestor was found "by a peasant in quest of building materials." Ashmolean Museum, formerly in the collection of Arthur Evans. The drawing is by Gilliéron fils. Is the ring by him as well?*

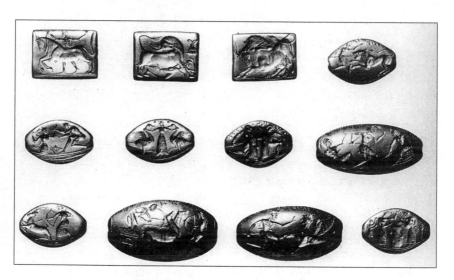

FIG. 7.3 *The Thisbê Treasure, Ashmolean Museum, formerly in the collection of Arthur Evans. The intaglios include representations of the Mother Goddess with a young male attendant (Fig. 4.10) and Oedipus and the Sphinx.*

covery from official channels." First published in 1925, the intaglios depicted scenes that Evans viewed as remarkable Minoan antecedents of later Greek myth and religion, including what he identified as Oedipus and the Sphinx and the revenge of Orestes. Another, as we have seen, he employed as evidence for the Minoan Boy-God who attended the Mother Goddess (Fig. 4.10).[9]

Evans was certainly aware of the existence of Minoan forgeries, such as the "bad company" surrounding his Boy-God, but he seems to have had little doubt of the authenticity of these intaglios and of many of the unprovenienced statuettes that came to light after the war. He was all too willing to accept as truthful the stories told by interested parties about the origins of Minoan works that conformed to his notions of ancient Cretan art, religion, and society. Just as the fake ivory figurine resembling a chess queen — as well as the larger, badly weathered, gold-trimmed Snake Goddess — had been guaranteed by Feuardent to come from Knossos (Figs. 4.2–4.5), so too were Evans's Boy-God and Lady of the Sports (also acquired through Feuardent) said to have come from the Palace of Minos, in fact, from the same deposit as the Boston Goddess.

The Fitzwilliam Goddess (Fig. 4.12), in contrast, was said to have been found "on the site of the old harbour town of Knossos." Although Evans later admitted that he had been unable to find out *"exactly where"* the figure came from and that he had "only heard in a vague manner that the statuette was said to have been found 'East of Candia,'" he nonetheless considered the alleged findspot to be "inherently probable" because it was the location of an ancient lapidaries' quarter. Others went further. As mentioned in Chapter 4, Alan Wace invented a more precise archaeological provenience for the figure in his book about the Fitzwilliam Goddess, just as Evans had done for the Boston Goddess:

> The circumstances of the discovery and exact provenance of this important statuette are both unknown. The first news of it was a bazaar rumour in Athens, but the statuette made its way direct from Crete to Paris whence it was acquired for the Fitzwilliam Museum. It is said to have been found in Crete not far to the east of Candia and the more recent report states that it came from the ruins of the harbour town of Knossos which lay on the sea close to the mouth of the river Kairatos. As the figure is badly discoloured and was broken into several pieces, the right arm being badly splintered, it would seem that it was found in the ruins

of some building, perhaps a shrine, which had been destroyed by fire.[10]

This, like most unconfirmed proveniences, is little more than wishful thinking. There is no evidence that there was such a building, let alone a shrine, and even the association with the port of Knossos seems to have been manufactured to suit expectations.

Other stone goddesses soon followed the Fitzwilliam statuette onto the international art market, for the forgers knew a good thing when they saw it. Some of these figures found buyers, but others have disappeared and are known today only from photographs. One (Fig. 7.4), once in the possession of a Michael Ritsos of Salonica, was posed like the Fitzwilliam Goddess, with her hands at her breasts, and wore a similar incised flounced skirt, apron, and bodice. Significantly larger (30.3 centimeters rather than 22.7 centimeters), she had a lower, round cap over her flowing locks, as well as a double beaded necklace. A more significant difference, however, is that her arms are entwined with snakes. Thus she combines the imagery of the Fitzwilliam Goddess with that of the faience figures and the Boston Goddess. Said to have been purchased "from a Syrian" in 1925, she was alleged to be from "near Knossos." Many scholars, however, noticed the "family resemblance" between this obvious forgery (its face is particularly unlike anything in Minoan art) and the Fitzwilliam Goddess, including the fact that it was carved from the same reddish brown stone, whose appearance was likened to that of corned beef.[11]

A third stone statuette of the Cretan Goddess "as 'Snake Mother'" was published by Evans in volume 4 of *The Palace of Minos* (Fig. 7.5). It was reported to be about 40 centimeters tall. Its present whereabouts are unknown, as are its origins, although Evans inferred that it came from the "same sanctuary deposit" at the "Harbour Town of Knossos" as the Fitzwilliam Goddess and other objects of stone, bronze, and terra cotta. These, he declared, were all "unquestionably genuine," although there can be no doubt that some, if not all, are forgeries. The stone Snake Mother held a long serpent draped

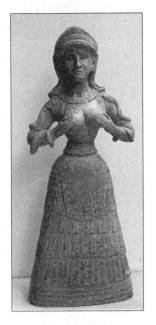
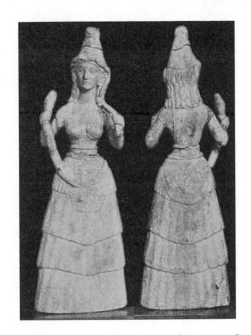

FIG. 7.4 *Stone Snake Goddess, said to have been found "near Knossos." Museum of Classical Archaeology, Cambridge. Height 11 7/8 in. (30.3 cm).*

FIG. 7.5 *Stone Snake Mother, with serpent wrapped around her face, said to be from the harbor town of Knossos. Its whereabouts are unknown. Height 15 3/4 in. (40 cm).*

between her two hands, its head rising on her right while its tail, wrapped around both ears and her brow, framed her head in a manner Evans thought reminiscent of the faience Goddess. Her dress was similar to that of the other unprovenienced stone figures, while her tiara, though broken, curved forward. All too ready to believe in the authenticity of this statuette, despite its exceptionally large size and stylistic anomalies, Sir Arthur employed it as evidence of Minoan religious sensibilities:

> The milder and more motherly aspect that the Snake Goddess could assume even in the most advanced phase of the Cult, and

in its highest artistic presentation has been singularly illustrated by the discovery of a further stone statuette of the Minoan divinity in this character, exceeding in size the other known figures. In this she appears grasping the neck and body that is here coiled about her as if it were rather her pet than the attribute of awesome powers.

Evans perceived in this figure

a human touch, and the snake that she so gently grasps seems to be brought into a certain personal relation with its divine Mistress. The reptile here is not held out as an emblem of infernal power such as it suggests in other cases. Still less is it brandished as we see two serpents in the upraised hands of the smaller snake divinity from the "Temple Repositories" where the action might well recall that of the Etruscan demon . . . Fat and well-liking as the reptile is here portrayed, it might well be a tame snake. The Goddess, in short, in her present incarnation is primarily a "Snake Mother" reflecting something of the originally beneficent character of the domestic serpents themselves.[12]

Evans claimed that this stone Snake Goddess belonged "to the same remarkable find of Minoan Cult figures" as a fourth, slightly smaller stone Goddess, also a forgery that seems to have disappeared (Fig. 7.6). Her hands rested on her hips, and her garments and features closely resembled those of the above-mentioned goddesses. There was also a terra cotta figurine (Fig. 7.7), said to have been found with this group of objects. She wore "the usual corset, open at the front for the ample breasts," but her apron was "of quite exceptional form, being square-cut." Reminiscent of figures found at Piskokephalo in east Crete, her hair rose in a curly topknot with a "bandeau round its middle zone." Although her arms were broken, to Evans "the attitude suggested by the parts that remain seems most compatible with the idea that she was holding forth two snakes."[13]

While some called the two stone figures "the Ugly Sisters," Evans thought that they and another (Fig. 7.8), allegedly from Tylissos

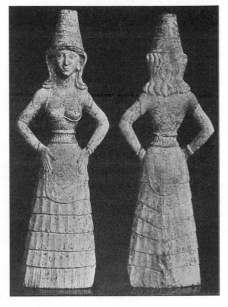

FIG. 7.6 Right: *Stone Goddess, said to be from the harbor town of Knossos, present whereabouts unknown. Height 14 in. (36 cm).*

FIG. 7.7 *Terra cotta Snake Goddess, said to be from the harbor town of Knossos. Its whereabouts are unknown. Height 6 7/8 in. (17.5 cm).*

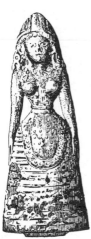 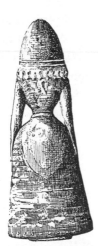

FIG. 7.8 *Stone Goddess, said to be from Tylissos. Ashmolean Museum, formerly in the collection of Arthur Evans. Height 3 5/8 in. (9.2 cm).*

(some thirteen kilometers west of Knossos), corroborated the genuineness of the Fitzwilliam Goddess. He even attributed all of the stone figurines to the same hand. The one "from Tylissos," which Evans donated to the Ashmolean, is smaller (9.2 centimeters) and seemed to Evans "to have been covered with a thin coating or *engobe* of white plaster, the patterns of [her] dress being subsequently rendered in a red ochreous tint. The whole is good sculptural work, answering in style and many details to the faience figures of the 'Temple Repositories,' and dating from the same fine transitional epoch, the advanced phase of M. M. III."[14] Thus we see the slippery slope along which restorations and unprovenienced objects were employed to confirm the authenticity of still more dubious pieces.

Henry Walters never revealed his Minoan ivories during his lifetime, but two years before his death he acquired through his Paris book dealer, Leon Gruel, a large stone statuette (Fig. 7.9 right).[15] Like the Fitzwilliam Goddess, it was made in two pieces, joined at the waist by a round dowel — a technique used in Cretan ceramics but hardly suitable in stone. This Goddess's gold and ivory twin, with which it had previously been offered to other buyers, unfortunately seems to have disappeared. To judge from photographs, the chryselephantine Goddess was carved from a single section of tusk except for the arms. Standing approximately 28 centimeters high, she held what appear to be the remains of gold snakes in her hands and coiled around her left forearm, while embossed gold armbands masked the joins on the biceps and a flat gold band served as a necklace. The armbands appear to have been tied in place with string; likewise the gold belt at the waist. This packaging recalls that of the less well preserved gold and ivory Snake Goddess purchased by Walters (Fig. 4.2). Unlike that statuette, however, neither this chryselephantine goddess nor the ivory head fragment that appears in only one photograph between it and its stone twin, seem to have found buyers.

The same is true of another ivory Goddess (Fig. 7.10), once in the possession of a certain P. Floros, that J. V. Mládek, a Czech official of the International Monetary Fund in Washington, D.C., offered to

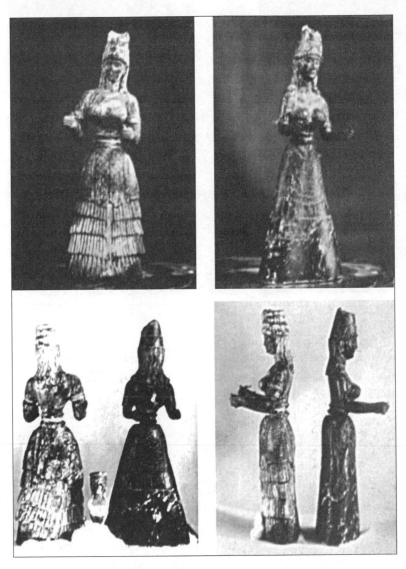

FIG. 7.9 *Two Snake Goddesses, one ivory, one stone, and the ivory head of a third. The whereabouts of the ivories are unknown; the stone figure (right) is now in the Walters Art Gallery. Height 10 7/8 in. (27.7 cm).*

FIG. 7.10 *Ivory Snake Goddess, whereabouts and height unknown.*

prospective collectors, including the Metropolitan Museum of Art in 1949. Its current whereabouts, too, are unknown, as are its dimensions, but from photographs it can be seen that this previously unpublished bare-breasted female wore a wide, flounced skirt and an apron incised with rhomboids. Her arms — the only parts of the figure carved separately — were outstretched like the faience votary excavated by Evans. Only the right hand was preserved, with a central drill hole, perhaps for a snake. The full face was unlike anything in genuine Minoan sculpture, and the figure wore a low flat-topped cap, also without parallel in Minoan art. There can be no doubt that the Metropolitan made the correct decision not to purchase her.

A tenth ivory Goddess (Fig. 7.11), however, did find a buyer, a New York collector, who acquired her from a Swiss dealer. The dealer claimed that she had passed through the hands of various Parisians including an "original" owner, who obtained her before World War I. Smaller than most of the other statuettes at just 11.7 centimeters, this

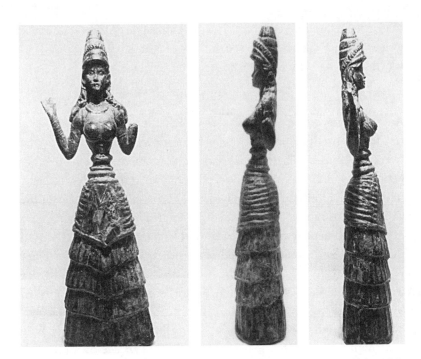

FIG. 7.11 *Ivory Goddess, said to be from Crete. Private collection, New York. Height 4 5/8 in. (11.7 cm).*

figure resembles nothing so much as Walters's small chess queen–like forgery (Fig. 4.5). She too wears a flounced skirt; her narrow waist is set off by multiple ringed belts; and the bodice below her ample bosom is carved as if it were woven. She wears a single strand of beads around her long neck, as well as incised armbands and bracelets. Her arms are bent sharply upward at the elbow, rather like the Goddess restored above the ankles by Gilliéron *père* in the center of the Procession Fresco (Fig. 5.15). Her face is concave in profile, has high cheekbones, sunken eyes, a low forehead, and impressionistic ears. Like the restored faience figures, the Boston Goddess, and other unprovenienced statuettes, she has a serious expression. Most of her surface is blackened, as if by fire, but the inside of a small hole at the top of the tiara remains white. This suggests that she was held over a flame

to give her a "weathered" look. The pose and style of this Goddess, as well as the fact that she is carved entirely of a single piece of ivory, betray her, too, as a modern work.

—◁◁◁◁▷▷▷—

Archaeologists active on Crete — as well as this parade of fakes — attest to the modern production of Minoica in the first half of the twentieth century. Their letters and memoirs mention not only forgeries but the forgers themselves. Stephanos Xanthoudides, director of the Candia Museum in the 1920s, claimed to know the name of the Cretan craftsman who had carved the Fitzwilliam Goddess: "a very experienced mender and manipulator of Cretan antiquities, of whom they say in Candia that when told of the prodigious price the last purveyor received for his creation, he 'wept bitter tears.'" Evans and Wace were both familiar with this man, a former employee of the Cretan Museum, but, as often occurs in cases of forgery, they could not believe that a modern craftsman might be as skilled as the ancients. Fine craftsmanship, however, is by no means proof of age or authenticity. Michelangelo launched his career by carving fake antiquities that he buried to give the patina of age; Han van Meergeren fooled the experts with his "early" Vermeers; Alceo Dossena's ancient, medieval, and Renaissance creations were purchased by major museums; and numerous other forgers continue to produce high-quality works today. In the debate surrounding the Fitzwilliam Goddess, Evans went so far as to assert that "there is no one [at the Candia Museum] or elsewhere in Crete or in Athens either who would have had the skill added to the knowledge of detail necessary for its production since the pattern on the dress implies a particular archaeological knowledge." Xanthoudides was accused of condemning the Fitzwilliam Goddess because he was upset that the "masterpiece" had slipped through his fingers and been exported abroad. Actually, he had recognized the statuette as a fake and had refused to purchase it when it was presented to him.[16]

That Cretan craftsmen did have the "particular archaeological knowledge" as well as the skill to produce convincing Minoan statu-

ettes is made clear by Sir Leonard Woolley, the excavator of Ur in Mesopotamia, who, in his memoirs, recounted the discovery of a forgers' factory:

> In Crete in the early years of this century I was stopping with Arthur Evans when he was excavating at Knossos, and one day he got a message from the police at Candia asking him to come to the police station, so we went together — he, Duncan Mackenzie who was his assistant, and myself. And the most surprising thing had happened.
>
> Evans had for many years employed two Greeks to restore the antiquities which he had found. They were extraordinarily clever men — an old man and a young one — and he had trained them, and they had worked under the artist whom he employed there, and they had done wonderful restorations for him. Then the old man got ill and at last the doctor told him he was going to die.
>
> He said, "Are you sure?" The doctor said, "Yes, I'm afraid there's no hope for you at all."
>
> "Right," he said. "Send for the police." The doctor said, "You mean the priest." "No I don't," he said. "I mean the police." He insisted, and they sent for the police and the police came and asked him, "What on earth do you want?"
>
> "Now I can tell you," said the sick man. "I'm going to die, so I'm all right, but for years I've been in partnership with George Antoniou, the young fellow who works with me for Evans, and we have been forging antiquities."
>
> "Well," said the policeman, "I don't know that that concerns me." "Yes," he said, "it does. Because we've sold a statuette of gold and ivory which was supposed to be a Cretan one to the Candia Government Museum, and that's a criminal offense. George is a scoundrel and I hate the fellow, and I've been waiting for this moment to give him away. Go straight to his house and you'll find all the forgeries and all our manufacturing plant there."
>
> The police went, they raided, and they found exactly what he said, and they asked Evans to come and look, and I never saw so

magnificent a collection of forgeries as those fellows had put together.

There were things in every stage of manufacture. For instance, people had been recently astounded at getting what they call chryselephantine statuettes from Crete; statuettes of ivory decked out with gold — there is one in the Boston Museum and one at Cambridge, and one in the Cretan Museum at Candia. These men were determined to do that sort of thing, and they had got there everything, from the plain ivory tusk and then the figure rudely carved out, then beautifully finished, then picked out with gold. And then the whole thing was put into acid, which ate away the soft parts of the ivory giving it the effect of having been buried for centuries. And I didn't see that anyone could tell the difference![17]

This colorful account is unfortunately problematic. Woolley mentions gold and ivory statuettes in Cambridge and the Cretan Museum, as well as in Boston. The two statuettes in Cambridge, however, are of stone (Figs. 4.12 and 7.4), and no such figure is known to be in the Cretan Museum, though an elderly guard there remembers boxes of forgeries being placed in the storerooms. There is, moreover, no record of a George Antoniou, although Gregorios Antoniou (aka Gregori) long served Evans as foreman of the excavations. Evans inherited Gregori, a former tomb robber from Cyprus, from David Hogarth in 1902, and it was Gregori who coordinated the sixty workmen engaged in the heroic effort to save the bulging wall of the Grand Staircase. Gregori does not seem to have worked as a restorer of small finds, however, and his career at Knossos apparently ended with the outbreak of the war. He returned to the Middle East, where he again dug with Hogarth and then at Carchemish with Woolley himself, who called him a "poacher turned gamekeeper." By 1919 Gregori seems to have retired to his native Cyprus, being "too old for excavations."[18]

Despite the similarity of their names, Gregori and George Antoniou do not seem to have been the same man, though they may

have been related. Another possibility is that Woolley, telling the story some forty years after the fact, grasped for a familiar-sounding Greek name for the one forger he bothered to identify. Other accounts confirm that a forgers' factory was unmasked and even help to date the episode more precisely, sometime between October 1923 and February 1924. Gustav Glotz, in the "Corrections and Addenda" to the second edition of his *Aegean Civilization,* wrote of the discovery of "a factory established in Crete for the production of forgeries." The preface to this book is dated 27 February 1924, less than half a year after Glotz's first edition was published, in October 1923, setting a narrow range of dates for the discovery. Thus, while Woolley seemed a bit fuzzy on the details — his memoir was called *As I Seem to Remember* — there can be no doubt of the substance of his tale. He explicitly stated that the forgers were Greeks who worked for Evans's artist (that is, Gilliéron).[19]

Georg Karo too attested to a connection between Cretan forgers and Evans's trusted Swiss restorers, implicating the latter without naming names:

> Only during the years of war 1915–1918 did ivory statuettes richly embellished with gold "from Crete" first come to light. These skillfully produced works always had to fit excellently with the results of Evans' research regarding Minoan religion. And he had no doubts as to their genuineness, because — as he wrote to me once — nobody yet had knowledge of the still unpublished results. That men to whom he must, after all, have indicated some of those results would repay his benevolence over many years in such a malevolent way was to a man of his character wholly incomprehensible. And the successful efforts of Spyridon Marinatos, while he was Ephor . . . to expose bit players, goldsmiths working on order as forgers, did not reach the men behind the scenes.[20]

Doro Levi, excavator of Phaistos and former director of the Italian Archaeological School in Greece, corroborated the involvement

of native Cretans. He reported that the same man who had carved the Fitzwilliam Goddess, a goldsmith and former restorer of antiquities at the Candia Museum, had also fashioned a number of high-quality figurines. This craftsman allegedly used illicitly excavated ancient materials, including ivory, in the production of Minoica. Moreover, it was said that he had fashioned "another, still more famous statuette of the Goddess, always considered a masterpiece of Minoan sculpture." He even claimed that he had modeled its face after his daughter.[21]

The unmasking of the forgers' factory outside Herakleion in the early 1920s, a decade after the advent of the Boston Goddess, may be the reason Henry Walters never revealed his Minoan ivory statuettes. Others were not so circumspect and continued to acquire Cretan artifacts: the Fitzwilliam Museum, Royal Ontario Museum, and Arthur Evans himself all purchased Minoan statuettes in the later 1920s and 1930s. These modern creations succeeded because they conformed to Evans's theories about Minoan art and religion; in fact, they seemed to confirm them, even before those ideas had been made known to a wider public. The Cretan forgers, like all counterfeiters, fashioned what the market desired. Hence the profusion of "Minoan" Mother Goddesses, with and without snakes.

Evans's cherished Boy-Gods and the Lady of the Sports are of particular interest in this context, for not only are the techniques used in their construction and their style problematic, like those of the other unprovenienced stone and ivory statuettes, their imagery, too, is anomalous: their subjects have no parallels in the scientifically excavated material. The leapers excavated by Evans at the turn of the century and larger ivory figures uncovered more recently alongside the Royal Road at Knossos and at Palaikastro in eastern Crete are true composites, constructed of numerous separately carved pieces.[22] These genuine ancient figures also exhibit minute renderings of anatomical details, such as tendons, veins, and even cuticles, which are not present on any of the unprovenienced statuettes. Though badly burned and broken, the now discolored Palaikastro youth (Fig. 7.1)

— constructed of at least twenty separately fashioned, finely joined components of hippopotamus ivory, serpentine, rock crystal, wood, and gold — demonstrates just how exquisite true Minoan ivory sculpture could be.

The damage to both of Evans's Boy-Gods and the Lady of the Sports, evident in prerestoration photographs (Figs. 4.6, 4.13, and 4.14), is merely superficial. In fact, it seems to illustrate the kind of deliberate injury described by Woolley, a common practice of forgers. The battered thighs of these figures in no way detract from our understanding of their poses; and each has lost one arm and hand (hands are among the most difficult parts of the body to render), though the Lady, improbably, has retained the right hand without that arm. All of their limbs, including the bare feet of Evans's favorite Boy-God, which are supported by an awkward wedge-shaped plinth, lack subcutaneous features. The feet of the excavated pieces, in contrast, are either carved fully in the round or have tenons or dowel holes for attachment to a base. The facial features of the unprovenienced statuettes, moreover, are well "preserved," unlike those of the excavated pieces. Because faces are cherished by buyers, forgers are reluctant to damage them. The faces of the unprovenienced figurines resemble one another and those of the *restored* faience figurines, especially in their triangular structure, deep-set eyes, and downturned mouths, but do not resemble the excavated material.[23]

More remarkable than the fact that Sir Arthur was duped when he purchased his Boy-Gods is that he took the statuette now in Seattle (see Figs. 4.6–4.8) to be a boy at all. A male consort to the Mother Goddess certainly suited his notions of Minoan myth and religion, but unlike the Boy God he donated to the Ashmolean, the Seattle figure has no male genitals (although Sir Arthur, in a fit of wishful thinking, perhaps, somehow managed to discern them). This significant absence might be explained by the claim that the figure originally would have worn the loincloth, kilt, or penis sheath typical of Minoan male figures in other media, and Evans eventually restored a loincloth in gold. Close examination of the Seattle Boy, however, re-

veals a slightly raised mons veneris and feminine buttocks, along with the wide hips and narrow waist that Sir Arthur sought to explain away. Granted, the breasts are undeveloped, but what we have here seems not to be a boy at all but rather a prepubescent girl. Standing on tiptoe, with arms raised, she resembles the white-fleshed bull leapers flanking the central, darker-skinned figure in the Taureador Fresco from Knossos, found in 1901 and restored by Gilliéron from fragments of several different panels (Fig. 4.15). Following the color conventions employed to distinguish gender in the art of other ancient civilizations, Evans — and many other scholars to this day — considered the light skin of these two figures an indication that they depicted young transvestite females "with a very slight pectoral development."[24]

Surprisingly, then, Sir Arthur fell short of associating this ivory figure with the bull sports that he considered such an important aspect of Minoan culture. Although all available evidence suggests that the Seattle "Boy" was created as a female bull leaper modeled closely after the one in the Taureador Fresco, Evans (mis)interpreted the figure, taking it to represent a "Boy Consort." In fact, following Frazer's ideas regarding boy gods and mother goddesses, he published it as a "Divine Child" adoring the Mother Goddess and enlisted Gilliéron *fils* to sketch a reconstruction of such a group (Fig. 4.9). Thus Evans created a market for ivory Boy-Gods, and the forgers went back to work, producing the unequivocally male Boy (Fig. 7.12) that he purchased and eventually donated to the Ashmolean.[25]

Just as Evans linked his first ivory "Boy" with the Boston Goddess, he connected the second, in particular "the gold plates of its loin clothing" (which the forgers had this time included), with yet another fake gold and ivory statuette, Our Lady of the Sports, the bull leaper that the forgers had endowed with the generous bosom of the Divine Mother so that there would be no confusion as to its gender. The always creative Evans identified this figure not as a mortal participant in the games but rather as the "Minoan Goddess herself in a novel aspect, as patroness of the arena." There was no end to the invention of the Minoan past.

FIG. 7.12 *Detail of the ivory Boy-God in the Ashmolean Museum (see Fig. 4.13).*

The comparisons Evans drew between various counterfeit figurines demonstrate how unprovenienced objects, when accepted uncritically as ancient, can provide a new class of precedents by which later forgeries are measured. Spurious works thus come to be considered both genuine and typical, reinforcing each other and skewing our knowledge of the past.[26] Like other forgeries, these statuettes were convincing, and continue to convince some, because their creators relied on an expert's — Evans's — pet theories and style criteria. And in this case the criteria were formulated, at least in part, on the basis of restorations executed by the forgers themselves!

Our notions of Minoan art rely heavily on the products of early twentieth-century craftsmen. Restorations and forged figures stimulated the imagination and shaped the perceptions of scholars as well as the general public. And talented modern Cretans should share credit with Evans, the Gilliérons, and others for re-creating their glorious ancestry.[27]

8

THE UNCERTAINTIES OF SCIENCE

The existence of forgeries can hardly be regarded as an unmixed evil. The knowledge of their existence tends . . . to encourage a more minute and scholarly investigation of every detail in genuine objects of antiquity, and assists in creating that judicial frame of mind which avoids too sudden conclusions. In the advance of science it is hard to say which is the more mischievous — to believe too little or to believe too much; and the true moral of what we have been considering seems to be that which two thousand years ago was enunciated by Epicharmus — "that the very nerves and sinews of knowledge consist in believing nothing rashly."

— Sir John Evans, "The Forgery of Antiquities,"
Longman's Magazine (December 1893)

SO WHAT IS THE LADY? The Boston Goddess can be traced back to Crete, even to the possession of the elder Gilliéron, but her exact origins remain mysterious and, it would seem, intentionally so. Those who believe in her authenticity have rightly observed that she was the first of the unexcavated figures "to make her *début*," and that despite stylistic inconsistencies she "remains the least unconvincing" of the group.[1] For these reasons, and on account of her alleged association with the Ivory Deposit at Knossos, the Goddess has repeatedly been presented as an outstanding example of Cretan Bronze Age art. Indeed, her appearances in newspapers, magazines, textbooks, and encyclopedias have been instrumental in shaping modern conceptions

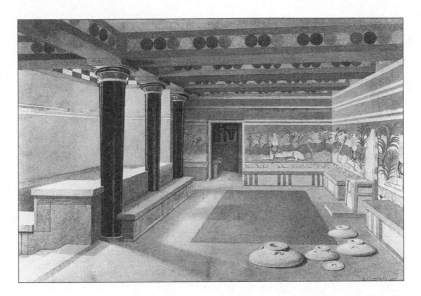

FIG. 8.1 *Watercolor of the Throne Room at Knossos by A. J. Lambert, the frontispiece to the final volume of* The Palace of Minos. *An enlarged version of the Boston Goddess stands alongside other Minoan religious symbols on a shelf in the inner shrine.*

of Minoan culture: in the color plate depicting a reconstruction of the Throne Room at Knossos (Fig. 8.1), which stands as the frontispiece to the final volume of *The Palace of Minos,* an oversize version of the Goddess is shown in the background, raised on a shelf in the Inner Sanctuary and flanked by the sacred Double Axes and Horns of Consecration.[2] And, as we have seen, her dubious charms have also been enlisted to authenticate other undocumented Minoan figures.

Given the problematic history of the statuette and the prevalence of Minoan forgeries in the early years of the twentieth century, the Boston Goddess must be viewed with great suspicion. Any assessment of her genuineness must be based on careful analysis of materials, techniques, style, and imagery and on comparisons both to unequivocally genuine, scientifically excavated figurines and to modern forgeries.

The Boston Goddess is iconographically similar to the faience

Snake Goddess from Knossos, which may well have served as a model for her production, but she also exhibits numerous differences. Rather than a high, spiral "tiara," she wears a low crown whose form is unparalleled in Minoan art. Its scalloped sides do seem to have something in common with the well-known Aegean Horns of Consecration motif (Fig. 3.2), but such imagery does not appear on other Cretan statues until hundreds of years after the Goddess's alleged date.[3]

Multiple drill holes in the Goddess's surface suggest the initial presence of further gold ornament at the top of the crown, on the hips as if for an apron, near the neck, and as if for more of her open bodice or jacket. A short gold strip in the center of the abdomen is held in place by three nails that appear to represent buttons closing the lower part of that garment. This, however, does not correspond to depictions of Cretan costume in other media, for buttons (which are more clearly present on the Toronto forgery, Fig. 4.14) were unknown in the Aegean Bronze Age. The Minoans used laces, as can be seen in the best-preserved faience figures. Recent research into Minoan dress, moreover, has revealed that the "bodice" or "jacket" — which is often compared to the traditional low-cut, long-sleeved early modern Cretan *kondochi* — is not a jacket at all but rather the upper part of a long shift, over which a flounced skirt was tied (Fig. 8.2).[4]

All of the Goddess's gold, in fact, is suspect. Evans believed that in ancient times, long before the statuette was illicitly excavated by his workmen, it, like the leapers of the Ivory Deposit, was stripped of most of its gold ornament. The Goddess, however, preserves considerably more precious metal than they do, and hers takes the form of rather heavy strips, like that of the statuettes in Baltimore and Toronto, rather than thinner foil. The patterns incised on the Goddess's gold bands, moreover, are unparalleled in Minoan metalwork (though the zigzags and figure-eight shields on two of her five flounces do appear elsewhere on Crete in other media). Likewise, the complicated construction of the snake heads is unique. The golden nail of the right nipple, imitated in both breasts of the Toronto figure, also finds no analogue in the excavated statuettes. The holes

FIG. 8.2 *A reconstruction of Minoan female dress by Nannó Marinatos, based on wall paintings excavated on Thera. The "corset," "bodice," or "sleeved jacket" attributed to the statuettes is actually part of a long shift.*

drilled in the chest of the excavated Palaikastro youth preserve traces of carbonized wood, which has been identified as a soft conifer. The darker wood nipples contrasting with creamy ivory flesh make sense in terms of polychromatic sculpture, but a gold nipple (despite parallels in Celtic mythology) does not.[5]

The series of drill holes at the Goddess's forehead are more convincing, for the leapers excavated by Evans have holes there as well as at the top of the head. Some of the holes in the leapers, however, preserve gilded copper wires that represented locks of hair, while the Goddess retains no trace of metal, and on the back of her head her hair is impressionistically carved in ivory, as on Evans's Seattle Boy and Our Lady of the Sports.

Perhaps most troubling are features of the Goddess's face (Fig. 8.3): the concave profile, deep-set eyes, and pouty lips. Closer inspec-

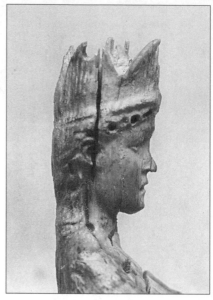

FIG. 8.3 *The face of the Boston Goddess, remarkable for its deep-set eyes, small, pouty mouth, and concave profile.*

tion reveals that the face is damaged. Ivory is subject to flaking, and part of the left side has sheared away. Yet the present features — eyes, nose, and mouth — are centered on what remains. This should not be the case: if the piece was damaged after carving, the surviving features should be off center. And what of her deep-set eyes? Early photographs reveal not just drill holes for pupils but also, in the better-preserved right eye, a second hole for the inner canthus. Eyes with drilled pupils *and* canthi have no parallel in Aegean sculpture and do not appear in ancient statuary before the second century A.D.[6]

The best preserved of the ivory heads excavated by Evans (Figs. 2.15 and 8.4), in contrast, is convex in profile and has shallow incised eyes with drilled pupils but no canthi. The face of the Palaikastro youth is all but destroyed, but its eyes were inlaid, as were those of at least one of the more badly damaged leapers excavated by Evans, whose hollow eye sockets and weathered visage today present a skull-like appearance (Fig. 8.5).[7] At an earlier point in my investigations I

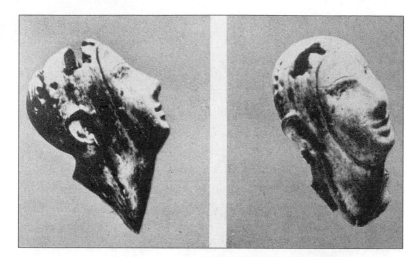

FIG. 8.4 *The best-preserved face excavated with the Ivory Deposit at Knossos in 1902, unlike the Goddess's, is convex in profile and has incised eyes and eyebrows and a slight smile.*

FIG. 8.5 *A battered head excavated with the Ivory Deposit preserves gilt bronze wires for hair and eyes hollowed as if for inlay.*

thought that the "modern" face of the Boston Goddess might be the result of recarving a similarly weathered ancient head, the problematic "natural" deep-set eyes perhaps being the remains of cavities for inlay. The face in modern times is considered to convey a figure's character, but that was not the case in antiquity, when pose and attributes were most important. (The sculptor Mark Moak, restorer of the Palaikastro statuette, told me he was sorely tempted to provide his damaged figure with a face.)

A badly damaged, illicitly excavated figure could be made more

valuable by the addition of gleaming gold ornament. Dorothy Kent Hill believed that the "weathered" ivory core of the larger ivory statuette in Baltimore was ancient, even if it had been improved with added gold. She further suggested that that Snake Goddess had been "enhanced" by the creation of its smaller, perfectly "preserved" companion.[8] It is possible that the Boston Snake Goddess and her counterpart in Baltimore, whose poses so closely parallel those of the faience figures excavated and restored by Evans, are neither entirely genuine nor fully fake but rather something in between, pastiches of ancient artifacts reworked by modern restorers to make them more appealing to contemporary viewers and buyers, like some of the Tanagras that preceded them in popularity. But given what we know of these statuettes and the circumstances in which they came to light, how can we determine if any of them dates back before the beginning of the twentieth century?

Richard Seager cited the fine carving of the Boston Goddess's well-preserved left arm, but, as I noted above, its carving is not nearly as detailed as that of the excavated material. While such stylistic judgments may be subjective, examination of the techniques used to assemble the various components of the statuette may be more revealing. The Boston Goddess's preserved arm, significantly, is attached to her body by means of a dovetail-in-slot join (Fig. 1.11), a technique common in Egyptian, but not in Cretan, ivories. The unequivocally ancient ivory components that have been excavated on Crete were assembled by other means: round, circular, and triangular dowels, tenons, pins, and mortises (Fig. 2.15e and f; Fig. 7.1). While the Goddess's composite construction is certainly more complex than that of the other problematic figures, none of the excavated statuettes exhibits anything as crude as the large vertical protrusion at the join in the Goddess's skirt, which is cut horizontally rather than on the diagonal in line with the flounces of her skirt (Figs. 1.11 and 1.12). Caskey identified what he thought was an ancient repair — an ivory dowel inserted below the Goddess's left shoulder blade from behind (Fig. 1.11). (The lower part of the battered Baltimore Snake Goddess is also held

together by ivory dowels.) The dowels of the excavated statuettes, however, were of wood. Ancient craftsmen didn't waste precious imported ivory where it wouldn't be seen.

Some scholars have pointed out the Boston Goddess's lack of wide hips and protruding buttocks, features that give authentic Minoan female figures in other media a characteristic hour-glass shape. Caskey explained this lack as a result of the loss of ivory. Unlike most of the unprovenienced figures, the Boston Goddess has lost much of her original surface, thus excusing, perhaps, the absence of anatomical detail apparent on the genuine figures. Examining the Goddess some years ago, the former curator of prehistoric art at the National Archaeological Museum in Athens, Agnes Sakellariou, noted what she thought were wear marks over the horizontal striations of the garment on the Goddess's left hip, as if the statuette had been repeatedly carried in some ritual, a detail she thought would never occur to a forger. But if the ivory had worn away to the degree that the Goddess had lost her round hips and buttocks, how could the grooves of the flounces still be visible? Woolley, moreover, reported that the forgers dipped their ivories in acid. This treatment, depending on the strength of the solution and duration of immersion, could dull some features to the degree seen on the Boston Goddess rather than obliterate them, as seems to have happened to the Baltimore statuette.[9]

—⚬—

Further contradictions in the details of imagery, construction, and appearance of the Boston Goddess (and, indeed, the other statuettes) might be enumerated but are unlikely to convince anyone who has made up his or her mind — in either direction. Thus Science is often enlisted as a magic bullet to solve such problems, for it is deemed to be entirely objective. Yet Science is unlikely to be of much help in this case, for a variety of reasons.

Because ivory is an organic material, it can be dated by radiocarbon tests that measure the amount of time that has elapsed since

the death of the living tissue. Carbon-14, a radioactive isotope, is produced by the interaction of nitrogen in the earth's stratosphere with neutrons generated by cosmic radiation. Incorporated in carbon dioxide, carbon-14 is distributed evenly throughout the atmosphere and absorbed by all living things. After the death of organic tissue, the carbon-14 in it decays at a known rate (its half-life is approximately 5568 years). Thus, by measuring the diminution of the isotope, organic materials can be dated within a reasonable margin of error.[10]

Carbon-14 tests, however, require the extraction and destruction of small samples of an artifact, which museums are understandably reluctant to allow, and the tests can produce inaccurate results. Samples contaminated by modern conservation materials — especially organic ones such as the animal glue, beeswax, and paraffin with which the Cretan ivories were suffused by early restorers — can yield erroneous dates, despite the best efforts of labs to cleanse them. But even if the results are not compromised by contamination, the tests can date only the raw material, not the finished product. Cretan forgers are alleged to have reused ancient ivory illicitly recovered from archaeological sites, and although most ancient ivory from Crete is in poor condition, at least one example of a genuine Minoan artifact recut in modern times has been identified.[11] Thus a Bronze Age date for the Goddess's ivory would be no guarantee of her authenticity, especially because she passed through the hands of the Gilliérons, who worked closely with Cretan workmen reported to have siphoned off ancient material. On the other hand, in the case of a composite figure, a modern date, even if not the result of contamination, can also be less than conclusive. Enthusiasts for a piece can claim that although some part of the figure might be shown by testing to be modern, other parts could still be ancient.

These problems notwithstanding, carbon-14 tests have been undertaken on three of the unprovenienced statuettes: the two Boy-Gods formerly owned by Arthur Evans and the Boston Goddess. According to analyses conducted by the Radiocarbon Accelerator Unit

of the Research Laboratory for Archaeology and the History of Art at Oxford University, the ivory of the Boy-God that Evans donated to the Ashmolean Museum (Fig. 4.13) was so modern that its result was off the calibration curve: it was estimated to be 230 ± 50 years old.[12] As Minoan art was virtually unknown before 1900, the carving itself must be at least a hundred years more recent than the ivory.

Tests on a sample taken from Evans's favorite "Boy," now in Seattle (Fig. 4.6), initially indicated that its ivory is about five hundred years old, a date far too recent for an original of the Aegean Bronze Age but surprisingly old for an early twentieth-century forgery. Of course, ivory was traded long before the Renaissance, and massive stores of older material were later gathered in commercial centers such as London and Antwerp and also made their way to the Mediterranean. Further analysis of these radiocarbon results and closer examination of the remaining portion of the sample, however, indicated that the odd date probably resulted from contamination. Scientific data, no less than stylistic features, are subject to varying interpretations.[13]

A strikingly similar date, of 420 ± 50 years before the present, was obtained from tests of ivory samples conducted on behalf of the Museum of Fine Arts by Beta Analytic, Inc., of Miami, Florida. If that date is correct, the ivory cannot be Minoan. But the similarity to the test results of the Seattle "Boy" suggests to me that contamination might be a factor here too, although the lab and the museum are confident that the results are valid (see Appendix 3). In any case, the sample was *not* taken from the Goddess but from fragments *thought* to belong to the Goddess that were stored in Caskey's green soap tin. These were more readily available and, not having been incorporated into earlier restorations, were considered less likely to be contaminated.

Gold, in contrast to ivory, cannot be tested for age, but its composition can be analyzed and compared to that of other pieces from different eras. In 1959 William J. Young reported that qualitative x-ray fluorescence analysis of remnants of the Boston Goddess's damaged

(right) snake revealed "high" gold content, "low" silver and zinc, "medium" copper, and a "trace" of iron.[14] Nondestructive *quantitative* analysis in 1998 of three of the gold bands decorating the Goddess's flounces yielded more precise results (see Appendix 3). Normalized to 100 percent, they are gold, 91.2 percent; silver, 4.1 percent; and copper, 4.7 percent.

Few analyses of excavated Minoan gold are available for comparison, but other samples of Aegean goldwork in the Museum of Fine Arts (albeit also unprovenienced) have a considerably higher silver content than the Snake Goddess's gold, and their composition is consistent with other Bronze Age gold objects from the eastern Mediterranean, including some pieces excavated at Mycenae. As there are no known sources of gold on Crete, the Minoans are likely to have imported the metal from Egypt, Anatolia, or the Greek mainland, though it could have come from Italy or still farther afield. Most of the gold objects from Eighteenth Dynasty Egypt (circa 1550–1292 B.C.), analyses of which are reported by Lucas and Harris in their standard handbook *Ancient Egyptian Materials and Industries,* also contain more silver than the Snake Goddess's flounces and considerably less copper, as do recently analyzed fragments of gold foil from first-millennium-B.C. Sardis, a metal-working center in western Anatolia. In fact, according to Jack Ogden, an expert in ancient Mediterranean jewelry and metallurgy, "as a rule of thumb, copper levels in gold were nearly always lower than the silver levels — a fact true for most of the ancient world up to, and including, Roman and Byzantine times." Furthermore, in Egypt, where the metal was relatively plentiful, purity levels above 90 percent became common only in the Late Period (circa 525–332 B.C.). According to Ogden, "High purity gold has sometimes been employed for the ubiquitous fakes of Egyptian gold objects, some dating back well before World War I; some authorities in the past have even erroneously assumed that high purity was a positive sign of antiquity."[15]

Yet there are always exceptions, and thus Science, our own modern myth, does not provide a solution to our mystery, although it

does seem to cast further doubt on the authenticity of the Boston Goddess.

<center>——◦◦◦——</center>

Although absolute proof for or against the authenticity of the Goddess is elusive (and probably illusive), the combined evidence of history, style, imagery, technique, and science suggests that she, like the fifteen other unprovenienced "Minoan" statuettes presented in these pages (all but two of them goddesses), is a modern work. But that does not mean that the Goddess is without value, or even that she should be removed from display. When I began my investigations of the statuette over a decade ago, an assistant in the Classical Department of the Museum of Fine Arts suggested to me that it really did not matter if the Goddess was a forgery — a modern piece presented as genuine to an unwary public — for she "had introduced generations of Bostonians to the glories of Minoan civilization." Since 1914, when Seager "dragged" her across the Atlantic, the Boston Goddess has shaped our perceptions of Cretan prehistory and, indeed, of the origins of Western civilization. She has provided a canvas on which archaeologists and curators, looters and smugglers, dealers and forgers, art patrons and museum-goers, feminists and spiritualists, have painted their preconceptions, desires, and preoccupations for an idealized past.

Neither she nor her unprovenienced counterparts can any longer be employed as evidence for Aegean Bronze Age art, religion, or culture, but they can nonetheless serve as important historiographical documents. For they reflect the mentalities of early investigators of Minoan Crete and those who have followed in their footsteps, and thus provide valuable lessons in the subjectivity of historical reconstruction.

For those who continue to hope that the Boston Snake Goddess is not entirely a modern construct — that she might contain within her some genuine Minoan kernel — the best comfort that can be offered, given the present state of knowledge, is that the bulk of her, like

FIG. 8.6 *Architect Theodore Fyfe (upper left) with local workmen at Knossos, circa 1901.*

so much of what we see at Knossos today, *was* fashioned by skilled Cretan craftsmen — not those who served the ruling elite of the second millennium B.C., but rather those who catered to different patrons three and a half millennia later (Fig. 8.6).

APPENDICES

NOTES

BIBLIOGRAPHY

ACKNOWLEDGMENTS

ILLUSTRATION CREDITS

INDEX

APPENDIX 1

The Cast of Characters

BACHOFEN, JOHANN JAKOB (1815–87): Swiss jurist; author of *Das Mutterrecht* (1861).

BLEGEN, CARL (1887–1971): American archaeologist; secretary, assistant director (1913–26), and director (1948–49) of the American School of Classical Studies at Athens; professor of archaeology at the University of Cincinnati; excavator of numerous Aegean Bronze Age sites, including Troy (1932–38) and Pylos (1939, 1952–65).

CASKEY, LACEY (1880–1944): American archaeologist; member and secretary of the American School of Classical Studies (1902–8); assistant curator (1908–12) and curator (1912–44) of the Classical Department, Museum of Fine Arts, Boston.

EVANS, SIR ARTHUR (1851–1941): English archaeologist; keeper of the Ashmolean Museum, Oxford (1884–1908); excavator of the Palace of Minos at Knossos (1900–41).

FAIRBANKS, ARTHUR (1864–1944): American archaeologist; director of the Museum of Fine Arts, Boston (1907–25).

FITZ, HENRIETTA G. (1847–1929): née Henrietta Goddard Wigglesworth; married to Edward Jackson Holmes (1871) and subsequently to Walter Scott Fitz (1888); major donor to the Museum of Fine Arts, Boston; mother of Edward Jackson Holmes, Jr.

FRAZER, SIR JAMES G. (1854–1941): English classicist; author of *The Golden Bough* (1890) and *Adonis, Attis, and Osiris* (1906).

GARDNER, ERNEST A. (1862–1939): English archaeologist; director of the British School at Athens (1887–95); Yates Professor of Classical Archaeology, University of London (1896–1929).

GILLIÉRON, ÉMILE, *PÈRE* (1850–1924): Swiss artist and restorer of antiquities; resident in Athens 1876–1924; active on Crete, especially at Knossos.

GILLIÉRON, ÉMILE, *FILS* (1885–1939): Swiss artist and restorer of antiquities, son of Émile *père.*

HALBHERR, FEDERICO (1857–1930): Italian archaeologist and epigrapher; director of the Italian Archaeological Mission to Crete; excavator of Gortyna, the Idaean Cave, Phaistos, and other Cretan sites.

HARRISON, JANE (1850–1928): English classicist; author of *Prolegomena to the Study of Greek Religion* (1903).

HATZIDAKIS, JOSEPH (1848–1936): Greek archaeologist; trained as a physician; founding member and president of the Cretan Syllogos; founder and director of the Candia (Herakleion) Archaeological Museum; codirector of Cretan Antiquities with Stephanos Xanthoudides.

HAWES, HARRIET BOYD (1871–1945): American archaeologist, excavator of Kavousi, Gournia, and other sites in eastern Crete (1900–1905).

HILL, BERT HODGE (1874–1958): American archaeologist; assistant curator, Museum of Fine Arts, Boston (1903–6); director, American School of Classical Studies (1906–26).

HOGARTH, DAVID G. (1862–1927): English archaeologist; director of the British School at Athens (1877–1900); early collaborator with Arthur Evans at Knossos; keeper of the Ashmolean Museum (1908–27).

HOLMES, EDWARD JACKSON, JR. (1873–1950): director (1925–34) and president (1934–50) of the Museum of Fine Arts, Boston; son of Henrietta G. Fitz and her first husband, Edward Jackson Holmes.

KALOKAIRINOS, MINOS (1843–1907): Cretan merchant and archaeologist; member and treasurer of the Cretan Syllogos; first excavator of Knossos (1878–79).

KARO, GEORG (1872–1963): German archaeologist; assistant director

(1905–10) and director (1912–20, 1930–36) of the German Archaeological Institute, Athens.

LEVI, DORO (1898–1991): Italian archaeologist; excavator of Phaistos and other Cretan sites (1949–67); director of the Italian Archaeological School at Athens (1947–77).

MACKENZIE, DUNCAN (1861–1934): Scottish archaeologist; assistant to Arthur Evans at Knossos.

SANDWITH, THOMAS B. (1831–1900): British consul to Crete; collector of antiquities.

SCHLIEMANN, HEINRICH (1822–90): German archaeologist, self-made millionaire; excavator of Troy (1870–73, 1878–79, 1882, 1890), Mycenae (1874, 1876), and other Bronze Age sites.

SEAGER, RICHARD BERRY (1882–1925): American archaeologist, excavator of Mochlos, Pseira, Gournia, and other sites in eastern Crete (1903–25).

SELTMAN, CHARLES (1886–1957): English archaeologist and antiquities dealer, fellow of Queen's College, Cambridge.

XANTHOUDIDES, STEPHANOS (1864–1928): Greek archaeologist; founding member of the Cretan Syllogos; codirector of Cretan Antiquities with Joseph Hatzidakis.

APPENDIX 2

SOME UNPROVENIENCED CRETAN STATUETTES

The names of the statuettes and the figure numbers are those used in this book.

IVORY

BOSTON SNAKE GODDESS, Museum of Fine Arts 14.863; 6 5/16 in. (16.1 cm), said to be from the Ivory Deposit in the Palace of Minos at Knossos. Frontispiece, Figs. 1.1, 1.11, 1.12, 8.3.

BALTIMORE SNAKE GODDESS, Walters Art Gallery, Baltimore, 71.1090, ex-Feuardent; 8 1/2 in. (21.5 cm), said to be from the Palace of Minos at Knossos. Figs. 4.2, 4.3, 4.4.

"CHESS QUEEN," Walters Art Gallery, Baltimore, 71.1091, ex-Feuardent, 4 1/8 in. (10.4 cm), said to be from the Palace of Minos at Knossos. Fig. 4.5.

SEATTLE BOY-GOD, Seattle Art Museum 57.56, ex-Hirsch, ex-Evans, ex-Feuardent; 6 7/8 in. (17.5 cm), said to be from the Ivory Deposit in the Palace of Minos at Knossos. Figs. 4.6, 4.7, 4.8, 4.9.

OXFORD BOY-GOD, Ashmolean Museum 1938.692, ex-Evans; 4 7/8 in. (12.5 cm), said to be from southern Crete. Figs. 4.13, 7.11.

OUR LADY OF THE SPORTS, Royal Ontario Museum, Toronto, 931.21.1, ex-Seltman, ex-Feuardent; "preserved" to 7 in. (17.8 cm), believed to come from Knossos. Fig. 4.14.

SNAKE GODDESS, whereabouts unknown, ex-Simiriotti, ex-Jonas; about 10 7/8 in. (28 cm). Fig. 7.9.

MINOAN GODDESS, whereabouts unknown, ex-Simiriotti, ex-Jonas, only head "preserved"; about 2 in. (5.5 cm). Fig. 7.9.

SNAKE GODDESS, whereabouts unknown, ex-Floros, ex-Mladek; height unknown. Fig. 7.10.

MINOAN GODDESS, private collection, New York; 4 5/8 in. (11.7 cm). Fig. 7.11.

STONE

FITZWILLIAM GODDESS, Fitzwilliam Museum, Cambridge, GR 1.1926, ex-Seltman, ex-Feuardent; 8 7/8 in. (22.7 cm), said to be from the harbor town of Knossos. Fig. 4.12.

CAMBRIDGE SNAKE GODDESS, Museum of Classical Archaeology, Cambridge University, 450, ex-Ritsos; 11 7/8 in. (30.3 cm), said to have been found "near Knossos." Fig. 7.4.

SNAKE MOTHER, whereabouts unknown; 15 3/4 in. (40 cm), said to be from Knossos. Fig. 7.5.

MINOAN GODDESS, whereabouts unknown, 14 in. (36 cm), said to be from Knossos. Fig. 7.6.

TYLISSOS GODDESS, Ashmolean Museum, 1938.693, ex-Evans, 3 5/8 inches (9.2 cm), said to be from Tylissos. Fig. 7.8.

SNAKE GODDESS, Walters Art Gallery, Baltimore, 23.196a+b, ex-Gruel, ex-Simiriotti, ex-Jonas; 10 7/8 in. (27.7 cm). Fig. 7.9.

TERRA COTTA

SNAKE GODDESS, whereabouts unknown; 6 7/8 in. (17.5 cm), said to be from the harbor town of Knossos. Fig. 7.7.

BRONZE

YOUTH, National Archaeological Museum, Athens, 6284; 9 in. (23 cm), acquired from a customs agent at Piraeus, said to be from Crete. Fig. 4.11.

APPENDIX 3

Analytical Report on the Ivory Snake Goddess

MFA Accession Number 14.863, Attributed to the
Late Minoan Period, 1600–1500 B.C.

by RICHARD NEWMAN
Head of Scientific Research, Museum of Fine Arts, Boston

INTRODUCTION

For many years, doubts have been expressed regarding the authenticity of the "snake goddess" in the collection of the Museum of Fine Arts, Boston. The only previous scientific analyses of the object were qualitative nondestructive x-ray fluorescence analyses of some of the gold attachments that were carried out in 1959.* This report presents results of radiocarbon dating of some ivory fragments associated with the snake goddess and electron microprobe analysis of samples from three of the gold attachments. The conservation history of the object will also be briefly reviewed in this report, since the history has some bearing on the scientific tests that were carried out and interpretation of the results.

CONDITION AND RESTORATIONS

Two major restorations have been carried out on the object, but no written record has been left by the persons responsible for either of

* All information on the 1914–15 restoration is based on L. D. Caskey, "A Chryselephantine Statuette of the Cretan Snake Goddess," *Journal of the Archaeological Institute of America* 19 (1915): 237–49.

the campaigns. Photographic documentation of the snake goddess's condition on arrival at the museum was published in 1915, along with brief notes on how it had been restored at the museum before it was exhibited. The photograph, however, was taken after "several fragments" had been separated in order that they "could be handled." So apparently the object as it actually came into the museum was not in as many separated pieces as shown in the photograph. The restoration at the museum was carried out by Paul Hoffmann. According to the publication, the fragments were impregnated with paraffin and then put back together. The fragments so impregnated appear to have been all the parts of the body, and perhaps also the surviving arm. This arm (the proper left one) was then put back in place, and a replacement right arm made from plaster. The tail part of the snake held in this new arm is also a restoration, which was made from lead plated with gold. The missing portions of the lower part of the skirt were filled out with wax. The 1915 publication notes that the "original tip of the nose which had flaked off was discovered by the repairer among the numerous tiny fragments of ivory and replaced, adding greatly to the individual character of the profile." Aside from the tail of the one snake, all of the gold pieces on the statuette came to the museum along with the ivory fragments of the object, as can be confirmed by the 1915 before-restoration photograph. Only the largest fragments of the statuette were documented in the photograph. The statement just noted indicates that along with the larger pieces were "numerous [other] tiny fragments," but exactly how many is not known. The statuette was made in several pieces, and the 1915 article describes these in some detail, their manner of attachment to each other, as well as discussing the metal parts and how they attached to the body. The article states that the hole drilled in obliquely from behind at the left side of the figure, then pinned with a piece of ivory, was an early repair made while "the statuette was still in use."

The second restoration of the statuette was carried out by William Young. A 1969 article reports that this restoration was carried out during the decade following its arrival in Boston, that is, during

the 1920s. Young, however, did not arrive at the museum until 1929, and in a recent conversation stated that he carried out the restoration in the early 1930s. There are no notes from the time of Young's work on the statuette. However, he stated recently that he took the object apart, removed animal glue that had been used to adhere the pieces together (presumably this glue had been applied by Hoffmann), and then impregnated the object with wax.* He re-created the missing lower part of the skirt in plaster. He may have reattached the earlier reconstructed proper right arm. Young also created a new tail part for the snake held by this arm. Recent x-ray fluorescence analysis shows that this new part was made from copper metal that has been gilded.

A few minor local treatments have been carried out since that time.** Basically, however, the snake goddess as we see it today is as it was after Young's restoration over sixty years ago. The Art of the Ancient World department has a metal box in which fragments are housed that are supposed to come from the "snake goddess."† The box itself originally held tubes of "Savon Kaloderma à base de Glycerine et Miel," manufactured by "F. Wolff & Sohn, Parfumeurs, Karlsruhe, Baden." The box contains hundreds of pieces of ivory, some very small slivers, a few up to about three centimeters in length.

* Comments on William Young's treatment were based on a 1997 conversation by Robert Ogilvie with Young and his wife, Florence, who worked with him in the museum during the time he treated the object.

** The conservation file on the object notes two treatments to readhere the slightly loosened snake head in the proper right hand. The first (in 1982) was done with PVA adhesive, the second (in 1983) with microcrystalline wax. In 1998, after the present examination, this snake head was again readhered. The end of one of the gold bands around the skirt had also become loosened and was readhered with a dilute solution of a synthetic resin.

† The fragments are currently housed in two smaller boxes within the larger tin. One is an old wooden box that originally had a lid (now missing) that slid into a slot along the top. The other is a more recent cardboard Dennison "parchment key tag" box. The latter contains fragments that are considered to have possibly come from the lost proper right arm. Most of the larger fragments are in this cardboard box, and it is some of these that were utilized for the radiocarbon dating.

In summary, it would appear that the major fragments of the snake goddess may have been impregnated with wax twice. The smaller fragments do not appear to have been so treated during either restoration campaign.

RADIOCARBON DATING

The most direct, and theoretically most definitive, scientific method for authentication of an artifact of this kind is radiocarbon dating. However, treatments with organic adhesives can seriously affect the results of such dating. The infusion of wax, and possibly glue, into the major ivory pieces makes the application of the dating technique to these parts of the object problematic, even assuming that a suitably large sample could be obtained. Because of these considerations, we picked several of the smaller ivory fragments for dating. Visual examination, combined with Fourier transform infrared (FTIR) microspectroscopy analysis of surface and interior scrapings of a number of these fragments, gives no indication that the ones selected for analysis have been treated, so contamination from this source can be considered negligible.* The drawback, however, is that there is no positive proof that these fragments were originally part of the snake goddess. Even if from the same site, the pieces could have come from another ivory artifact (or even more than one other artifact). It is also not guaranteed that the ivory pieces tested would necessarily have dated to the same period. Of course, if indeed the goddess is authentic, and the fragments were recovered at the same time as the pieces of the goddess, presumably they would have all dated to the same period. In this scenario, the radiocarbon date for the ivory could be assumed to be about that of the carving of the goddess, since

* Small scrapings were taken with a scalpel from the surfaces and interiors of several of the ivory pieces. A portion of each sample was placed in a few drops of methylene chloride. The ring of material left after evaporation of the solvent was analyzed by Fourier transform infrared (FTIR) microspectroscopy. No evidence of wax was detected in these analyses. Had the fragments been impregnated with wax in the same manner that the ivory pieces in the reconstructed figure itself have been, this analytical procedure would have readily indicated that.

relatively "fresh" ivory would have been utilized by the artist who carried out the carving.

A sample, consisting of several fragments weighing a total of about 800 milligrams, was analyzed by accelerator mass spectrometry. The calibrated radiocarbon was determined to be either between 1420 and 1535 or between 1545 and 1635.* Obviously this date is an unexpected result, for which there is no simple obvious explanation. We feel that contamination was not a problem. And while the sample was small, the lab that carried out the sample preparation felt that this did not introduce any inaccuracy in the results. If the snake goddess is a forgery, it would in all likelihood have been carved around the time of its presumed discovery, between 1900 and 1914, or about one hundred years ago. One explanation for the date is that the carving was carried out using an old piece of ivory, perhaps because it already was somewhat deteriorated and would have more easily passed for an object of Minoan date than would a piece made from new ivory. Another possible explanation is that the ivory dated did not originally belong to the snake goddess itself, and possibly was not even found in the exact same place as the snake goddess, so the date is not relevant to the question of the snake goddess's authenticity. Unfortunately, neither scenario, nor others that could be suggested, can be ruled out. The dating does, however, cast some doubt on the authenticity of the piece, but cannot under the circumstances be considered proof one way or the other.

Obviously, radiocarbon dating of a piece of ivory from one of the main carved parts of the figure would remove a number of the problematic aspects of the analysis that was carried out for this re-

* The dating was carried out by Beta Analytic, Inc. (Miami, Florida). The reported conventional radiocarbon age was 420 ± 50 before present (BP). The calibrated results, with 95% probability, are A.D. 1420–1535 or 1545–1635 (the age could fall in either of these two ranges). The C_{13}/C_{12} ratio was 16.4 (relative to PDB-1). The sample, which consisted of several small fragments, weighed about one gram. It was prepared by standard collagen extraction procedures, including an alkali wash to ensure absence of secondary organic acids.

port. However, as already noted, the treatment of these pieces with wax may make this impossible. The head of the lab that carried out the sample preparation for the radiocarbon analysis said that in the case of bone that has been treated by impregnation, they discard the portion that has been impregnated and only carry out the dating on material into which none of the impregnating material has penetrated; they feel that it is not entirely possible to remove impregnating materials with solvents. Since the principal pieces of ivory that were put together to form the body of the snake goddess are relatively large, it is possible that they are not impregnated throughout by wax. This could only be determined by disassembling the object and carefully examining the individual pieces. If the fragments are not entirely impregnated, it might be possible to take a sample large enough for radiocarbon dating with a small core drill, drilling in from the inner surface of one or more of the major fragments (these surfaces do not include any of the carved image).

GOLD COMPOSITION

Three small samples were taken with a scalpel, mounted in epoxy resin, and polished as cross sections. These were analyzed in an electron-beam microprobe for gold, copper, and silver content.* The table on page 202 summarizes the results.

Notable about these results is that the three samples have virtually identical compositions: it is possible that all three came from

* The samples were mounted in Buehler Epoxide resin, polished and coated with carbon for analysis. The analysis was carried out on a Cameca MBX microprobe equipped with a Tracor Northern 1310 wavelength-dispersive x-ray fluorescence system and stage automation and Tracor Northern 5500 energy-dispersive x-ray fluorescence system. Pure metal standards were utilized and matrix corrections carried out by the ZAF (fundamental parameters) method. These results were then corrected by an empirical correction procedure developed by David Lange of the Harvard University Department of Earth and Planetary Sciences. This program, which uses the original data and calibration curves prepared from analysis of NIST gold-silver microprobe standards, gives more accurate results for alloys containing gold, silver, and copper than does the ZAF program alone.

SAMPLE AND SITE (POINT NO.)	GOLD (WT.%)	COPPER (WT.%)	SILVER (WT.%)	TOTAL (WT.%)
1. Top gold band around skirt				
(1)	88.7	4.55	4.14	97.4
(2)	89.2	4.51	4.16	97.9
(3)	89.4	4.64	4.06	98.1
(4)	90.0	4.27	4.22	98.5
(5)	90.3	4.60	3.99	98.9
Average of five points[1]	89.5 (0.6)	4.51 (0.14)	4.14 (0.07)	98.2 (0.6)
2. Gold band around skirt, second from top				
(1)	90.3	4.72	4.09	99.1
(2)	90.1	4.71	3.98	98.8
(3)	90.4	4.82	3.93	99.2
(4)	89.4	4.86	4.06	98.4
(5)	91.0	4.57	4.12	99.7
Average of five points[1]	90.2 (0.6)	4.74 (0.11)	4.04 (0.08)	99.0 (0.5)
3. Gold band around skirt, fourth from top (bottom band)				
(1)	90.2	4.84	3.96	99.0
(2)	90.6	4.74	3.99	99.4
(3)	90.4	4.71	4.05	99.2
(4)	91.1	4.63	4.10	99.8
(5)	91.2	4.48	4.08	99.8
(6)	89.0	4.37	4.06	97.5
Average of six points[1]	90.4 (0.8)	4.63 (0.17)	4.04 (0.05)	99.1 (0.8)

1. Standard deviations given in parentheses.

one batch of metal. Normalized to 100%, the composition is about 91.2% gold, 4.7% copper, and 4.1% silver. If this gold is ancient, it almost certainly was an intentional alloy of gold and copper, since the copper content of native gold usually is less than 2%. The gold utilized could have been native gold that had a low silver content (around 4%). There seems to be virtually no published information on ancient Minoan gold alloys, so it is not known whether the composition found is typical or not.* Copper was reportedly intentionally alloyed with gold as far back as the ancient Egyptian period, so there is no reason to conclude that such an alloy would not have been possible in the Minoan period.

It should be noted that although the gold could be ancient, it could also be a modern alloy made from pure gold, silver, and copper. Possibly trace element analysis, which some researchers have begun to carry out on ancient gold, could provide additional information that would bear on this question.

SUMMARY

Both radiocarbon dating of the ivory and general compositional analysis of some of the attached gold pieces have not provided conclusive evidence on the question of the authenticity of the snake goddess.

Radiocarbon dating of some fragments of ivory associated with

* Naturally occurring gold almost always contains some silver, although the relative amount can be quite variable. It is generally thought that gold used during the Bronze Age would not have been refined. (For gold refining, see A. Ramage and P. Craddock, *King Croesus' Gold: Excavations at Sardis and the History of Gold Refining* [London: British Museum Press, 2000].) Thus, depending on the source of the raw materials, the gold used in ancient Crete would be expected to contain at least some silver. The relatively low silver content in the three analyzed samples (a little over 4%) is not lower than has been found in some European Bronze Age gold artifacts (see, for example, G. Lehrberger, J. Fridrich, R. Gebhard, and J. Hrala, eds., *Das Prähistorische Gold in Bayern, Böhmen und Mähren: Herkunft — Technologie — Funde*, Band I (Prague: Institute of Archaeology, 1997).

the snake goddess gave a date of several hundred years, nearly three thousand years too young for the ancient Minoan period to which the object has been attributed. This suggests that the object is not authentic. However, there are some problems with the dating, as discussed above, and this analysis cannot be considered proof that the object is either genuine or a forgery.

Analysis of gold from three of the skirt bands showed that they were likely made from a single batch of metal. The alloy could be a mixture of native gold and copper. Since there is little comparative information on ancient Minoan gold compositions, it cannot be determined whether this alloy is consistent with the attribution or not.

5 May 1998 (revised 12 October 2001)

Notes

ABBREVIATIONS

EA The Evans Archive Department of Antiquities, Ashmolean Museum, University of Oxford.

LIMC *Lexicon Iconographicum Mythologiae Classicae*. 8 vols. (1980–1999) plus indexes. Zurich.

MFA The Museum of Fine Arts, Boston.

PM Arthur J. Evans. *The Palace of Minos: A Comparative Account of the Successive Stages of the Early Cretan Civilization as Illustrated by the Discoveries at Knossos*. 4 vols. (1921, 1928, 1930, 1935), plus *Index* (1936) compiled jointly with Joan Evans. London.

PROLOGUE

1. Becker and Betancourt 1997: 177–78. Candia, now Herakleion, located midway along the north coast of Crete, is the largest city on the island. The local Greeks knew it as Megalokastro, "Great Fortress"; the Arabs called it Rhabdh-al-Kandak, after a trench dug around it in the early ninth century. The Byzantines, who liberated the city in the mid-tenth century, shortened the name to Khandax, and the Venetians, who occupied it from 1210 to 1669 before surrendering it to the Turks, knew it as Candia. The city was rechristened Herakleion (after its ancient Roman name, *Heracleum*) in 1898, when Crete gained independence from the

Ottoman Empire. The name Candia was still used, however, in the early years of the twentieth century.

2. J. Evans 1943: 379.
3. Ibid.

1. THE BOSTON GODDESS

1. Caskey 1915a: 93.
2. Caskey, who joined the museum in 1908, was promoted to curator in 1912, the same year he received his Ph.D. from Yale, replacing Arthur Fairbanks, also an expert on ancient Greek art, who had since 1907 administered the museum as well as the Classical Department: Whitehill 1970; Dyson 1998: esp. 127–57.
3. For chryselephantine statuary in general, see Lapatin 2001.
4. For Caskey's career, see Lord 1947: 112–14, 372, 376; Whitehill 1970: 174, 301, 374. Caskey's assessment of the Goddess: Caskey 1914; 1915a.
5. "Most refined," Whitehill 1970: 376. "Pose is strictly frontal," Caskey 1915b: 237; compare Caskey 1914: 54.
6. For the preserved correspondence between Fairbanks and Mrs. Fitz, in the archives of the MFA's Department of Art of the Ancient World, see Lapatin 2000b.
7. For Mrs. Fitz and her family, see *Massachusetts Biographical Dictionary* 1998: 2: 554–55; Howe 1939: 56–57; Small 1962: 50, 142, 157; Hoyt 1979: 230, 242, 261; Whitehill 1970: esp. 876.
8. For values of artworks, see Smyth 1913–14: 552 and passim. Praise for the Knossos exhibit: *Speaker,* 3 Jan. 1903; *Globe,* 13 Feb. 1903; *Builder,* 31 Jan. 1903; Hogarth 1903; *Globe,* 2 July 1904.
9. *New York Times,* 23 May 1944: 23:3 (Caskey obituary); Whitehill 1970: 409–10.
10. Quotes are from MFA 1919: 67; Barnett 1982: 35; Vermeule 1982: 33; Palmer 1962: 10–11; Cheney 1968: 29; Seltman 1927: 118; Van Rensselaer 1916: 551; Burn 1930: 93; Matton 1955: 102; Faison 1958: 86, 157; Vaughan 1959: 142; Woodhouse 1976: 26; Pickman 1969: 242; and Davenport 1948: 43–44.

11. Although initially restored by Paul Hoffmann, the Goddess was disassembled and rerestored, sometime in the early 1930s, by William J. Young, founder of the museum's Research Laboratory and the son of William H. Young, who had worked for Evans as *formatore* at the Ashmolean Museum and who later restored one of the ivory Boy-Gods in Evans's private collection. For accounts of these restorations, see Caskey 1915b: 239 n.1; Whitehill 1970: 484–88; Evans 1930: 439 n.4, 444 n.1; Comstock and Vermeule 1969: 13; Eisenhart 1969: 68; and Appendix 3. The 1996 Art in Bloom flower arrangement was described on a label affixed to the statuette's podium. The quote is from the handout "Garden Club Arrangers' Interpretations."

12. Lerman 1967: 103.

13. On provenience and provenance, see Coggins 1998; Chippindale and Gill 2000. "According to information," Caskey 1915b: 237.

14. Robinson 1915: 211. For other statements on the Goddess's origin, see obituary of Harriet Boyd Hawes 1945: 203; Kardara 1960: 343 n.4; Pijoán 1946: 473; Vaughan 1959: 142; Barnett 1982: caption to pl. 28; Castleden 1990: 96. For the cave at Arkalokhori, see Owens 1996a: 177. Compare Vermeule 1959; Whitehill 1970: 651–52; Chase and Vermeule 1963: 14–15, fig. 10; Higgins 1997: 142–43; Wohlauer 1999: 60–61. The cave is variously thought to have been sacred to Astarte/Aphrodite, Demeter, or Athena.

15. On looting, past and present, see Meyer 1973; Gill and Chippindale 1993; Watson 1997; Sakellarakis 1998; Chippindale and Gill 2000.

16. J. Evans 1943: 310–11; 316.

17. On unauthorized excavations, see Higgins 1979; A. Brown 1986; Allsebrook 1992: 90, 104; Dyson 1998; Momigliano 1999a: 26–28; MacGillivray 2000: 110–15, 124–25, 139, 144–49; Gill 2000. For Evans's views, see MacGillivray 2000: 43, 54, 110–15, 124–25, 139, 144–49.

18. See Gill 2000: esp. 521–23 for the activities of J. H. Marshall and others, including "a piece of piracy" at Palaikastro in 1901. "The

name of Lord Elgin," EA 0126 of 6 Apr. 1899. "Demand for Greek antiquities," Capps 1899: 88–89.

19. For Greek and Cretan laws, see Capps 1899: 89; see also Allsebrook 1992: 123; Petrakos 1982. Effects on collectors: EA 0085; 0086; 0121; 0126; 0187; 0188; J. Evans 1943: 334; A. Brown 1986; Becker and Betancourt 1997: 72; see also Dyson 1998: 41. For the Aristides case, see Evans 1909: 46; *PM* 3: 438; *PM* 4, pt. 2: 697; Momigliano 1999a: 65, 155–58; Plutarch, *Life of Aristides;* compare MacGillivray 2000: 211.

20. EA 0025; 0130; Powell 1973: 42; Momigliano 1999a: 192; MacGillivray 2000: 225–26.

21. *PM* 1: 507.

22. *PM* 3: 440; see also viii.

23. Ibid.: 437–39.

24. Colin Renfrew on Mackenzie quoted by Momigliano 1999: 5, 23.

25. Obituary of Caskey 1944a; 1944b. Pickman 1969: 242. Whitehill 1970: 376. Caskey 1915b: 239.

26. Comstock and Vermeule 1969: 13.

27. See E.N.H. 1945. Hawes's whereabouts: Allsebrook 1992: 2 (quote), 114, 130–51, esp. 139 (for summer of 1914), 182–88; Whitehill 1970: 387. See also J. Bowman 1991: 6.

28. For Sanborn's career, see Whitehill 1970, esp. 884, and Lord 1947.

29. Caskey's use of tins: M. Comstock, personal communication.

30. Immigration Information Bureau 1931: esp. 165–83. The few ships that sailed from Greece to the United States in those years arrived in New York. Most ships arriving in Boston came from northern Europe — Antwerp, Bremen, Christiania, Glasgow, Hamburg, Liverpool, and Rotterdam — although a few ships of the Italia, Navagazione Generale Italia, and White Star lines came from unspecified "Mediterranean" ports.

31. Unknown reviewer: J 1915. Gardner 1915: 49–50.

32. Van Rensselaer 1916: 551.

33. "Curiously modern": *PM* 3: 440–41; Gardner 1915: 50. "Anglo-

Saxon": Glotz 1925: 397. "European-looking": Barnett 1982: 35. "Victorian": Faison 1958: 86. "Edwardian": S. Hood 1978: 120.

34. Gardner 1915: 50. On Cretans' reputation, see Liddell and Scott 1940: 995; Ovid, *Ars Amatoria* 1.298; Lucan 8.872; Paul, *Epistle to Titus* 1.12. See also Statius, *Thebiad* 1.279; Tertullian, *De anima* 20; Jerome, *Commentary on Galatians* 13, p. 416. In an early example of Cretans' deceit, after an earthquake in the reign of Nero, prehistoric texts were discovered at Knossos and were falsely "deciphered" as a Phoenician account of the Trojan War; see Evans 1909: 108–10; Bennet in Huxley 2000: 129.

35. Caskey 1915b: 237.

2. THE PALACE OF MINOS

1. For accounts of King Minos, see Calasso 1993; "Minos I" (J. Bazant) in *LIMC* 6 (1992); Gantz 1993; and B. C. Dietrich et al. in Hornblower and Spawforth 1996: 987. For Europa, see "Europe I" (M. Robertson) in *LIMC* 4 (1988); Reid 1993: 421–29. For Crete as the site of Zeus's birth and conflicting ancient traditions, see S. Thorne in MacGillivray et al. 2000: 149–62.

2. For the various ancient traditions, see the sources listed above as well as the entries for Pasiphaë, Minotaur, Theseus, Ariadne, Daidalos, and Ikaros in Hornblower and Spawforth 1996 and in *LIMC*.

3. Diodoros Siculus 4.60.2–5. Evans 1883: 438; 1902–3: 111; J. Evans 1943: 392; *PM* 1: 1–3.

4. For Evans's life and training, see J. Evans 1943; McNeal 1974; Horwitz 1981; Harden 1983; A. Brown 1986; 1993; and in Huxley 2000; MacEnroe 1995; Fitton 1996; MacGillivray 2000; Warren 2000. For his interest in early scripts, see also Evans 1909: 8–17.

5. For Calvert, Schliemann, Troy, and Mycenae, see Traill 1995; Duchêne 1996; and Allen 1999. For a discussion of the accusations of forgery, see Calder et al. 1999.

6. For Minos as founder of Gortyna, see Strabo 10: 476–77. For early modern travelers, see Woodward 1949; Paton 1951; and P. Warren

in Huxley 2000. On Belli, see L. Beschi in Di Vita et al. 1984. Perrot quoted by Farnoux 1996: 18.

7. For Sandwith, see S. Hood 1987 (quote is from 91); and Williams 1996.

8. S. Hood 1987: 87.

9. On the popularity of Tanagras, see Higgins n.d.: esp. 27–31, 162–78; Kriseleit et al. 1994. C. A. Hutton 1899: 44.

10. Higgins n.d.: 163–66. See also Kriseleit et al. 1994: esp. 59–70, 71–76.

11. S. Hood 1987: 90.

12. On Tanagra collectors, see Kurz 1967: 144–45. Reinach quoted by Higgins n.d.: 175–76.

13. For Stillman's descriptions of his activities at Knossos, see Stillman 1881: 41, 47–49; 1901: 636.

14. Schliemann quoted by Farnoux 1996: 30–31. "Mahometans": Evans 1899–1900: 5.

15. A. Brown 1983; 1986.

16. For an account of the climate prior to Cretan independence, see Allsebrook 1992. Brown in Huxley 2000 discusses the role of David Hogarth, director of the British School from 1897 to 1900 and thereafter one of the directors, along with Arthur Evans, of the Cretan Exploration Fund, in formulating Cretan antiquities law and acquiring a permit to excavate Knossos. See also Lock 1990.

17. *PM* 1: vi.

18. Ibid.: 2. For the decipherment of Linear B, see Chadwick 1987; Bennet in Huxley 2000.

19. The unearthing of the Throne Room on 13 April is recorded in Evans's 1900 notebook and Mackenzie's first Knossos daybook, both in EA. Evans 1899–1900 is a preliminary excavation report; the throne itself is treated in detail in *PM* 4, pt. 2: 915–19. For the excavations, see also J. Evans 1943: 332; A. Brown 1983: 37–41; Allesbrook 1992: 88; and MacGillivray 2000: 180.

20. For Evans's period designations, see McNeal 1974; Momigliano 1999b.

21. J. Evans 1943: 350.

22. *The Speaker* 3 Jan. 1903.

23. Evans on quality of Minoan ceramics: *PM* 1: 490. Minoan latrines: Clarke cited by Evans in *PM* 1: 228 n.2.

24. Reinach quoted by Farnoux 1996: 105.

25. For the original context of La Parisienne, see Immerwahr 1990; and see Cameron 1964 for additional literature.

26. Pottier quoted by Farnoux 1996: 105.

27. Baudelaire 1964: esp. 13, 34, 36 (secs. 4, 11, 12). For Evans's references to Morris, see Farnoux 1996: 104; see also *Manchester Guardian*, 2 July 1902.

28. *PM* 1: 1, 24. Seager also associated early Cretan finds with Europe rather than Asia; see Becker and Betancourt 1997: 56–57, 64.

29. Duncan at Knossos: Candy 1984: 26.

30. *PM* 1: 1 passim.

31. Evans on the classical standard: MacGillivray 2000: 37, 54, 62, 64, 300. Letter to his father: J. Evans 1943: 345; see also *Saturday Review*, 20 Aug. 1904. Paraphrase of Evans's remarks: *American Journal of Archaeology* 7 (1903): 117.

32. Reports in the popular press: see *Manchester Guardian*, 2 July 1902; *The Architect*, 19 Sept. 1902; *Globe*, 13 Feb. 1903. See also *Journal of Hellenic Studies* 22 (1902): 383; Evans 1901–2: 68–74, esp. 73; *PM* 3: 497–509. The *Globe* of 26 Sept. 1904, however, used another cultural high point for comparison — that of medieval Venice, which had been exalted by John Ruskin, who rejected the Renaissance as corrupt. Other archaeologists' views: Charbonneaux 1929: 20; Pendlebury 1939: 217; Lagrange 1908: 40. For a comparison of the Knossos leapers to more recently excavated Minoan composite ivory figures, see Lapatin 2001.

33. *Scientific American* suppl. 5, 22 Nov. 1902: 22488. Hogarth 1903: 328–29, 332; Mackenzie 1903: 200. For Myron's "particularly famous" bronze heifer at Athens, later taken to Rome, see Pliny the Elder, *Natural History* 34.57; see Overbeck 1868: 103–7 (nos. 550–91) for additional references by ancient authors, many of whom compare Myron's statue to the one that Daidalos made

for Pasiphaë. Evans himself compared the stucco bull's head at Knossos to the Parthenon sculptures in a lecture delivered at the Royal Institution on 8 Feb. 1924 (typescript [p. 7] in EA). For Hogarth's excavations at Knossos and elsewhere on Crete — such as the Cave at Psychro, where he took the unconventional step of using explosives — see Lock 1990; Allsebrook 1992: 97–98; and Huxley 2000.

34. Evans 1902–3: 40.
35. For the restoration of the faience statuette, see Evans, *PM* 1: esp. 500–504 and fig. 362 (here Fig. 2.20), which makes clear the extent of restoration.
36. Evans's notes: Panagiotaki 1993.

3. THE DIVINE MOTHER

1. J. Evans 1943: 93, 94.
2. Changing connotations of Olympian goddesses: R. Hutton 1997: 91.
3. Gerhard 1849. *Das Mutterrecht,* first published in Stuttgart in 1861, has been only partially translated into English; see Bachofen 1967.
4. On Demeter, see, for example, Harrison 1908: 271–72.
5. For recent treatment of the prehistoric female figurines and the tendentious anachronistic interpretations of them, see Ucko 1996; R. Hutton 1997; and esp. Goodison and Morris 1998.
6. *PM* 1: 45–52 (quote); *PM* 4, pt. 2: 427–29. For Evans's notes from 1900, see also MacGillivray 2000: 184–85. *PM* 3: 457, 466.
7. Harrison 1908; quotes from 262 n.1 and 285.
8. Ibid.: 306 n.2; 266 n.1; see also Beard 2000.
9. Goodison and Morris 1998; Owens 1996b; Dickinson 1994. See also Spretnak 1978.
10. MacEnroe 1995: 3–4.
11. Ibid.: 4. See also Trigger 1989; Schnapp 1996.
12. Ample evidence of a female deity or deities at Knossos is collected in *PM*. See also, more recently, N. Marinatos 1993: esp. 147–66.

13. "Minoan Rhea": Evans 1901–2: 28–30; *PM* 3: 463; 2, pt. 2: 808–9.
14. For Evans's views of the Cretan Goddess, see esp. *PM* 2, pt. 1: 227, 251–52. Evans 1902–3: 87; *PM* 1: 500.
15. Evans's notes: Panagiotaki 1993: 54.
16. *PM* 1: 504–5; 505 n.1.
17. Ibid.: 517.
18. Evans 1902–3: fig. 63; *PM* 1: fig. 377.
19. Blurring of goddess/priestess distinction: N. Marinatos 1993: 155; Shepsut 1993; Graham 1997: 28; Peatfield in Huxley 2000.
20. On the symbolism of snakes, see, for example, Nissenson and Jonas 1995.
21. Freud 1913; see also D'Agata 1994; Warburg 1938–39: 277, 278, 280, 288; Gombrich 1970: 216–27.
22. On Christian snake handlers, see Kimbrough 1995; Covington 1995.
23. Snakes as intermediaries: Witcombe 1998. The story of Glaukos was told by Apollodoros, *Bibliotheke* 3:17–20, and by other ancient authors. The episode is depicted on an inscribed Athenian cup of the fifth century B.C. in London (British Museum no. D5) and on other ancient objects. See "Glaukos II" (O. Palagia) in *LIMC* 4 (1988).
24. Domestic snakes: *PM* 3: 509. The Goddess's girdle: Evans 1902–3: 85. Her "infernal powers": *PM* 1: 187–88; see also *PM* 3: 438.
25. On exposed breasts, see Hawkes 1968: 110; compare Mann and Lyle 1995; Nissenson and Jonas 1995; Yalom 1997.
26. Dussaud 1905: 44–51. Thiersch 1906: 372.
27. For Orientalism in nineteenth-century European art and culture, see Said 1979 and Brown 2000.
28. Caskey 1914: 54. Van Rensselaer 1916: 354–51.
29. Waddell 1930: frontispiece and title page.
30. Madame Eta's gown is MFA no. 45.95. Shepsut 1993: title page.
31. Johnson 1988: 144–45.
32. "sternness of her expression": Streep 1994: 149; compare Davenport 1948: 34–44: "It is pure sacrilege to have a restoration of a wall painting appear on the same page as the Museum of Fine

Arts' tiny snake goddess." Females in Aegean dress hold sheaves or necklaces, for example, on an ivory plaque from Ugarit (Ras Shamra), now in the Louvre (Barnett 1982: pl. 24b; here Fig. 3.12) and on a fresco from Mycenae, the so-called Mykenaia (Immerwahr 1990: 119, pl. 20; here Fig. 3.13). Streep 1994: 149. Other interpretations: Baring and Cashford 1991: 110–11.

33. On the nature of the Goddess cult, see Dickinson 1994; Motz 1997; Goodison and Morris 1998; Peatfield in Huxley 2000.

34. Deities on Linear B tablets: Burkert 1985: 43–46.

35. On the decipherment of Cretan scripts, see Duhoux 1998; Bennet in Huxley 2000.

4. BOY-GODS, BULL LEAPERS, AND CORSETED GODDESSES

1. The Baltimore statuettes are Walters Art Gallery nos. 71.1090 and 71.1091. D. K. Hill 1942; Kirby 1952–53; Paul 1962: 187; Buitron 1983: 10–11; Buitron and Oliver 1985: 62; Hegemann 1988; S. Hemingway in MacGillivray et al. 2000: 120. Feuardent's certificate: "Je certifie que les deux objets en ivoire (1° déesse aux serpents recouverte d'une résille d'or 2 déesse couronnée avec le tête couronnée et une robe plissée) ont été trouvés en Crète à Cnossos. Elles proviennent des environs du palais du roi Minos, d'après les renseignements que j'ai pu recueillir. Les objets remontent à une époque légendaire qu'il faût placer vers le XVe siècle avant J.C."

2. D. K. Hill 1942: 260. Feuardent and fake Tanagras: Alexander 1994: 9.

3. The typescript of Evans's letter (p. 5), EA: "This figure, of which the Lecturer was able to exhibit slides for the first time on this occasion"; see also MacGillivray 2000: 282.

4. The public and critical reception of this stone figure, known as the Fitzwilliam Goddess, has been examined in detail by Butcher and Gill 1993. I have drawn on their account (p. 384) for Evans's letter and other archival material.

5. The figurine is Seattle Art Museum no. 57.56. See *PM* 3: viii, 442–

57; *PM* 4, pt. 1: 28; Rumpf 1965; Robkin 1984: 60–65; Joice et al. 1987: 15; Castleden 1990b: 106; S. Hemingway in MacGillivray et al. 2000: 120; Lapatin 2000.

6. Clark 1974: 107. The precise date of Clark's visit to Boars Hill is uncertain, but he was an undergraduate at Oxford from 1922 to 1926.

7. See Evans 1936: 8, 17, for his replica of the Boston Goddess. It is also possible that Clark was shown one of the stone statuettes discussed in Chapter 7.

8. Boy-God alluded to: *PM* 2, pt. 2: 235. "Young god": Hall 1928: 171. For Hall's association with Seager, see Becker and Betancourt 1997: 128–29, 137, 139. "Last night": Bosanquet 1938: 218–19.

9. *PM* 3: 443; see also viii.

10. Later authors: for example, Woolley 1958: 68. According to J. Evans 1943: 378, Sir Arthur, in the autumn of 1921 "had suddenly decided to go to Paris to see some Minoan objects . . . and had flown over as an experiment." It is not clear whether he acquired the Boy on that occasion. "The figurine migrated": *PM* 3: 443–44.

11. Ibid.: 444.

12. Ibid.: 444, 456, 450.

13. Ibid.: 453–54.

14. Ibid.: 454–57.

15. Ibid.: 457, 458–59, figs. 319–20. The Thisbê gems are discussed in Chapter 7. For the bronze (Athens National Museum no. 6284), see esp. Verlinden 1984: 36–39, 229 (V.1), pl. 102, for detailed arguments against its authenticity.

16. Butcher and Gill 1993. Quotes from 387.

17. Ibid.; Wace 1927.

18. Evans's letter to Cockerell, 26 Oct. 1927, quoted by Butcher and Gill 1993: 392. "Only example" and other Evans quotes: *PM* 2, pt. 1: 237. Lack of Minoan parallels: Evans 1928: 61–62, offers a neolithic statuette without hands, four small faience images with hands above the breasts, and an unnamed unprovenienced figure for comparison.

19. Butcher and Gill 1993: 391. Wace 1927: 9; see also Boucher 1967: 82: "The most surprising garment is the corset apparently worn by the 'Serpent Goddess' and the fashionable women of the frescoes . . . which . . . must have been formed of a framework of metal plates."

20. The second figure is Ashmolean Museum AE1938.692. See *PM* 4, pt. 2: 468–75; Evans 1936: 9, 17; Harden 1951: 26; Woolley 1958: 68; Robkin 1984: 64–65; Castleden 1990b: 106; S. Hemingway in MacGillivray 2000: 120; Lapatin 2000. "The skill": Evans 1936: 9.

21. *PM* 4, pt. 2: 475.

22. Ibid.: 483.

23. Royal Academy exhibition: Evans 1936: 8–9, 16–17.

24. As the price of the Lady was high, payments were made in installments: letter from N. Leipen to C. Chippindale, 16 Dec. 1993, kindly provided by Dr. Leipen. The statuette is Royal Ontario Museum no. 931.21.1. See Evans 1931; Anon. 1931; Wason 1932; *PM* 4, pt. 1: 28–40; Pendlebury 1939: 216; Pioján 1946: 470–71; Seltman 1948: 16–17; 1955: 57; Matton 1955: 87, 103 (no. 40); Hutchinson 1962: 136; Currelly 1965: 230; Alexiou 1973: 44–45; Kunzle 1982: 63–64; Verlinden 1984: 28–29 n.50, 36; Davaras 1989: 155, s.v. "ivory"; Baring and Cashford 1991: 141–42; Bowman 1992; Taylor 1992; Shepsut 1993: 131; McDowell 1997; Wilde 2000: 31–32; S. Hemingway in MacGillivray et al. 2000: 120; Lapatin 2000.

25. *PM* 4, pt. 1: 19.

26. Evans 1931: 150.

27. *PM* 4, pt. 1: 22.

28. Sherrow 1996: ix–xvii.

29. Evans's initial viewing of the Vapheio cups: loose notes in EA, quoted by MacGillivray 2000: 104; see also earlier publications of the cups, for example, Perrot and Chipiez 1894 2: 233. Compare *PM* 3: 182; *PM* 4, pt. 1: 22. Ivory components: *PM* 3: 428, 432. Gilliéron's restoration of the Taureador Fresco: N. Marinatos, personal communication; see also Damiani-Indelicato 1988;

Marinatos 1989. See Hitchcock 2000: 76–78 for ancient color conventions. For recently excavated Cretan-style frescoes depicting bull leapers from Avaris in the Nile Delta, see Bietak 1992 and Bietak and Marinatos 1995.

30. Evans 1931: 150.
31. Ibid.
32. McDowell 1997. Wilde 2000: 31–32, 106.

5. EVANS AND THE GILLIÉRONS

1. Émile Gilliéron *père* is often confused with his son of the same name, who also worked for Evans. I have pieced together their careers from interviews with their descendants, from letters in EA and The Harvard University Art Museums, and from sporadic and often erroneous references in other sources. See, for example, Coubertin et al. 1897: 44; Gilliéron and Son n.d. a and b; Seager 1912: 99 n.1; *PM Index:* 58; Picard 1942–43; J. Evans 1943: 333, 377; Vollmer 1955: 2:247; Plüss 1958–61: 1:359–60; Karo 1959b: 41–42; Levi 1960: 115–16; Woolley 1962; Cameron 1971; A. Brown 1983: 21–22, 82; Di Vita et al. 1984: 56; Warren 1987: 498 n.15; Immerwahr 1990: 234; Stürmer 1995a and b; Becker and Betancourt 1997: 112; Momigliano 1997; R. Hood 1998: 22–26; Sanna 1998: 278; Bénézit 1999: 6:123; Haywood 2000; MacGillivray 2000: 362.

2. On the need to protect the architectural remains at Knossos, see Evans 1900–1901: 2; and the comments of Doll in Evans 1927: 267. For the reconstructions in general, see also A. Brown 1983; Papadopoulos 1997; Huxley 2000. On railings: Evans 1900–1901: 2.

3. Evans 1927: 262.
4. Evans 1900–1901: 104.
5. Evans 1927: 261–62.
6. Mackenzie quoted in A. Brown 1983: 80. Evans 1905.
7. Iron girders: A. Brown 1983: 81. Evans 1905.
8. Papadopoulos 1997: 107; see also A. Brown 1983.
9. Papadopoulos 1997: 110.

10. Sources for the Gilliérons' lives are listed in note 1 above.

11. Saffron Gatherer/Blue Boy: Immerwahr 1990: 41, 170 (Kn no. 1); Farnoux 1996: 76–77. Taureador: Immerwahr 1990: 90–92, 175 (Kn no. 23); Shaw 1996: 181–82, pls. C and D.

12. Procession Fresco: Immerwahr 1990: 174–175 (Kn no. 22). Ladies in Blue: Immerwahr 1990: 172 (Kn no. 11). For similar phenomena from later periods, see Eco 1986; Lowenthal 1985.

13. Gilliéron and Son n.d. a and b. Both editions of *Galvanoplastic Copies* are, sadly, undated, but one seems to have been produced in 1909. Younger 1985: 56 n.13 dates them to 1905 and 1910.

14. For a concise account of the galvanoplastic process, see Haywood 2000: 5–6.

15. Gilliéron n.d. b [2nd ed.?]: second page (unnumbered) of English text.

16. *PM* 3: 157 refers to the "translation" of the design on the "Ring of Nestor" into a miniature fresco. See Haywood 2000 for numerous instances in which the Gilliérons corrected or improved metal originals.

17. Converted price of Vapheio copies: S. Sherratt in Haywood 2000: 4. A copy of the Gilliérons' price list is preserved in the library of the Metropolitan Museum, New York. See also Gilliéron n.d. a: seventh unnumbered page; Haywood 2000; Stürmer 1995; *PM* 3: 183 n.1, and 130, fig. 86; Bossert 1921.

18. The MFA's replicas are inv. nos. 01.535–542 and 11.3026–57.

6. THE ROAD TO BOSTON

1. Whitehill 1970: 484–88 mistakenly dates the second restoration to the late 1920s; see Appenix 3.

2. "*Now it can be told.* Im Herbst 1914, bald nach dem Ausbruch des Ersten Weltkrieges, erhielt ich in Athen einen Brief des älteren Gilliéron: Er bot mir eine in Knossos gefundene minoische Statuette aus Elfenbein und Gold an. Ich erwiderte, dass ich sie nicht erwerben könnte; da mir aber sehr viel daran lag, ein so seltenes Stück geruhsam zu untersuchen, bat ich ihn um befristete leihweise Überlassung und bot ihm dafür eine ihn sicher lockende

Gebühr. Eine Antwort erfolgte nicht. Statt dessen schickte mir wenige Wochen später mein alter Freund Lacey Caskey Photographien der Statuette in dem Zustand, wie sie ihm angeboten war. Er hatte sie sofort für sein Museum of Fine Arts in Boston erworben. Neben einer Anzahl grössere Stücke gab es auch viele kleine und winzige Splinter." Karo 1959b: 110–11 (translation mine).

3. Karo even sent Evans proofs of his magisterial publication of the material Schliemann had excavated at Mycenae: Evans 1935: xi–xii. He eventually held a number of visiting professorships at American universities and returned to Germany only in 1952, at which time he was honored by the West German government. For his career, see Marinatos 1966; Lullies 1988; R. Hood 1998: 34–37. I am also grateful to William Loerke for his personal reminiscences.

4. For Seager's connection to the MFA, see Seager 1912: prefatory note; Fairbanks 1928: 3; Becker and Betancourt 1997: 86, 96–97. For Hill's career, see MFA 1904: 56; 1905: 64; 1906: 48; 1907: 57; Lord 1947; Blegen 1959; Becker and Betancourt 1997: passim; Hood 1998: 166. Hill's relationship with Caskey: Whitehill 1970: 174, 301, 374; Lord 1947: 112–14; Medwid 2000: 53. Caskey's son John, born in 1908, became a distinguished Aegean Bronze Age archaeologist. Hill was apparently fond of remarking, "You must remember, it is not really important what happens to one person — even if that person is oneself."

5. MFA/Metropolitan competition: Whitehill 1970: esp. 167–68, 206–7; Dyson 1998: esp. 129–44.

6. Parthenon excavation: B. H. Hill 1912. Gennadeion: Lord 1947: 156–57.

7. Lord 1947: 191. See also Blegen 1959; Dyson 1998: 169–70.

8. Seager 1912: 99 n.1; Becker and Betancourt 1997: 112. Gilliéron's work for Seager in 1914 is mentioned in a letter (0080) in EA. Because the Gilliéron family's archives were lost during World War II, it cannot be determined whether Gilliéron *père* ever received photographs of the Boston Goddess.

9. Lord 1947: 140, 120.

7. SNAKE GODDESSES, FAKE GODDESSES?

1. Gardner 1915: 51.
2. Uncatalogued letter, EA. Among others who have expressed doubts in print about the statuette are Reinach 1924: 105 no. 7; Baikie 1926: 116n.; Lippold 1929: 289–91; Praschniker 1935: 93; Bossert 1937: 3–5; Kurz 1948: 122; Nilsson 1950: 312–14; Dow 1954: 156; Matz 1958: 385 n.7; Albizzati 1959: 939–41; Sp. Marinatos and M. Mallowan, reported in Hutchinson 1962: 136; Woolley 1962: 21–23; Buchholz 1970: 115, 127; Alexiou 1973: 44–45; Foster 1979: 78; Haackens and Winkes 1983: 38–41; Verlinden 1984: 29 n.50, 36; J. Bowman 1991; 1992; Butcher and Gill 1993; Evely 1993: 227, 253 n.57; Lapatin 1997; 2000a and b; 2001.
3. Deep-set eyes: Gardner 1915: 50; *PM* 3: 440–41. For the unequivocally genuine excavated pieces, see S. Hood 1958; MacGillivray et al. 2000; Lapatin 2001.
4. For anatomical detail in later Greek sculpture, see Métraux 1995.
5. Hawes and Hawes 1909: vii.
6. Lecture: Evans 1884. Modern craftsmen have fulfilled the desire for ancient artifacts more recently by producing Cycladica; see Chapter 2 and esp. Gill and Chippindale 1993.
7. Zeus: EA 0063–65; Letter from Richard Berry Seager to Edith Hall (Dohan), 8 Dec. 1912, in the archives of the University Museum, University of Pennsylvania, Philadelphia. Edith Hall's previous message to Seager is unfortunately not preserved.
8. *PM* 3: 145.
9. The Ring of Nestor is now Ashmolean Museum no. AE 1938.1130. See Evans 1925; *PM* 3: 145–57; *PM* 4, pt. 2: 949. Further bibliography is in Buchholz 1970: 132 n.113. See also Warren 1987: 498 n.15 (for the admission of Gilliéron *fils*); Hughes-Brock 1994; and esp. Pini 1998. The Thisbê Treasure is now Ashmolean Museum no. AE 1938.1113–25. Quotes are from Evans 1925: 1. For other Cretan forgeries, see Buchholz 1970; Verlinden 1984; and Hughes-Brock 1989. See also Appendix 2.
10. Wace 1927: 3.

11. This goddess, Cambridge University, Museum of Classical Archaeology no. 450, was purchased in 1928 as a forgery. See Butcher and Gill 1993: 394; Budde and Nicholls 1964: 114.

12. *PM* 4, pt. 1: 35–36, 193–99. Quotes are from 193 and 196.

13. Ibid.: 197–98. For the finds from Piskokephalo, see Bossert 1921: fig. 141; Marinatos and Hirmer 1986: pls. 16–17.

14. *PM* 3: 426–27. The Tylissos figure is Ashmolean Museum no. 1938.693.

15. The stone statuette had been offered to European museums in 1927 by one D. Simiriotti and to the Metropolitan Museum early in 1928 by Edouard Jonas, both of Paris. Published as "present location unknown" by Butcher and Gill 1993: 395, fig. 8, it is, in fact, Walters Art Gallery inv. no. 23.196 A+B. The piece was previously published by Piojàn 1946: 472, fig. 737, as a snake-handling priestess of the Mother Goddess.

16. For Xanthoudides' claim, see Forsdyke 1927: 300; see also Levi 1960: 115. For Michelangelo and other forgers, see Werness 1983; Sox 1987; M. Jones 1990; Butcher and Gill 1993; Pasquier et al. 1994; Radnóti 1999; Preston 1999; Lapatin 2000b. For the abilities of Cretan forgers, see Evans, letter to Cockerell, 26 Oct. 1927; Butcher and Gill 1993: esp. 392–93; and Levi 1960: 115.

17. Woolley 1962: 21–23.

18. For Gregori, see J. Evans 1943: 340; A. Brown 1983: 15; Winstone 1990: 28, 46, 101; Lock 1990: 179–80; Momigliano 1999a: 67, 132; MacGillivray 2000: esp. 277; R. and S. Hood in Huxley 2000: 211, fig. 132.

19. Woolley's biographer H. V. F. Winstone suggested (personal communication) that George Antoniou might have been Gregori's son. For the date of discovery of the forgers' factory, see also Bossert 1921; 1923; and 1937; the last omits the Boston Goddess and other dubious pieces with the following explanation (pp. 3–5): "This edition has been augmented by 200 pictures, from 256 plates to 304. It is true that a few pictures of the second edition had to be omitted in order to save space. But these were

mostly presumed to be of fakes, or such as are contained in other illustrations . . . I hope that this edition distinguishes itself in one respect from the two preceding ones: I took special care to omit doubtful objects and fakes *including such as have been regarded by others as 'principal works' of Cretan and Mycenaean art.* Furthermore I have included only a very few of the numerous objects which during the last fourteen years found their way into non-Greek museums and collections and were presented to the public as genuine. Most of them are doubtless fakes. It was a difficult and responsible task to decide which to include as genuine. Art books are full of copies and descriptions of gold rings, gems, *ivories,* and similar 'museum pieces' which were decidedly considered genuine by the collectors; most of them well-known specialists. Everyone acquainted with the subject knows that once in a while original objects of art are illegally removed from Greece. In such cases sellers and buyers are most concerned in hiding the provenience of such pieces originating from pirate excavations and theft. This fact is exploited by clever forgers who smuggle their works into the hands of art dealers in the same mysterious way" (emphasis added).

William Loerke and John Younger independently suggested to me that Woolley might have conflated the two Greek forgers, an older and a younger, with the father-son restoration team for whom they worked, but although Gilliéron *père* died in 1924, Woolley, Xanthoudides, Karo, Levi, and others leave no doubt that Cretans, too, were involved in the production of fakes.

20. Karo 1959b: 41–42: "Erst während der Kriegsjahre 1915–1918 kamen mit Gold reich verzierte Elfenbeinstatuetten 'aus Kreta' hinzu. Stets mussten diese kunstvoll hergestellten Werke vortrefflich zu Evans Forschungsergebnissen über minoische Religion passen. Und ihm kamen keine Zweifel an ihrer Echtheit, weil ja — wie er mir einmal schrieb — niemand von jenen noch unveröffentlichten Ergebnissen erfahren habe. Dass Männer, denen er doch etwas davon angedeutet haben musste, jahrelang

von ihm erwiesene Wohltaten so übel lohnen könnten, war einem Manne von seinem Charakter völlig unfassbar. Und die erfolgreichen Bemühungen von Spyridon Marinatos, kleine, auf Bestellung arbeitende Goldschmiede als Fälscher zu entlarven, während er Ephoros, d. h. Provinzialkonservator von Kreta war, trafen die Hintermänner nicht" (translation in text mine).

21. Levi 1960: 115–16. Raw tusks were excavated at Zakro in eastern Crete in the 1960s; see Platon 1971: 61, 245. Other sites might have provided the material to looters and forgers.

22. S. Hood 1958; MacGillivray et al. 2000; Lapatin 2001.

23. Only the badly weathered Baltimore Snake Goddess lacks a well-preserved face, and it was paired with a well-preserved forgery.

24. Evans's perception of genitals: *PM* 3: 447: "In the case of the boy-God — as in these still more infantile figures [excavated at other sites] — there are indications of the sexual organs, and obviously the 'Minoan sheath' was not worn by him." For the Taureador Fresco, see *PM* 3: figs. 144–45. Quote is from *PM* 4, pt. 1: 31. See also Immerwahr 1990: 175 (Kn no. 23) passim. For rejections of the traditional view that the white-fleshed figures in the fresco necessarily represent females, see Damiani-Indelicato 1988; N. Marinatos 1989; and Hitchcock 2000.

25. Robkin (1984: 63) identified the Seattle ivory as a female bull leaper but considered it to be ancient. The unequivocally ancient ivory triad excavated at Mycenae in 1939 (Athens National Museum no. 7711) seems to be another case in which the figure of a child, long identified as a boy, may well represent a girl. See Buchholz and Karageorghis 1973: no. 1280; S. Hood 1978: fig. 114, and, for the gender of the figure, Rehak and Younger 1998: 240 and n.110.

26. Goodman 1983: esp. 101–2; Muscarella 1977: esp. 156, 161, 164–65.

27. There are, of course, many genuine Minoan artifacts that have not suffered from overrestoration. See, for example, Buchholz and Karageorghis 1973; Hood 1978; and, for especially fine photographs, Marinatos and Hirmer 1986.

8. THE UNCERTAINTIES OF SCIENCE

1. Hood 1978: 120; see also Higgins 1997: 33–35: "The authenticity of the gold and ivory figure has been questioned, and is still debated, though the details of the costume and feature, the tautness of the pose and the delicacy of execution all ring absolutely true. . . . It is accepted by most of those best qualified to judge, and we, too, may accept it."

2. In *PM* 4, pt. 2, the frontispiece is also pl. 33. Although Evans (*PM* 4, pt. 1: xxiv) attributes this drawing of the reconstruction to Gilliéron *fils*, the most complete version in the Ashmolean Museum is signed by E. J. Lambert. Lambert and Gilliéron both worked for Evans and borrowed from each other's reconstructions; see, for example, *PM* 3: 302 n.2. For other versions of the Throne Room reconstruction, see Farnoux 1996: 80–83.

3. See, for example, a "Subminoan" terra cotta from Karphi dating to about 1100–1000 B.C.: Sp. Marinatos and Hirmer 1986: pls. 142–43. I am grateful to Paul Rehak (personal communication) for this observation.

4. Buttons: Iakovides 1977. *Kondochi:* Caskey 1914: 52. Long shift: N. Marinatos 1984: fig. 70.

5. The gold of the Palaikastro youth varies in thickness from 0.35 mm (approximately the thickness of a human hair) to 0.125 mm (M. Moak, personal communication). The Goddess's gold is considerably thicker, more akin to sheet than foil.

 I recently discovered that William T. M. Forbes also reached the conclusion that the golden nail in the Goddess's right nipple does not belong there. In an unpublished letter to Arthur Evans dated 17 Sept. 1935, now in EA, he wrote: "I saw the Boston Goddess last year, and got the strong impression that the gold tack that represented the nipple was misplaced, — that the tack belonged to her costume (it was identical) and the nipple had been larger, and perhaps was made of some paste that had perished(?). I wonder therefore if the new Goddess [Toronto] went through the hands of the same restorer." Modiano (1987), however, suggested soon after the discovery of the Palaikastro youth that

"golden nipples had been inserted" into the holes in its chest, presumably on the analogy of the Boston and Toronto statuettes.

6. Flaking of ivory: see Krzyszkowska 1990. Drilled pupils do appear in Aegean ivories and gems (see Buchholz and Karageorghis 1973: nos. 1180, 1186, 1399, 1400; Boardman 1970: pls. 14, 15, 19, 20, 27, 43–48, 60). Miranda Marvin (personal communication) has kindly reminded me of the indented pupils of classical bronzes (see Kozloff et al. 1988: passim), but the double drilling of the Goddess's apparently well-preserved right eye is, to the best of my knowledge, unparalleled.

7. PM 3: 431, figs. 297a–b; 432, figs. 298a–b.

8. Hill 1942: 260. For the combining of probably authentic artifacts with likely forgeries, see Betts 1981: 17–18.

9. The Goddess's lack of wide hips: Verlinden 1984; I. Pini and O. H. Krzyszkowska (personal communication). Sakellariou quoted in Temin 1991. Acid: Woolley 1962: 21–23 (quoted in Chapter 7).

10. To compensate for atmospheric change resulting from the burning of fossil fuels and nuclear explosions in recent years, radiocarbon dates must be slightly adjusted or calibrated; see S. Bowman 1990.

11. Erroneous dates: as noted by Wohlauer 1999: 66, who states incorrectly that the Boston Goddess "was initially restored in the nineteenth century."

The single unequivocal example known to me of an illicitly excavated Minoan artifact recut in modern times is an "ivory seal" "found in the vicinity of Knossos" and now in the Ashmolean Museum (no. 1938.790; see PM 1: fig. 145, and Hughes-Brock 1989: 83–84), which is actually a highly polished piece of bone, originally cut for inlay, that was carved on both sides with figured scenes. The shape of the piece — inappropriate for a seal but paralleled in inlays (known as D-plaques) excavated at Knossos and elsewhere — and its iconography are what finally gave it away. For raw ivory recovered in modern excavations on Crete, see Platon 1971: 61, 245. Levi 1960: 115–16 notes that modern Cretan forgers employed ancient ivory. See also the vaguer statements

of Budde and Nicholls 1964: 115 (no. 186) n.1; Buitron and Oliver 1985: 62.

12. Ramsey et al. 1999: 203; P. Pettitt (personal communication).

13. Ivory trade: Maskell 1905; Bassani et al. 1988. Contamination: P. Pettitt (personal communication). Large amounts of nitrogen introduced by an external agent led to a high CN ratio. These tests were generously funded by a grant from the Institute for Aegean Prehistory.

14. Young 1959: 20.

15. A preliminary report of tests conducted on Cretan gold in the Ashmolean Museum indicated an average silver content of 12.5 percent: R. E. Jones 1980: 464. The Museum of Fine Arts' Aegean gold ranges from 9.8 to 30.4 percent silver and 0.9 to 3.9 percent copper. I am grateful to R. Newman and J. J. Herrmann Jr. for sharing this information with me. Gold excavated at Mycenae has 8.55 to 23.37 percent silver and 0 to 2.22 percent copper: Hartmann 1970: 81, table 1. Not all of these analyses have been normalized for trace elements. For ancient sources of gold, see, for example, Stos-Gale and Gale 1984: 61; and Lehrberger 1995: esp. 137–38. Analysis of Egyptian gold shows 11.2–17.2 percent silver; 0–1.5 percent copper: Lucas and Harris 1962: 490. According to J. Ogden in Nicholson and Shaw 2000: 162, "the copper content of 'as-mined' gold is typically under about 2 per cent, but there are exceptions, and there will generally be detectable traces of numerous other metals including iron, tin and members of the platinum family." Gold from Sardis is 10.2–31.7 percent silver; 0–1.3 percent copper: Ramage et al. 2000: 145, table 5.3. The silver content of gold objects from the early Iron Age cemetery at Lefkandi in Eretria varies substantially (most pieces have well over 5 percent silver), but the copper content is quite low; most pieces have none, and 3 percent (one object) is the maximum: R. E. Jones 1980: 462 63. Ogden on high-purity gold: in Nicholson and Shaw 2000: 163–64.

BIBLIOGRAPHY

Albizzati, C. 1959. "Crisoelefantina, Tecnica." In *Enciclopedia dell'arte antica, classica e orientale* 2: 939–41. Rome.

Alexander, K. 1994. "The History of the Ancient Art Collection at the Art Institute of Chicago." In *Ancient Art at the Art Institute of Chicago* (Art Institute of Chicago. Museum Studies 20, no. 1), 7–13. Chicago.

Alexiou, S. 1973. *Minoan Civilization.* 2nd ed. Herakleion, Crete.

Allen, S. H. 1999. *Finding the Walls of Troy: Frank Calvert and Heinrich Schliemann at Hisarlik.* Berkeley.

Allsebrook, M. 1992. *Born to Rebel: The Life of Harriet Boyd Hawes.* Oxford.

Anon. 1931. "From the Archeologist's Note Book." *Scientific American* 145 (Dec.): 395.

Bachofen, J. J. 1861. *Das Mutterrecht: Eine Untersuchung über die Gynaikokratie der alten Welt nach ihre religiösen und rechtlichen Natur.* Stuttgart.

———. 1967. *Myth, Religion, and Mother Right: Selected Writings of J. J. Bachofen.* Trans. R. Manheim. New York.

Baikie, J. 1926. *The Sea-Kings of Crete.* 4th ed. London.

Bammer, A. 1990. "Wien und Kreta: Jugendstil und minoische Kunst." *Jahreshefte des Oesterreichischen archäologischen Instituts in Wien* 60: 130–51.

Baring, A., and J. Cashford. 1991. *The Myth of the Goddess: Evolution of an Image.* London.

Barnett, R. D. 1982. *Ancient Ivories in the Middle East and Adjacent Countries.* Qedem 14. Jerusalem.

Bassani, E., et al. 1988. *Africa and the Renaissance: Art in Ivory.* New York.

Baudelaire, C. 1964. *The Painter of Modern Life and Other Essays.* Trans. and ed. Jonathan Mayne. London.

Beard, M. 2000. *Inventing Jane Harrison.* Cambridge, Mass.

Becker, M. J., and P. P. Betancourt. 1997. *Richard Berry Seager: Pioneer Archaeologist and Proper Gentleman.* Philadelphia.

Bénézit, E. 1999. *Dictionnaire critique et documentaire des Peintres, Sculpteurs, Dessinateurs et Graveurs* . . . 14 vols. 2nd ed. Paris.

Betts, J. 1981. "Some Early Forgeries: The Sangiorgi Group." In I. Pini, ed., *Studien zur minoischen und helladischen Glyptik. Beiträge zum 2. Marburger Siegel-Symposium 26.–30. September 1978, Corpus der minoischen und mykenischen siegel.* Beiheft 1: 17–35. Berlin.

Bietak, M. 1992. "Minoan Wall-Paintings Unearthed at Ancient Avaris." *Egyptian Archaeology* 2: 26–28.

Bietak, M., and N. Marinatos. 1995. "Minoan Wall Paintings from Avaris." *Egypt and the Levant* 5: 50–62.

Bintliff, J. 1984. "Structuralism and Myth in Minoan Studies." *Antiquity* 58: 33–38.

Blegen, C. W. 1959. "Necrology [Bert Hodge Hill]." *American Journal of Archaeology* 63: 193–94.

Boardman, J. 1970. *Greek Gems and Finger Rings.* London.

Bosanquet, R. C. 1938. *Letters and Light Verses.* Ed. Ellen Bosanquet. Gloucester, Eng.

Bossert, H. T. 1921. *Alt Kreta: Kunst und Kunstgewerbe im ägäischen Kulturkreise.* Berlin.

———. 1923. *Altkreta: Kunst und Handwerk in Griechenland, Kreta und auf den Kykladen während der Bronzezeit. Die ältesten Kulturen des Mittelmeerkreises* 1. Berlin.

———. 1937. *The Art of Ancient Crete from the Earliest Times to the Iron Age.* London.

Botsford, G. W. 1939. *Hellenic History.* Rev. and rewritten by C. A. Robinson, Jr. New York.

Boucher, F. 1967. *20,000 Years of Fashion: The History of Costume and Personal Adornment*. New York.

Bowman, J. 1991. "Mysterious Snake Goddess . . . and the Mystery Deepens." *Museum Insights* 3, no. 4 (July/Aug.): 1, 6–7.

———— 1992. "A North American School of Minoan Art." *Museum Insights* 4, no. 4 (Mar./Apr.): 3–4.

Bowman, S. 1990. *Radiocarbon Dating*. Berkeley.

Brown, A. 1983. *Arthur Evans and the Palace of Minos*. Oxford.

————. 1986. "'I Propose to Begin at Gnossos': John Myres's Visit to Crete in 1893." *Annual of the British School at Athens* 81: 37–44.

————. 1993. *Before Knossos . . . Arthur Evans's Travels in the Balkans and Crete*. Oxford.

Brown, C. 2000. *Victorian Painting*. London.

Buchholz, H.-G. 1970. "Ägäische Kunst gefälscht." *Acta praehistorica et archaeologica* 1: 113–35.

Buchholz, H.-G., and V. Karageorghis. 1973. *Prehistoric Greece and Cyprus: An Archaeological Handbook*. London.

Budde, L., and R. Nicholls. 1964. *A Catalogue of the Greek and Roman Sculpture in the Fitzwilliam Museum Cambridge*. Cambridge, Eng.

Buitron, D. 1983. "Ivories of the Aegean and Mediterranean Worlds." In R. P. Bergman et al., *Ivory: the Sumptuous Art. Highlights from the Collection of the Walters Art Gallery, Baltimore*, 10–11. Baltimore.

Buitron, D., and A. Oliver. 1985. "Greek, Etruscan, and Roman Ivories." In R. H. Randall, ed., *Masterpieces of Ivory from the Walters Art Gallery*, 54–79. New York.

Burkert, W. 1985. *Greek Religion*. Trans. J. Raffan. Cambridge, Mass.

Burn, A. R. 1930. *Minoans, Philistines, Greeks*. New York.

Burrows, R. M. 1907. *Discoveries in Crete*. London.

Butcher, K., and D. W. J. Gill. 1993. "The Director, the Dealer, the Goddess, and Her Champions: The Acquisition of the Fitzwilliam Goddess." *American Journal of Archaeology* 97: 383–401.

Calasso, R. 1993. *The Marriage of Cadmus and Harmony*. New York.

Calder, W. A., D. A. Traill, K. Demakopoulou, K. D. S. Lapatin, O. Dickinson, and J. G. Younger. 1999. "Behind the Mask of Agamemnon." *Archaeology* 52, no. 4 (July/Aug.):51–59.

Cameron, M. A. S. 1964. "An Addition to 'La Parisienne.'" *Kretika Chronika* 18: 38–53.

———. 1971. "A Lady in Red." *Archaeology* 24: 35–42.

Cameron, P. 1988. *Blue Guide: Crete*. 5th ed. London.

Candy, J. S. 1984. *A Tapestry of Life: An Autobiography*. Braunton, Devon, Eng.

Capps, E. 1899. "A New Archaeological Law for Greece." *The Nation* 69 (Aug. 3): 88–90.

Carrà, M. 1966. *Gli avori in occidente*. Milan.

Caskey, L. D. 1914. "A Statuette of the Minoan Snake Goddess." *Museum of Fine Arts Bulletin* 12, no. 73 (Dec.): 52–55.

———. 1915a. "Report of the Department of Classical Art." In Museum of Fine Arts, Boston. *Thirty-Ninth Annual Report for the Year 1914*, 93–97. Boston.

———. 1915b. "A Chryselephantine Statuette of the Cretan Snake Goddess." *American Journal of Archaeology* 19: 237–49.

Castleden, R. 1990a. *Minoans: Life in Bronze Age Crete*. London.

———. 1990b. *The Knossos Labyrinth: A New View of the "Palace of Minos."* London.

Chadwick, J. 1987. *Linear B and Related Scripts*. Berkeley.

Charbonneaux, J. 1929. *L'art égéen*. Paris.

Chase, G., and C. C. Vermeule III. 1963. *Greek, Etruscan & Roman Art. The Classical Collections of the Museum of Fine Arts, Boston*. 2nd ed. Boston.

Cheney, S. 1968. *Sculpture of the World: A History*. New York.

Chippindale, C., and D. W. J. Gill. 2000. "The Material Consequences of Contemporary Classical Collecting." *American Journal of Archaeology* 104: 463–511.

Clark, K. 1974. *Another Part of the Wood: A Self-Portrait*. London.

Clarke, G. 1986. *Symbols of Excellence: Precious Materials as Expressions of Status*. Cambridge, Eng.

Coggins, C. C. 1998. "United States Cultural Property Legislation:

Observations of a Combatant." *International Journal of Cultural Property* 7: 52–68.

Cohon, R. 1996. *Discovery and Deceit: Archaeology and the Forger's Craft.* Kansas City, Mo.

Comstock, M. B., and C. C. Vermeule III. 1969. "Collectors of Greek Art: Edward Perry Warren and His Successors." *Apollo* (Dec.): 466–73.

Cottrell, L. 1984. *Bull of Minos.* 3rd ed. London.

Coubertin, P. de, T. J. Philemon, N. G. Politis, and Ch. Anninos. 1897. *The Olympic Games B.C. 776–A.D. 1896.* London.

Covington, D. 1995. *Salvation on Sand Mountain: Snake Handling and Redemption in Southern Appalachia.* Reading, Mass.

Currelly, C. T. 1965. *I Brought the Ages Home.* Toronto.

D'Agata, A. L. 1994. "Sigmund Freud and Aegean Archaeology." *Studi Micenei ed Egeo-Anatolici* 34: 7–42.

Damiani-Indelicato, S. 1988. "Were Cretan Girls Playing at Bull Leaping?" *Cretan Studies* 1: 39–47.

Davaras, C. 1989. *Guide to Cretan Antiquities.* 2nd ed. Athens.

Davenport, M. 1948. *The Book of Costume.* Vol. 1. New York.

Dickinson, O. T. P. K. 1994. "Comments on a Popular Model of Minoan Religion." *Oxford Journal of Archaeology* 13: 173–84.

Di Vita, A., V. La Rosa, and M. A. Rizzo, eds. 1984. *Creta Antica: Centi anni di archeologia italiana (1884–1984).* Rome.

Dixon, P. J. 1929. Review of *A Cretan Statuette in the Fitzwilliam Museum,* by A. J. B. Wace. *Classical Review* 43: 18–19.

Dow, S. 1954. Review of *The Minoan-Mycenaean Religion and Its Survival in Greek Religion,* vol. 2, by M. P. Nilsson. *American Journal of Archaeology* 58: 155–57.

Downing, C. 1985. "Prehistoric Goddesses: The Cretan Challenge." *Journal of Feminist Studies in Religion* 1: 7–22.

Driessen, J. 1999. "'The Archaeology of a Dream': The Reconstruction of Minoan Public Architecture." *Journal of Mediterranean Archaeology* 12: 121–27.

Duchêne, H. 1996. *Golden Treasures of Troy: The Dream of Heinrich Schliemann.* New York.

Duhoux, Y. 1998. "Pre-Hellenic Language(s) of Crete." *Journal of Indo-European Studies* 26: 1–39.

Dussaud, R. 1905. "Questions mycéniennes." *Revue de l'historie des religions* 51: 24–62.

Dyson, S. L. 1998. *Ancient Marbles to American Shores: Classical Archaeology in the United States.* Philadelphia.

Eco, U. 1986. *Travels in Hyperreality.* New York.

Eisenhart, W. 1969. "The Boston Museum of Fine Arts, 1870–1970." *Art News* 68 (Sept.): 34–47, 68–73.

Elderkin, K. M. 1928. Review of *A Cretan Statuette in the Fitzwilliam Museum,* by A. J. B. Wace. *American Journal of Archaeology* 32: 542–43.

Evans, A. J. 1883. Review of *Troja,* by H. Schliemann. *Academy* 24 (Dec. 29): 437–39.

———. 1884. *The Ashmolean Museum as a Home of Archaeology in Oxford.* Oxford.

———. 1899–1900. "Knossos I: The Palace." *Annual of the British School at Athens* 6: 3–70.

———. 1901. "The Neolithic Settlement at Knossos and Its Place in the History of Early Aegean Culture." *Man* 1, no. 146: 184–86.

———. 1901–2. "The Palace at Knossos: Provisional Report of the Excavations of the Year 1902." *Annual of the British School at Athens* 8: 1–124.

———. 1902–3. "The Palace of Knossos: Provisional Report for the Year 1903." *Annual of the British School at Athens* 9: 1–153.

———. 1905. "The Sixth Campaign at Knossos." *Times* (London), 31 Oct.: 4.

———. 1909. *Scripta Minoa.* Vol. 1. Oxford.

———. 1921–35. *The Palace of Minos. A Comparative Account of the Successive Stages of the Early Cretan Civilization as Illustrated by the Discoveries at Knossos.* 4 vols. plus an Index compiled jointly with J. Evans. London.

———. 1927. "Work of Reconstruction in the Palace of Knossos." *Antiquaries Journal* 7: 258–66.

————. 1928. "The Fitzwilliam Goddess." *Classical Review* 42: 61–62.

————. 1931. "'Our Lady of the Sports': A Unique Minoan Figure." *Illustrated London News,* 25 July: 148–50.

Evans, A. J., et al. 1936. *British Archaeological Discoveries in Greece and Crete 1886–1936. Catalogue of the Exhibition Arranged to Commemorate the Fiftieth Anniversary of the British School of Archaeology at Athens Together with an Exhibit Illustrative of Minoan Culture with Special Relation to the Discoveries at Knossos.* London.

Evans, Joan. 1943. *Time and Chance: The Story of Arthur Evans and His Forebears.* London.

Evans, John. 1893. "The Forgery of Antiquities." *Longman's Magazine* 23, no. 134 (Dec.): 142–55.

Evely, R. D. G. 1993. *Minoan Crafts: Tools and Techniques: An Introduction.* Vol. 1. Studies in Mediterranean Archaeology 92.1. Göteborg, Sweden.

Fairbanks, A. 1928. *Museum of Fine Arts, Boston: Catalogue of Greek and Etruscan Vases.* Vol. 1. Cambridge, Mass.

Faison, S. L., Jr. 1958. *A Guide to the Art Museums of New England.* New York.

————. 1982. *Art Museums of New England.* 2nd ed. Boston.

Fall, F. 1973. *Art Objects: Their Care and Preservation.* La Jolla, Calif.

Farnoux, A. 1996. *Knossos: Searching for the Legendary Palace of Minos.* New York.

Fitton, J. L. 1996. *The Discovery of the Greek Bronze Age.* London.

Forsdyke, E. J. 1927. Review of *A Cretan Statuette in the Fitzwilliam Museum,* by A. J. B. Wace. *Journal of Hellenic Studies* 47: 299–300.

————. 1929. *Minoan Art.* Annual Lecture on Aspects of Art. Henriette Hertz Trust of the British Academy 1929. *Proceedings of the British Academy* 15:45–72.

Foster, K. P. 1979. *Aegean Faience of the Bronze Age.* New Haven.

Frazer, J. G. 1890. *The Golden Bough.* London.

————. 1906. *Adonis, Attis, and Osiris.* London.

Freud, S. 1913. *Totem and Taboo: Some Points of Agreement Between*

the Mental Lives of Savages and Neurotics. Trans. and ed. James Strachey. Reprint: New York, 1989.

Gantz, T. 1993. *Early Greek Myth: A Guide to Literary and Artistic Sources.* Baltimore.

Gardner, E. A. 1915. "A Cretan Statuette." *Ancient Egypt* 1, no. 2: 48–51.

Gerhard, E. 1849. *Über Metroen und Götter-Mutter.* Berlin.

Gill, D. W. J. 2000. "Collecting for Cambridge: John Hubert Marshall on Crete." *Annual of the British School at Athens* 95: 517–26.

Gill, D. W. J., and C. Chippindale. 1993. "Material and Intellectual Consequences of Esteem for Cycladic Figurines." *American Journal of Archaeology* 97: 601–59.

Gilliéron, É., and Son. N.d. [ca. 1906], a. *A Brief Account of E. Gilliéron's Beautiful Copies of Mycenaean Antiquities in Galvano-Plastic Manufactured and Sold by the Wurtemberg Electro Plate Co. Galvano Bronze Department Geislingen-St. (Germany).* Stuttgart.

———. N.d., b. *Galvanoplastische Nachbildungen mykenischer und kretischer (minoischer) Altertümer.* Stuttgart. (Issued in German, English, and French and in two different editions.)

Glotz, G. 1925. *The Aegean Civilization.* 2nd ed. New York.

Gombrich, E. H. 1970. *Aby Warburg: An Intellectual Biography.* London. Reprint: Chicago, 1986.

Goodison, L., and C. Morris, eds. 1998. *Ancient Goddesses.* London.

Goodman, N. 1983. "Art and Authenticity." In D. Dutton, ed., *The Forger's Art,* 93–114. Berkeley.

Graham, L. 1997. *Goddesses in Art.* New York.

Haackens, T., and R. Winkes. 1983. *Gold Jewelry: Craft, Style and Meaning from Mycenae to Constantinople.* Aurifex 5. Louvain-la-Neuve, Belgium.

Hall, H. R. 1928. *The Civilization of Greece in the Bronze Age.* London.

Harden, D. B. 1983. *Sir Arthur Evans 1851–1941: A Memoir.* Oxford.

Harden, D. B., ed. 1951. *A Summary Guide to the Collections: University of Oxford, Ashmolean Museum, Department of Antiquities.* Oxford.

Harrison, J. E. 1903. *Prolegomena to the Study of Greek Religion.* Cambridge, Eng.

———. 1908. *Prolegomena to the Study of Greek Religion.* 2nd ed. Cambridge, Eng.

Hartmann, A. 1970. *Prähistorische Goldfunde aus Europa. Spektralanalytische Untersuchungen und der Auswertung.* Studien zu den Anfängen der Metallurgie 3. Berlin.

Hawes, C. H., and H. B. Hawes. 1909. *Crete: The Forerunner of Greece.* London.

Hawkes, J. 1968. *Dawn of the Gods: Minoan and Mycenaean Origins of Greece.* New York.

Haywood, C., ed. 2000. *All That Glitters . . . An Exhibition of Replicas of Aegean Bronze Age Plate.* Dublin.

Hegemann, H. W. 1988. *Geschichte des Elfenbeins.* Mainz.

Higgins, R. 1979. *The Aegina Treasure.* London.

———. 1997. *Minoan and Mycenaean Art.* 3rd ed. London.

———. N.d. *Tanagra and the Figurines.* London.

Hill, B. H. 1912. "The Older Parthenon." *American Journal of Archaeology* 16: 535–38.

Hill, D. K. 1942. "Two Unknown Minoan Statuettes." *American Journal of Archaeology* 46: 254–60.

Hitchcock, L. A. 1999. "Postcards from the Edge: Towards a Self-Reflexive Reconstruction of Knossos." *Journal of Mediterranean Archaeology* 12: 128–33.

———. 2000. "Engendering Ambiguity: It's a *Drag* to Be a King." In M. Donald and L. Hurcombe, eds., *Representations of Gender from Prehistory to the Present,* 69–86. London.

Hitchcock, L., and P. Koudounaris. In press. "Virtual Discourse: Arthur Evans and the Reconstructions of the Minoan Palace at Knossos." In Y. Hamilakis, ed., *Labyrinth Revisited: Rethinking Minoan Archaeology.* Oxford.

Hogarth, D. G. 1903. "The Cretan Exhibition." *Cornhill Magazine* 14: 319–32.

Honour, A. 1961. *Secrets of Minos.* New York.

Hood, R. 1998. *Faces in Archaeology in Greece*. Oxford.

Hood, S. 1958. "The Largest Ivory Statuettes to Be Found in Greece; and an Early *Tholos* Tomb: Discoveries During the Latest Knossos Excavations." *Illustrated London News*, 22 Feb.: 299–301.

————. 1978. *The Arts in Prehistoric Greece*. Harmondsworth, Eng.

————. 1987. "An Early British Interest in Knossos." *Annual of the British School at Athens* 82: 85–94.

Hornblower, S., and A. Spawforth, eds. 1996. *The Oxford Classical Dictionary*, 3rd ed. Oxford.

Horwitz, S. 1981. *The Find of a Lifetime: Sir Arthur Evans and the Discovery of Knossos*. New York.

Howe, M. A. D. 1939. *Holmes of the Breakfast Table*. New York.

Hoyt, E. P. 1979. *The Improper Bostonian: Dr. Oliver Wendell Holmes*. New York.

Hughes-Brock, H. 1989. "Early Minoan White Seals in the Ashmolean Museum, Ancient and Modern: Some Enigmatic Materials." In W. Müller, ed., *Fragen und Probleme der bronzezeitlichen ägäischen Glyptik: Beiträge zum 3. Internationalen Marburger Siegel-Symposium, 5.–7. September 1985. (Corpus der minoischen und mykenischen Siegel Beiheft* III), 79–89. Berlin.

————. 1994. "Les Révélations de Sir Arthur Evans." *Ashmolean* 27 (Christmas): 7–9.

Hutchinson, R. W. 1962. *Prehistoric Crete*. Baltimore.

Hutton, C. A. 1899. *Greek Terracotta Statuettes* (*Portfolio* no. 40). London.

Hutton, R. 1997. "The Neolithic Great Goddess: A Study in Modern Tradition." *Antiquity* 71: 91–99.

Huxley, D., ed. 2000. *Cretan Quests: British Explorers, Excavators and Historians*. London.

Iakovides, S. 1977. "On the Use of Mycenaean 'Buttons.'" *Annual of the British School at Athens* 72: 113–19.

Immerwahr, S. A. 1990. *Aegean Painting in the Bronze Age*. University Park, Pa.

Immigration Information Bureau. 1931. *The Morton Allan Directory of*

European Passenger Steamship Arrivals for the Years 1890 to 1930 at the Port of New York and for the Years 1904 to 1926 at the Ports of New York, Philadelphia, Boston, and Baltimore. New York. Reprint: Baltimore, 1980.

J. 1915. "American Periodicals." *Burlington Magazine* 27 (May): 45.

James, E. O. 1959. *The Cult of the Mother-Goddess.* New York.

Johnson, B. 1988. *Lady of the Beasts: Ancient Images of the Goddess and Her Sacred Animals.* San Francisco.

Joice, G., et al. 1987. *Ivories in the Collection of the Seattle Art Museum.* Seattle.

Jones, M., ed. 1990. *Fake? The Art of Deception.* London.

————. 1992. *Why Fakes Matter: Essays on Problems of Authenticity.* London.

Jones, R. E. 1980. "Appendix E: Analyses of Gold Objects from the Cemeteries." In M. R. Popham et al., *Lefkandi I. The Iron Age.* British School of Archaeology at Athens supplementary vol. 11: 461–64. London.

Kardara, C. 1960. "Problems of Hera's Cult-Images." *American Journal of Archaeology* 64: 343–58.

Karo, G. 1959a. *Fünfzig Jahre aus dem Leben eines Archäologen.* Baden-Baden, Germany.

————. 1959b. *Greifen am Thron.* Baden-Baden, Germany.

Kimbrough, D. L. 1995. *Taking Up Serpents: Snake Handlers of Eastern Kentucky.* Chapel Hill, N.C.

Kirby, J. C. 1952–53. "The Care of a Collection." *Journal of the Walters Art Gallery* 15–16: 9–29.

Klynne, A. 1998. "Reconstructions of Knossos: Artists' Impressions, Archaeological Evidence and Wishful Thinking." *Journal of Mediterranean Archaeology* 11: 206–29.

Kozloff, A. P., et al. 1988. *The Gods' Delight: The Human Figure in Classical Bronze.* Cleveland.

Kriseleit, I., et al. 1994. *Bürgerwelten, Hellenistische Tonfiguren und Nachschöpfungen im 19. Jh.* Berlin-Mainz.

Krzyszkowska, O. 1990. *Ivory and Related Materials: An Illustrated*

Guide. (*Bulletin of the Institute of Classical Studies* supplement 59). London.

Kunz, G. F. 1916. *Ivory and the Elephant in Art, in Archaeology, and in Science.* New York.

Kunzle, D. 1982. *Fashion and Fetishism: A Social History of the Corset, Tight-Lacing and Other Forms of Body Sculpture in the West.* Totowa, N.J.

Kurz, O. 1948. *Fakes: A Handbook for Collectors and Students.* New Haven, Conn.

—————. 1967. *Fakes.* 2nd ed. New Haven, Conn.

Lagrange, P. M.-J. 1908. *La Crète ancienne.* Paris.

Lapatin, K. D. S. 1997. "Mysteries of the Snake Goddess: The Creation of 'Minoan' Art and Culture." Abstract. *Bulletin of the Institute of Classical Studies* 42: 244–45.

—————. 2000a. "Boy Gods, Bull Leapers, and Mother Goddesses." *Source: Notes in the History of Art* 20:18–28.

—————. 2000b. "Journeys of an Icon: The Provenance of the 'Boston Goddess.'" *Journal of Mediterranean Archaeology* 13: 127–54.

—————. 2001. *Chryselephantine Statuary in the Ancient Mediterranean World.* Oxford.

Lawrence, A. W. 1929. *Classical Sculpture.* London.

Lehrberger, G. 1995. "The Gold Deposits of Europe: An Overview of the Possible Metal Sources for Prehistoric Gold Objects." In G. Morteaani and J. P. Northover, eds., *Prehistoric Gold in Europe: Mines, Metallurgy and Manufacture*, 115–44. Dordrecht.

Lerman, L. 1967. "Where Is It?" *Mademoiselle* 65, no. 2 (June): 103–5.

Levi, D. 1960. "Per una nuova classificazione della civiltà minoica." *Parola del passato* 15, no. 71: 81–121.

Lexicon Iconographicum Mythologiae Classicae. 8 vols. 1980–99. Zurich.

Liddell, H. G., and R. Scott. 1940. *A Greek English Lexicon.* 9th ed. Rev. by H. Stuart Jones with the assistance of R. McKenzie. Oxford.

Lippold, G. 1929. Review of *A Cretan Statuette in the Fitzwilliam Museum* by A. B. Wace. *Gnomon* 5: 289–91.

Lock, P. 1990. "D. G. Hogarth (1862–1927): 'A Specialist in the Science of Archaeology.'" *Annual of the British School at Athens* 85: 175–200.

Lord, L. E. 1947. *A History of the American School of Classical Studies at Athens 1882–1942.* Cambridge, Mass.

Lucas, A., and J. R. Harris. 1962. *Ancient Egyptian Materials and Industries.* 4th ed. London.

Lowenthal, D. 1985. *The Past Is a Foreign Country.* Cambridge, Mass.

Lullies, R. 1988. "Georg Karo 1872–1963." In R. Lullies and W. Schiering, eds., *Archäologenbildnisse. Porträts und Kurzbiographien von klassischen Archäologen deutscher Sprache*, 181–82. Mainz.

MacEnroe, J. 1995. "Sir Arthur Evans and Edwardian Archaeology." *Classical Bulletin* 71: 3–18.

MacGillivray, J. A. 2000. *Minotaur: Sir Arthur Evans and the Archaeology of the Minoan Myth.* New York.

MacGillivray, J. A., J. M. Driessen, and L. H. Sackett, eds. 2000. *The Palaikastro Kouros: A Minoan Chryselephantine Statuette and Its Aegean Bronze Age Context (British School at Athens Studies 6).* London.

Mackenzie, D. 1903. "The Pottery of Knossos." *Journal of Hellenic Studies* 23: 157–205.

MacKenzie, D. A. 1917. *Myths of Crete and Prehistoric Europe.* London.

Mann, A. T., and J. Lyle. 1995. *Sacred Sexuality.* Shaftesbury, Eng.

Marinatos, N. 1984. *Art and Religion in Thera: Reconstructing a Bronze Age Society.* Athens.

———. 1989. "The Bull as Adversary: Some Observations on Bull-hunting and Bull-leaping." *Ariadne* 5: 23–32.

———. 1993. *Minoan Religion: Ritual, Image, Symbol.* Columbia, S.C.

Marinatos, N., and R. Hägg. 1983. "Anthropomorphic Cult Images in Minoan Crete." In O. H. Krzyszkowska and L. Nixon, eds., *Minoan Society, Proceedings of the Cambridge Colloquium 1981,* 185–202. Bristol, Eng.

Marinatos, Sp. 1941. "The Cult of Cretan Caves." *Review of Religion* 5: 129–36.

———. 1966. "Necrology [Georg Karo]." *American Journal of Archaeology* 70: 73.

Marinatos, Sp., and M. Hirmer. 1986. *Kreta, Thera und das mykenische Hellas.* 3rd ed. Munich.

Maskell, A. 1905. *Ivories.* London. Reprint: Rutland, Vt., 1966.

Massachusetts Biographical Dictionary. 1988. St. Clair Shores, Mich.

Matton, R. 1955. *La Crète antique.* Athens.

Matz, F. 1958. *Göttererscheinung und Kultbild im minoischen Kreta. Akademie der Wissenschaften und der Literatur in Mainz; Abhandlungen der Geistes- und Sozialwissenschaftlichen Klasse,* no. 7. Wiesbaden.

McDonald, W. A., and C. G. Thomas. 1990. *Progress into the Past.* 2nd ed. Bloomington, Ind.

McDowell, C. 1997. "Treasured Chests." *Times* (London), 26 Jan.: Style sec.: 9.

McNeal, R. A. 1974. "The Legacy of Arthur Evans." *California Studies in Classical Antiquity* 6: 205–20.

Medwid, L. M. 2000. *The Makers of Classical Archaeology: A Reference Work.* New York.

Métraux, G. P. R. 1995. *Sculptors and Physicians in Fifth-Century Greece: A Preliminary Study.* Montreal.

Meyer, K. E. 1973. *The Plundered Past: Traffic in Art Treasures.* New York.

Modiano, M. 1987. "British Dig Uncovers Earliest Gilt-Ivory Sculpture of Cretan Zeus." *Times* (London), 9 June: 18.

Momigliano, N. 1999a. *Duncan Mackenzie: A Cautious Canny Highlander at the Palace of Minos at Knossos.* London.

——— . 1999b. "A Note on A. J. Evans's *The Palace of Minos: A Comparative Account of the Successive Stages of the Early Cretan Civilization as Illustrated by the Discoveries at Knossos.*" In P. P. Betancourt et al., eds., *Meletemata: Studies in Aegean Archaeol-*

ogy Presented to Malcolm H. Wiener as He Enters His 65th Year. *Aegaeum* 20, 493–501. Liège, Belgium.

Motz, L. 1997. *The Faces of the Goddess.* Oxford.

Muhley, J. D., ed. 2000. *One Hundred Years of American Archaeological Work on Crete.* Athens.

Muhly, P. 1990. "The Great Goddess and the Priest King: Minoan Religion in Flux." *Expedition* 32, no. 3: 54–60.

Muscarella, O. W. 1977. "Unexcavated Objects and Ancient Near Eastern Art." In L. D. Levine and T. Cuyler Young, Jr., eds., *Mountains and Lowlands,* 153–207. Malibu, Calif.

Museum of Fine Arts, Boston. 1904. *Twenty-Eighth Annual Report for the Year 1903.* Cambridge, Mass.

———. 1905. *Twenty-Ninth Annual Report for the Year 1904.* Cambridge, Mass.

———. 1906. *Thirtieth Annual Report for the Year 1905.* Cambridge, Mass.

———. 1907. *Thirty-First Annual Report for the Year 1906.* Cambridge, Mass.

———. 1915. *Thirty-Ninth Annual Report for the Year 1914.* Boston.

———. 1919. *Museum of Fine Arts Handbook.* Boston.

Myers, J. W., E. E. Myers, and G. Cadogan, eds. 1992. *The Aerial Atlas of Ancient Crete.* Berkeley.

Neumann, E. 1963. *The Great Mother: An Analysis of the Archetype.* 2nd ed. Trans. R. Manheim. Bollingen Series 47. Princeton.

Nicholson, P. T., and I. Shaw, eds. 2000. *Ancient Egyptian Materials and Technology.* Cambridge, Eng.

Nilsson, M. P. 1950. *The Minoan-Mycenaean Religion and Its Survival in Greek Religion.* 2nd ed. Lund, Sweden.

Nissenson, M., and S. Jonas. 1995. *Snake Charm.* New York.

Obituary of Harriet Boyd Hawes. 1945. *Smith College Quarterly* (Aug.): 203.

Obituary of Lacey D. Caskey. 1944a. *New York Times,* 23 May: 23.

Obituary of Lacey D. Caskey 1880–1944. 1944b. *Bulletin of the Museum of Fine Arts* 42, no. 248:37–38.

Overbeck, J. 1868. *Die antiken Schriftquellen zur Geschichte der bildenden Künste bei den Griechen.* Leipzig.

Owens, G. A. 1996a. "Evidence for the Minoan Language (1): The Minoan Libation Formula." *Cretan Studies* 5: 163–206.

———. 1996b. "'All Religions Are One' (William Blake 1757–1827) Astarte/Ishtar/Ishassaras/Asasarame: The Great Mother Goddess of Minoan Crete and the Eastern Mediterranean." *Cretan Studies* 5: 209–18.

Palmer, H. 1962. *Greek Gods and Heroes.* Boston.

Panagiotaki, M. 1993. "The Temple Repositories of Knossos: New Information from the Unpublished Notes of Sir Arthur Evans." *Annual of the British School at Athens* 88: 49–89.

———. 1998. "The Vat Room Deposit at Knossos: Unpublished Notes of Sir Arthur Evans." *Annual of the British School at Athens* 93: 181–84.

Pantel, P. S., ed. 1992. *A History of Women in the West.* Vol. 1: *From Ancient Goddesses to Christian Saints.* Cambridge, Mass.

Papadopoulos, J. K. 1997. "Knossos." In M. de la Torre, ed., *The Conservation of Archaeological Sites in the Mediterranean Region: An International Conference Organized by the Getty Conservation Institute and the J. Paul Getty Museum, 6–12 May 1995,* 93–125. Los Angeles.

Pasquier, A., et al. 1994. "La Tiare de Saïtapharnès: histoire d'un achat malheureux." In Chantal Georgel, ed., *La Jeunesse des Musées,* 300–13. Paris.

Paton, J. 1951. *Medieval and Renaissance Visitors to the Greek Lands.* Princeton.

Paul, E. 1962. *Die falsche Göttin.* Heidelberg.

Pedley, J. G. 1998. *Greek Art and Archaeology.* Upper Saddle River, N.J.

Pendlebury, J. D. S. 1939. *The Archaeology of Crete.* London.

Perrot, G., and C. Chipiez. 1894. *History of Art in Primitive Greece.* London.

Petrakos, V. Ch. 1982. *Dokimio gia ten archaiologike nomothesia. Demosieumata tou Archaiologikou Deltiou* 29. Athens.

Picard, C. 1942–43. "E. Gilliéron (†1940)." *Revue archéologique* (6th series) 20:72–73.

Pickman, D. 1969. "Museum of Fine Arts, Boston: The First One Hundred Years." *Curator* 12, no. 4: 237–56.

Pijoán, J. 1946. *Summa Artis. Historia General del Arte.* Vol. 6: *El Arte Prehistórico Europeo.* 2nd ed. Madrid.

Pini, I. 1998. "The 'Ring of Nestor.'" *Oxford Journal of Archaeology* 17: 1–13.

Platon, N. 1971. *Zakros: The Discovery of a Lost Palace of Ancient Crete.* New York.

Plüss, E., ed. 1958–61. *Künstler Lexikon der Schweiz XX. Jahrhundert.* Frauenfeld, Switzerland.

Powell, D. 1973. *The Villa Ariadne.* London.

Praschniker, C. 1935. Review of *The Palace of Minos*, vol. 33, by A. J. Evans. *Wiener Jahrbuch für Kunstgeschichte* 10: 91–94.

Preston, D. 1999. "Woody's Dream." *The New Yorker* (15 Nov.): 80–87.

Radnoti, S. 1999. *The Fake: Forgery and Its Place in Art.* Lanham, Md.

Ramage, A., et al. 2000. *King Croesus' Gold: Excavations at Sardis and the History of Gold Refining.* Cambridge, Mass.

Ramsey, C. B., et al. 1999. "Radiocarbon Dates from the Oxford AMS System: *Archaeometry* Datelist 27." *Archaeometry* 41, no. 1: 197–206.

Rehak, P., and J. G. Younger. 1998. "International Styles in Ivory Carving in the Bronze Age." In E. H. Cline and D. Harris-Cline, eds., *The Aegean and the Orient in the Second Millennium. Proceedings of the 50th Anniversary Symposium, Cincinnati, 18–20 April, 1997* (*Aegaeum* 18), 229–54. Liège, Belgium.

Reid, J. D. 1993. *The Oxford Guide to Classical Mythology in the Arts 1300–1990s.* Oxford.

Reinach, S. 1906. "L'Artémis Arcadienne et la Déesse aux Serpents de Cnossos." *Bulletin de correspondance hellénique* 30: 150–60.

———. 1924. *Répertoire de la sculpture grecque et romaine.* Vol. 1. Paris.

Robinson, D. M. 1915. "Statuette from Crete." *Art and Archaeology* (Mar.): 211–12.

Robkin, A. L. H. 1984. "The Eye of the Beholder: Interpretations of the Human Form." In A. L. H. Robkin, ed., *Art and Archaeology in the Mediterranean World,* 60–65. Seattle.

Rogers, M., and G. Wohlauer. 1996. *Treasures of the Museum of Fine Arts, Boston.* Boston.

Rumpf, B. 1965. "The Museum's Boy God." *Puget Soundings* (Jan.): 25.

Said, E. W. 1978. *Orientalism.* New York.

Sakellarakis, J. 1998. Ἀρχαιολογικὲς ἀγωνίες στὴν Κρήτη τοῦ 19ου αἰώνα Herakleion, Crete.

Sanna, J. de. 1998. *De Chirico and the Mediterranean.* New York.

Schnapp, A. 1996. *The Discovery of the Past.* London.

Seager, R. B. 1912. *Explorations in the Island of Mochlos.* Boston.

Seltman, C. T. 1927. *Cambridge Ancient History.* Plates, vol. 1. Cambridge, Eng.

———. 1948. *Approach to Greek Art.* London.

———. 1955. *Women in Antiquity.* London.

Shaw, M. C. 1996. "The Bull-Leaping Fresco from Below the Ramp House at Mycenae: A Study in Iconography and Artistic Transmission." *Annual of the British School at Athens* 91: 167–90.

Shepsut, A. 1993. *Journey of the Priestess: The Priestess Traditions of the Ancient World. A Journey of Spiritual Awakening and Empowerment.* New York.

Sherratt, S. 2000. *Arthur Evans, Knossos and the Priest-King.* Oxford.

Sherrow, V. 1996. *Encyclopedia of Women and Sports.* Santa Barbara, Calif.

Small, M. R. 1962. *Oliver Wendell Holmes.* New York.

Smyth, G. I., ed. 1913–14. *Art Prices Current 1913–1914. Being a Record of Sale Prices at Christie's During the Season; Together with Representative Prices from the Sales of Messrs. Sotheby, Wilkinson & Hodge, and Messrs. Puttick & Simpson.* London.

Snijder, G. A. S. 1936. *Kretische Kunst.* Berlin.

Sox, D. 1987. *Unmasking the Forger: The Dosenna Deception.* New York.

Spanaki, S. G. 1960. "Ἡ οἰκογένεια τῶν Καλοκαιρινῶν τῆς Κρήτης." *Kretika Chronika* 14: 271–307.

Spretnak, C. 1978. *Lost Goddesses of Early Crete: A Collection of Pre-Hellenic Myths.* Boston.

Stillman, W. J. 1881. "Extracts from Letters of W. J. Stillman Respecting Ancient Sites in Crete." *Appendix to the Second Annual Report of the Executive Committee of the Archaeological Institute of America 1880–81,* 41–49. Cambridge, Mass.

————. 1901. *Autobiography of a Journalist.* Boston.

Stos-Gale, Z. A., and N. H. Gale. 1984. "The Minoan Thalassocracy and the Aegean Metal Trade." In R. Hägg and N. Marinatos, eds., *The Minoan Thalassocracy: Myth and Reality. Proceedings of the Third International Symposium at the Swedish Institute in Athens, 31 May–5 June, 1982,* 59–63. Stockholm.

Streep, P. 1994. *Sanctuaries of the Goddess: The Sacred Landscapes and Objects.* Boston.

Stürmer, V. 1995a. *Gilliérons Minoisch-Mykenische Welt. Eine Austellung des Winckelmann-Instituts.* Berlin.

————. 1995b. "Gilliérons Aquarell-Kopien der Fresken von Hagia Triada." In D. Rössler and V. Stürmer, eds., *Modus in Rebus. Gedenkschrift für Wolfgang Schindler,* 201–5. Berlin.

Symonds, M., and L. Preece. 1928. *Needlework through the Ages.* London.

Taylor, K. 1992. "The Mystery of the Bull Leaper." *Toronto Globe and Mail,* 14 May: Arts sec.

Temin, C. 1991. "Author Questions Origin of Prized MFA Statue." *Boston Globe,* 12 July: 50.

Thiersch, H. 1906. "Die übrigen Weigeschenke." In A. Fürtwangler, ed., *Aegina. Das Heiligtum der Aphaia* 1: 370–469. Munich.

Traill, D. 1995. *Schliemann of Troy: Treasure and Deceit.* New York.

Trigger, B. 1989. *A History of Archaeological Thought.* Cambridge, Eng.

Ucko, P. J. 1996. "Mother, Are You There?" *Cambridge Archaeological Journal* 6: 300–304.

Van Rensselaer, M. G. 1916. "A Cretan Snake Goddess." *Century Magazine* 92, no. 70: 545–51.

Vaughan, A. C. 1959. *The House of the Double Axe.* Garden City, N.Y.

Verlinden, C. 1984. *Les statuettes anthropomorphes crétoises en bronze et en plomb, du IIIe millénaire au VIIe siècle av. J.-C.* (Archaeologia Transatlantica 4). Louvain, Belgium.

Vermeule, C. C., III. 1982. *The Art of the Greek World: Prehistoric Through Perikles.* Boston.

Vermeule, E. T. 1959. "A Gold Minoan Double Axe." *Bulletin of the Museum of Fine Arts, Boston* 57, no. 307: 4–14.

Vollmer, H., ed. 1955. *Allgemeines Lexikon der bildener Künstler des XX. Jahrhunderts.* Leipzig.

Wace, A. J. B. 1927. *A Cretan Statuette in the Fitzwilliam Museum.* Cambridge, Eng.

Waddell, L. A. 1930. *The British Edda.* London.

Warburg, A. 1938–39. "A Lecture on Serpent Ritual." *Journal of the Warburg Institute* 2: 277–92.

Warren, P. 1987. "The Ring of Minos." In L. Kastrinaki, G. Orphanou, and N. Giannadakes, eds., *Eilapine: tomos timetikos gia ton kathegete Nikolao Platona,* 486–500. Herakleion, Crete.

———. 2000. "Sir Arthur Evans and His Achievement." *Bulletin of the Institute of Classical Studies* 44: 199–211.

Wason, C. R. 1932. "Cretan Statuette in Gold and Ivory." *Bulletin of the Royal Ontario Museum of Archaeology* (University of Toronto) 9 (Mar.): 1–12.

Waterhouse, H. 1986. *The British School at Athens: The First Hundred Years* (British School at Athens suppl. vol. 19). London.

Watson, P. 1997. *Sotheby's: The Inside Story.* New York.

Waugh, E. 1930. "A Pleasure Cruise in 1929." In Waugh, *A Bachelor Abroad.* New York. Reprinted in *Labels. A Mediterranean Journal.* London, 1930. Reprint, 1974.

Werness, H. B. 1983. "Han van Meegeren *fecit.*" In D. Dutton, ed., *The Forger's Art,* 1–37. Berkeley.

Whitehill, W. M. 1970. *Museum of Fine Arts, Boston: A Centennial History.* Cambridge, Mass.

Wilde, L. W. 2000. *On the Trail of the Women Warriors: The Amazons in Myth and History.* New York.

Williams, D. 1996. "T. B. Sandwith's Cretan Collection." In D. Evely, et al., eds., *Minotaur and Centaur: Studies in the Archaeology of Crete and Euboea Presented to Mervyn Popham,* 100–104. Oxford.

Winstone, H. V. F. 1990. *Woolley of Ur: The Life of Sir Leonard Woolley.* London.

Witcombe, C. L. C. E. 1998. "The Minoan 'Snake Goddess.'" At http://www.arthistory.sbc.edu/imageswomen/aegeanindex.html.

Wohlauer, G. S. 1999. *A Guide to the Collections of the Museum of Fine Arts, Boston.* Boston.

Woodhouse, C. P. 1976. *Ivories.* Newton Abbot, UK.

Woodward, A. M. 1949. "The Gortyn 'Labyrinth' and Its Visitors in the Fifteenth Century." *Annual of the British School at Athens* 44: 324–25.

Woolley, C. L. 1958. *History Unearthed.* London.

———. 1962. *As I Seem to Remember.* London.

Yalom, M. 1997. *A History of the Breast.* New York.

Young, W. J. 1959. "Technical Examination of a Minoan Gold Double Axe." *Bulletin of the Museum of Fine Arts, Boston* 57, no. 307: 17–20.

Younger, J. G. 1985. "Aegean Seals of the Late Bronze Age: Stylistic Groups, IV. Almond- and Dot-Eye Groups of the Fifteenth Century B.C." *Kadmos* 24: 34–73.

Acknowledgments

This book could not have been written without the kindness and co-operation of many scholars and friends who generously provided information, suggestions, and criticism, as well as access to artifacts and documents. Numerous museum officials searched for, located, and allowed me to study and publish here the often obscure objects, notebooks, diaries, and letters in their care. I am especially grateful to John J. Herrmann Jr., co-curator of the Department of Ancient Art at the Museum of Fine Arts, Boston, who took the risk of fostering this study, and to his colleagues, past and present: Cornelius C. Vermeule III, Mary B. Comstock, Laura M. Gadbery, Pamela J. Russell, Florence Wolsky, Rebecca Reed, and Amy Raymond. Richard Newman, head of Scientific Research, kindly provided results of scientific tests. Michael Vickers, at the Ashmolean Museum in Oxford, in addition to introducing me to Ron Phillips, provided valuable assistance, as did Nicoletta Momigliano, Susan Sherratt, and Julie Clements in the Evans Archive, who responded to numerous queries with alacrity and alerted me to still more relevant material. I am also grateful to Paul Pettitt of the Radiocarbon Accelerator Unit of Oxford University's Research Laboratory for Archaeology and the History of Art. John Donaldson and Eleni Vassilika facilitated my research at the Museum of Classical Archaeology and the Fitzwilliam Museum in Cambridge. In Baltimore, Ellen D. Reeder, Terry C. Weiser, Donna Strahan, Carol Benson, and Christianne Henry assisted me at the Walters Art Gallery. In Cambridge, Massachusetts, Amy Brauer provided access to the Harvard University Art Museums' collection of Gilliéron replicas.

J. Lesley Fitton, at the British Museum, answered numerous queries. Claire L. Lyons of the Getty Center for the History of Art in Los Angeles alerted me to the existence of photographs in the Komor Archive of a lost statuette. Dietrich von Bothmer, Elizabeth Milleker, Oscar White Muscarella, Carlos Picón, Christine Lilyquist, and Seán Hemingway of the Metropolitan Museum of Art all lent their assistance and expertise, as did Jay Gates, Gail Joice, Trevor Fairbrother, Christina Oldknow, P. Sims, and Melissa Klotz at the Seattle Art Museum, and Neda Leipen, Alison H. Easson, Julia D. Fenn, and A. Margani at the Royal Ontario Museum in Toronto.

Excavators and museum officials in Crete have graciously permitted me to examine their finds. I am particularly grateful to Joseph Alexander MacGillivray, L. Hugh Sackett, and Mark Moak (Palaikastro), M. S. F. Hood (Knossos), and Yannis Sakellarakis (Archanes).

Thanks are also due to Mark Patterson and Arthur Evans's trustees; Natalia Vogiekoff and the American School of Classical Studies at Athens; Alessandro Pezzati and Ann Brownlee at the University of Pennsylvania Museum; and the Managing Committee of the British School at Athens.

My research was generously supported by the Department of Classics and the Graduate Division of the University of California at Berkeley; the Center for Advanced Study in the Visual Arts at the National Gallery, Washington, D.C.; the Graduate School of Arts and Sciences at Boston University; and the Institute for Aegean Prehistory. I have presented the results of that research in abbreviated form at the 1996 annual meeting of the College Art Association in Boston, the "Techne" Aegean Conference in Philadelphia, the Albright-Knox Gallery in Buffalo, the Mycenaean Seminar at the University of London, the University of Washington in Seattle, and at Brown University. I am grateful to those who invited me to speak on those occasions and to audience members who asked stimulating questions and provided additional information. Abstracts of some of those talks have appeared in print, as have my articles on this topic in *Source:*

Notes on the History of Art (2000), *The Journal of Mediterranean Archaeology* (2000), and *Archaeology* (2001); the editors of these journals have kindly allowed me to reproduce some of that material here. I am grateful as well to Morgan Baird, Ian Begg, Patricia Berman, Harriet Blitzer, John S. Bowman, John Cherry, Robert Cohon, Kathleen Coleman, A. A. Donohue, Kenneth Gaulin, David Gill, Alfredo Gilliéron, Émile Gilliéron III, Nonna Gilliéron, Crawford H. Greenewalt jr, Mark Hall, Christopher Hallett, Yannis Hamilakis, Christina Haywood, Louise Hitchcock, Bernard Knapp, Michael Koortbojian, Andreas Lapourtas, K. Lewartowski, William Loerke, Nannó Marinatos, Elizabeth Marlowe, Miranda Marvin, Murray McClellan, Michael Melford, C. Hays Miller, Stephen G. Miller, Sarah Morris, Maria Mouliou, Walter Müller, Oscar White Muscarella, Jenifer Neils, Danielle Newland, Tom Palaima, Marina Panagiotaki, John Papadopoulos, Ron Phillips, Ingo Pini, Bruce Redford, Paul Rehak, Beatrice Rehl, Maria Shaw, Joanna Smith, Jacqueline Spafford, Richard Stadtherr, Andrew Stewart, Veit Stürmer, Sarolta Takács, Michael Tillotson, Francesca Tronchin, Peter Warren, L. Vance Watrous, Judith Weingarten, H. V. F. Winstone, and John Younger, all of whom provided information, suggestions, and other assistance. I am also grateful to those individuals and institutions who helped me secure photographs and permissions, especially Christopher Atkins and Kristin Bierfelt (Museum of Fine Arts, Boston), Victoria Burrows (Mark Patterson and Associates), Julie Clements (Ashmolean Museum), Sylvia Diebner and Georgia Migotta (Deutsches Archäologisches Institut, Rome), Hans Goette (Deutsches Archäologisches Institut, Athens), Adam Grummitt (National Portrait Gallery, London), Sandra Hachey and Bo Mompho (Davis Museum and Cultural Center, Wellesley College), Iain Harrison (Birmingham [England] Museum and Art Gallery), Amalia Kakissis (British School at Athens), Giovanni Lattanzi (Rome), Kate Lau (Walters Art Gallery), Rich Lingner (Isabella Stewart Gardner Museum), Marie Mauzy and Natalia Vogeikoff (American School of Classical Studies at Athens), Tom Palaima and J. P. Olivier, Michael Hamilton (Boston), and Julie

Yankovsky (Shelburne Museum, Vermont). Thanks also to Harry Foster, Julie Burns, Elizabeth Kluckhohn, the amazing Peg Anderson, and Anne Chalmers at Houghton Mifflin.

A special debt of gratitude is owed to Olga Krzyszkowska for her unstinting generosity and encouragement, and to my own personal Goddess, Marina Belozerskaya, whose patience and insight have improved the text immeasurably.

None of the above-mentioned, of course, is responsible for any errors that may remain, nor do they necessarily share the opinions expressed.

ILLUSTRATION CREDITS

The author and publisher are grateful to all individuals and institutions that provided photographs and permissions as well as those who facilitated their acquisition. All images from the publications of Arthur Evans, as well as quotations from his books, articles, letters, notes, and diaries, are reproduced by permission of Mark Paterson and Associates on behalf of The Sir Arthur Evans Trust. All images from the Museum of Fine Arts are reproduced with permission. © 2000 Museum of Fine Arts, Boston. All rights reserved.

FIG. NO.

frontispiece, 1.1, 1.11: MFA 14.843, gift of Mrs. W. Scott Fitz. Courtesy of the Museum of Fine Arts, Boston.

1.2: Courtesy of the Museum of Fine Arts, Boston.

1.3: Courtesy of the Ashmolean Museum, Oxford.

1.4: Courtesy of the American School of Classical Studies at Athens.

1.5, 1.6: Photos by Michael Hamilton. Letters reproduced by permission of the Museum of Fine Arts, Boston.

1.7: MFA 65.631, bequest of Mrs. Edward Jackson Holmes, Edward Jackson Holmes Collection. Courtesy of the Museum of Fine Arts, Boston.

1.8: Chase and Vermeule 1963, frontispiece and title page. Reproduced by permission of the Museum of Fine Arts, Boston.

1.9: Photo by the author.

1.10: Courtesy of *Mademoiselle.* Copyright © 1967 by the Condé Nast Publications, Inc.

1.12 Courtesy of the Museum of Fine Arts, Boston.

1.13, 1.14: Photos by Michael Hamilton. Courtesy of the Museum of Fine Arts, Boston.

1.15: Reproduced by permission of the British School at Athens.

2.1: Courtesy of the Deutsches Archäologisches Institut, Rome.

2.2: Courtesy of the Isabella Stewart Gardner Museum, Boston.

2.3: Photo courtesy of Giovanni Lattanzi.

2.4: Courtesy of the Birmingham Museums & Art Gallery.

2.5: Papadopoulos 1997, fig. 3. Reproduced by permission of John Papadopoulos.

2.6: Pashley 1837, vol. 1, plate opp. p. 208.

2.7: Spanaki 1960.

2.8: Davis Museum and Cultural Center no. 1959.29.5 and 1939.2. Courtesy of the Davis Museum and Cultural Center, Wellesley College, Wellesley, Mass.

2.9: Knossos K (1)740 or K (1)829+874. From the archives of the Program in Aegean Scripts and Prehistory, University of Texas at Austin. Courtesy of T. G. Palaima and J.-P. Olivier.

2.11 Evans, *PM* 1, fig. 1.

2.10, 2.12, 2.19: Courtesy of the Ashmolean Museum, Oxford.

2.13: Courtesy of the Alison Frantz Photographic Collection, American School of Classical Studies at Athens.

2.14: Photo by Michael Hamilton.

2.15: Evans, *PM* 3, suppl. pl. XXXVIII.

2.16: Evans, *PM* 3, fig. 296.

2.17: Evans, *PM* 1, frontispiece and title page.

2.18: Evans, *PM* 1, fig. 333.

2.19: Courtesy of the Ashmolean Museum, Oxford.

2.20: Evans, *PM* 1, fig. 362.

2.21, 2.22: Photos by the author.

3.1: Evans 1901, p. 185.

3.2: Evans, *PM* 3, fig. 323.

3.3: Detail of Fig. 2.19.

3.4: Evans, *PM* 1, fig. 377.

3.5: Courtesy of the Deutsches Archäologisches Institut, Athens.

3.6: © Shelburne Museum, Shelburne, Vermont.

3.7: By courtesy of Fine Art Photographs, London.

3.8: Mackenzie 1917, title page and frontispiece.

3.9: Mackenzie 1917, plate opp. p. 58.

3.10: Waddell 1930, title page and frontispiece.

3.11: MFA 45.95, gift of Mrs. Eta Hentz. Courtesy of the Museum of Fine Arts, Boston.

3.12: Louvre, Département des Antiquités orientales AO 11601. © Pierre et Maurice Chuzeville/Musée du Louvre.

3.13: Photo courtesy of O. H. Krzyszkowska.

4.1–4.5: Courtesy of the Walters Art Museum, Baltimore.

4.6: Evans, *PM* 3, fig. 309.

4.7: Photo by the author.

4.8: Courtesy of the National Portrait Gallery, London.

4.9: Evans, *PM* 3, fig. 318.

4.10: Evans, *PM* 3, fig. 319.

4.11: Evans, *PM* 3, fig. 320.

4.12: Reproduced by permission of the Syndics of the Fitzwilliam Museum.

4.13: Evans, *PM* 4, fig. 394.

4.14: Evans, *PM* 4, pt. 1, suppl. pl. XLIII.

4.16: Evans, *PM* 3, fig. 123.

4.17: Bossert 1921, p. 11.

5.1, 5.3–5.13: Courtesy of the Ashmolean Museum, Oxford.

5.2: Coubertin 1897, p. 44.

5.14: Photos by the author.

5.15: Evans, *PM* 2, fig. 450.

5.16: Evans, *PM* 1, fig. 397.

5.17: Gilliéron n.d., title page.

5.18: Courtesy of the Metropolitan Museum of Art, Rogers Fund, 1920, 20.100.1.

5.19: Evans, *PM* 2, suppl. pl. XVII.

6.1: Courtesy of the Deutsches Archäologisches Institut, Athens.

6.2–6.6: Photos by the author. Reproduced by permission of the American School of Classical Studies at Athens.

7.1: Courtesy of H. Sackett, J. A. MacGillivray, and M. Moak.

7.2: Evans, *PM* 3, fig. 104.

7.3: Courtesy of the Ashmolean Museum, Oxford.

7.4: Photo by the author.

7.5: Evans, *PM* 4, pt. 1, suppl. pl. XLIV.

7.6: Evans, *PM* 4, pt. 1, suppl. pl. XLVII.

7.7: Evans, *PM* 4, pt. 1, fig. 152.

7.8: Evans, *PM* 3, fig. 293.

7.9: Courtesy of Dietrich von Bothmer.

7.10: Photos by Peter Juley from the Matthias Komor Collection. Courtesy of the Getty Research Institute, Los Angeles.

7.11, 7.12: Photos by the author.

8.1, 8.6: Courtesy of the Ashmolean Museum, Oxford.

8.2 Marinatos 1984, fig. 70. Reproduced by permission of Nannó Marinatos.

8.3: Courtesy of the Museum of Fine Arts, Boston.

8.4: Detail of Fig. 2.15.

8.5: Photo by the author.

8.6: Courtesy of the Ashmolean Museum, Oxford.

INDEX

Page numbers in italics indicate illustrations.

Adonis (god), *72*

Adonis, Attis, and Osiris (Frazer), 71, 91, 104

Aegean Bronze Age, 40, 72, 133, 136, 178, 184, 185, 186, 187, 202n

archaeologists of, 7, 17, 219n4

artifacts of, at Museum of Fine Arts, 15, 16, 143, 176

See also Arkhalokhori; Gournia; Knossos; Mochlos; Mycenae; Orchomenos; Palace of Minos; Palaikastro; Phaistos; Pseira; Troy

Aegean Civilization (Glotz), 171

Aegeus, King, 33

Agamemnon, 37

Alexander the Great, 41, 58

Alfred, Prince, duke of Edinburgh, 40

American School of Classical Studies at Athens, 7–8, 19, 23, 143, 147, 150, 151–52

Anatolia. *See* Turkey (Ottoman Empire; Anatolia)

Ancient Egyptian Materials and In-dustries (Lucas and Harris), 186

Antoniou, Gregori, 127, 170

Aphrodite (goddess), 65, 67, 72, 89

"Aphroditian hetairism," 68

"Bartlett head" of, 16

"of Knôsos," *70*

Apollodoros, 71, 213n23

Archaeological Institute of America, 43

Ariadne, 9, 33, 49, 65, 81

"Throne of," 50

Aristides, 20

Arkhalokhori, Greece, sacred cave at, 17

Art Deco architecture, 131

Artemis (goddess), 65, 67, 89, 90

Arthur, King, 85

Art in Bloom festival (MFA, Boston), 16

art market, international, 91–92, 96–98

Art Nouveau, 100, 134

architecture, 131

Ashmole, Elias, 1

Ashmolean Museum, Oxford, England, 1, 97, 139

Cretan gold analyzed, 226n15
Evans and, 19, 64, 100
Evans donates artifacts to, 3, 98, 108, 164, 173, 174, 185
Evans as keeper of, 3, 59, 137, 156, 207n11
Hogarth as keeper of, 192
See also Boy-Gods
Asia, matriarchal myths of, 68
As I Seem to Remember (Woolley), 171
Asklepios (healing god), 80
Assyrian script, 38. *See also* writing systems
Astarte/Ashtoreth (goddess), 72, 75
Athena (goddess), 65, 67, 80, 89, 90
 chryselephantine statue of, 7
 Snake Goddess thought to be prototype of, 71
Athens National Archaeological Museum, 133, 183
 Mycenaean Room, 8
Agora (Athens), excavations of, 147
Atlantis, 8, 9
Attis (god), 72
ax. *See* Double Axes

Babylonian script, 38. *See also* writing systems
Bachofen, Johann Jakob, 30, 67–68, 70–71, 72, 104, 114, 191
Bagge, Halvor, 62, 75, 87, 120
Baltimore Snake Goddess (ivory), *94, 95,* 110, 142, 178, 194, 223n23

"provenience" of, 92, 141, 182
restoration of, 93, 143, 182–83
See also Snake Goddesses; Walters Art Gallery
Baudelaire, Charles, 54
Belli, Onorio, 39
Berlin Museum, 38
Blegen, Carl W., 151, 152, 191
Bloomer, Amelia, 115
"Blue Boy" fresco, 133, *134. See also* frescoes
Boccaccio, Giovanni, 31
Boiotia, Greece, 40, 104, 157
Bosanquet, Robert Carr, 100
Boston Snake Goddess (Museum of Fine Arts 14.863), *frontispiece, 3, 5, 14, 15, 17, 24, 26, 84, 104, 180,* 194
 age of, 7, 8, 85
 analytical report on, 196–204
 arrival in Boston, 13–14, 20–23, 25–29, 64, 141–52, 153, 172
 condition of, 142, 197
 as gift of Mrs. Fitz, 4, 7, 10, *11 (letter),* 13, 14, 23, 143, 146, 150
 Boy-God linked to, 96, 99–101, 103, 110, 118, 174
 as deity, 75
 descriptions of, 7, 9, 14–16, 23, 118
 face of, 14, 23, 87, 102, 154, 179–81
 "modern" appearance, 28, 96, 100, 181
 fame and popularity of, 14–16
 garments of, 7, 93, 113, 140, 178, 182
 mythologized, 9, 82–85

Boston Snake Goddess, (*cont.*)
 parallels adduced to, 86–87, 154
 lacking, 178–79
 price of, 12–13, 146, 149, 150, 152
 origins of, 8–9, 20–23, 25–26,
 27–29, 149, 152, 187
 "Cretan peasant" story, 23, 25,
 27, 141, 143
 defended, 153–56
 Evans supplies, 21–22, 58, 96,
 159
 fragments in tin box, 23, 25,
 26, 139, 185, 198
 questions about, 16–17, 27–29,
 65, 85, 87, 91, 152, 153, 176–
 88, 196
 statuette illegally exported,
 146–47
 reconstructions of, 15, 22–23, 25,
 87, 140, 152, 154, 196–99
 alleged ancient repair, 182
 replicas of, 140
 Seager's concern for, 2–3, 143,
 144, 147–51, 153–56
 statuettes resembling, 60, 62–
 64
 See also Snake Goddesses; Mu-
 seum of Fine Arts
Boy-Gods, 92
 carbon-14 tests of, 184–85
 exhibited in London, 110
 Oxford, 98, 108, *109*, 110, 172, *175*,
 194
 forgery of, 174
 gender of, 110, 173, 174
 origins of, 101, 104, 108, 158–59,
 172
 restoration of, 140, 173, 207n11
 Seattle ("Divine Child"), *97*, *99*,

98–106, *104*, 140–41, 158–59,
 179, 184–85, 194
gender of, 173–74
gold loincloth of, 101, 173, 174
linked to Boston Goddess,
 96, 99–101, 103, 110, 118, 174
parallels for, 102
sold to Seattle Art Museum,
 99
See also Ashmolean Museum;
 Seattle Art Museum
British Edda, The (Waddell), *84*,
 85
British Empire, 35
British Medical Journal, 52
British Museum (London), 40, 42,
 43, 153
British School (Athens), 27, 106,
 110, 124, 150, 210n16
Britomartis (goddess), 65
bronze figurines and objects, 107,
 121, 160
 Bronze Youth, 104, 195
 looted by peasants, 17
bull leapers, 56, 111, *112*, 113, 115–18,
 116, 174. *See also* leaping
 figures
bull of Minos. *See* Minotaur, myth
 of
bull relief at Palace of Minos, 59
bull's hoof in fresco, 47
Butcher, Kevin, 106, 108
Byzantine empire, 37, 133, 186,
 205n1

Calasso, Roberto, 31
Calvert, Frank, 37
Cambridge Ancient History
 (Seltman), 108

Cambridge Ritualists, 71
Cambridge statuettes (stone), 170
 Snake Goddess, *161*, 195
 See also Fitzwilliam Goddess
Candia (now Herakleion), Crete, 39, 107
 early history of, 205–6n1
 forgeries produced at, 43
 smuggling from, 20
Candia (Herakleion) Archaeological Museum, 8, 45, 62, 118, 172
 forgeries at, 168, 169–70
Capps, Edward, 19
carbon dating. *See* Radiocarbon dating
Caskey, John, 143
Caskey, Lacey D., *6*, 191
 at American School of Classical Studies at Athens, 7, 143
 and Boston Goddess, 14, 22–23, 27, 82, 142, 146, 154, 182, 183
 and green soap tin, 25–26, 185, 198
 on origins of, 8–9, 16–17, 29, 149, 151–52
 at Boston Museum, 4, 143
Celtic mythology, 86, 179
Champollion, Jean François, 38
Chania, Crete, 39
Charbonneaux, Jean, 58
"Chess Queen" at Walters Art Gallery, *95, 96*, 159, 167, 194
 See also Walters Art Gallery
Chirico, Giorgio de, 121
Christ and Christianity, 72, 76, 79
 Judeo-Christian tradition, 89

Christie's (auction house), 13
chryselephantine statuettes, 6–7, 8, 22, 29, 154, 164
 forgeries of, 170
 Palaikastro Youth, *155*, 172–73, 179, 180, 181
 See also Boston Snake Goddess; gold; ivory statuettes
Clark, Kenneth, 99–100, 134
Clarke, T. H. M., 52
clay tablets, inscribed. *See* Knossos tablets
Cleopatra, 81
Clodion (Claude Michel), 42
clothing, fashions in, 85, *86*, 119.
 See also women
Cockerell, Sydney, 98, 99, 106, 107, 110
Comstock, M., 208n29
Constantinople, 40, 44. *See also* Turkey (Ottoman Empire; Anatolia)
Copper and copper-gold alloy, 179, 186, 202, 204
Corinth, excavations at, 147
Corinth Lady, 143
Cretan Goddess, 74. *See also* Mother Goddess
Cretan Statuette in the Fitzwilliam Museum, A (Wace), 107
Cretan Syllogos (society), 45, 121, 192
Crete
 ancient scripts of, 46, 65, 90
 antiquities looted from, 17–18
 Boston Goddess said to come from, 17, 27, 29, 85 (*see also* Boston Snake Goddess: origins of)

Crete, (*cont.*)
 bronze figurines from, 104, 107
 as cradle of European civiliza-
 tion, 55–56, 59
 "Cretan peasant" story, 23, 25,
 27, 141, 143
 Evans first visits, 36, 38
 Evans's view of, 51, 52, 55
 excavations on, 40, 45
 female deities of, 73, 87, 89–90
 gemstones from, *see* sealstones,
 engraved
 independence of, 45, 55, 205–6n1
 laws controlling export of an-
 tiquities, 19–20
 Minoan culture on, *see* Minoan
 civilization
 Minos as legendary king of, *see*
 Minos, King
 Mycenaean domination of, 65
 mythology of, *see* Greek my-
 thology
 and Ottoman Empire, 18, 40, 44
 "Prehistoric Sanitation in," 52
 Seager's illness and death in, 2
 "Tanagra" figurines from, *41*
 in World War II, 85
Crete: The Forerunner of Greece
 (Hawes and Hawes), 55,
 156
Currelly, Charles T., 110–12

Daidalos myth, 9, 31, 33, *34*, 38, 58,
 211–12n33
Darwin, Charles, 72
Degas, Edgar, 16
Demeter (goddess), 65, 67, 69
Diana. *See* Artemis (goddess)

Dictynna (goddess), 65
Diodoros of Sicily, 33, 35
Dionysos (god), 90
Discus Thrower (sculpture), 59
"Divine Child." *See* Boy-Gods
Divine Mother, 80. *See also*
 Mother Goddess; Snake
 Goddesses
dix-neuf cent style, 100, 134
Dodd, Francis, 98
Dossena, Alceo, 168
Double Axes
 Goddess of the, 74
 Hall of the (Palace of Minos),
 127, *177*
 miniature gold, 17
Dove Goddess, 74, 81. *See also*
 Mother Goddess
Duncan, Isadora, 55
Duncan, John, 83
Dürer, Albrecht, 31
Dussaud, René, 52, 81–82
Dying God exemplified, 72

Earth Goddess, 71, 74, 81. *See also*
 Mother Goddess
Egypt, ancient, 37, 65, 82
 deities of, 72, 75, 80, 82
 Egyptian curse, 2
 Eighteenth Dynasty gold, 186
 kings of, 35
 language deciphered, 38
 Minoan culture and workman-
 ship compared to, 9, 18, 36,
 55, 75, 81, 182
Egyptian Girl with Snakes (paint-
 ing by Francis Bramley
 Warren), 82, *83*

Eileithyia (goddess), 65
Elgin, Lord (Thomas Bruce), 19
Endymion (god), 72
engraved gems or seals. *See*
 sealstones, engraved
Epicharmus, 176
Eta, Madame (Eta Valer Hentz),
 85, 140
 gown designed by, *86*
Europa myth, 31, *32*, 65, 81
Evans, Sir Arthur, 8, *99*, 191
 and Ashmolean Museum, 19,
 64, 100
 donations to, 3, 98, 108, 164,
 173, 174, 185
 as keeper of, 3, 59, 137, 156,
 207n11
 as author, see *Palace of Minos at
 Knossos, The*
 begins investigations, 30, 36–
 38
 biography of (*Time and
 Chance*), 45
 and Boston Goddess, 4, 21–22,
 28, 58, 96, 153, 154, 159, 178
 and Boy-Gods, *see* Boy-Gods
 correspondence of, 19, 21
 excavations and discoveries by,
 7, 9, 27, 29, 44–46, 70, 71,
 170, 179, 180
 frescoes, 13, 46
 Palace of Minos, 2, 9, 35, 46–
 52, 60–64, 120–36, 170
 unauthorized, 18–19, 20, 21,
 146, 178
 and Fitzwilliam Goddess, 106,
 107
 honors received by, 59

and "Our Lady of the Sports,"
 111, 113–18, 172
 Minoan culture as viewed by,
 35, 51–52, 54–59, 70, 74–76,
 161–62, 174
 Frazer's influence, 71–72
 and Mother Goddess, 73, 74, 80,
 87–89
 "Snake Mother," 160–62
 mother's death, 66–67
 private collection of, 91, 96, 98,
 100, 140, 207n11
 purchases by, 18, 157–58
 and restorations and replicas,
 137–38, 140, 168, 169, 171, 175
 of Palace of Minos, 50–51,
 120–36, 170
 scripts identified by, 65
 and Seager's illness and death, 2
 and Snake Goddesses, 74–76,
 80–82, 160–62
 and "truth in myth," 35
Evans, Joan, 45, 51, 66
Evans, Sir John, 36, 45, 56, 66, 72,
 176
Evans, Mrs. John (Harriet), 66–67
Evans Archive, 3
Eve, 77, 81, 85
evolutionism, 72, 73

faience images from Knossos, 8, 71,
 60, 60–64, *63*, 65, 75, 76, *77*,
 81–82, 87, 120, 164, 173, 177–78
Fairbanks, Arthur, 7, 14, 143, 144,
 149, 151, 191, 206n2
 correspondence with Mrs. Fitz,
 10, *11*, 12–13, 23, 60, 142, 146
fakes. *See* forgeries; replicas

Fashion and Fetishism: A Social History of the Corset, Tight-Lacing and Other Forms of Body-Sculpture in the West (Kunzle), 119
female deities, female images. *See* women
feminism, 89
fertility figures, 69, 75
Feuardent Frères, 92, *93* (*letter*), 96, 98, 101, 110, 141, 159, 195
Fitz, Walter Scott, 12
Fitz, Mrs. Walter Scott (Henrietta Goddard Wigglesworth Holmes), *13*, 60, 191
 letters of, 10, *11*, 12, 142
 presents Goddess and other art works to Museum of Fine Arts, 4, 7, 10–13, 14, 23, 143, 146, 150
Fitzwilliam Museum, 98, 99, 107, 139, 159, 172
Fitzwilliam Goddess (stone), 99, 100, *105*, 113, 118, 195, 214n4
 exhibited in London, 110
 as forgery, 168, 172
 price of, 97–98, 111
 origins of, 98, 106–8, 141, 159–60, 164
 restoration of, 140
Floros, P., 164, 195
Forbes, William T. M., 224n5
forgeries, 101, 159–64, 167–75
 ancient, 28–29
 ancient material used in, 184, 185
 Boston Goddess doubted, 153, 177–83, 187–88

"chess queen" of Walters Art Gallery, *95*, *96*, 159, 167
detection of, 183–87
erasure of provenience in, 92
Evans quoted on, 176
forgers' factory on Crete, 43, 169–72
prices of, 168
Schliemann suspected of, 37
of Tanagra figurines, *41*, 42–43, 157
See also Boy-Gods; "Our Lady of the Sports"; reconstruction and restorations; replicas
Fourier transform infrared (FTIR) microspectroscopy, 199
Fra Angelico, 12
Frazer, Sir James George, 71–72, 91, 104, 191
frescoes, 46–47, 73, 74, 111
 "Blue Boy," 133, *134*
 compared to contemporary art, 51–52, 54
 "Ladies in Blue," 134, *135*, 136
 as "Oldest Masters," 13
 "La Parisienne," 52, *53*, 54, 130–31
 Mycenaean, *88*
 Procession, 134, *135*, 167
 Taureador, *112*, 115, 134, 174
 restoration and replicas of, 121, 130–31, 134–37, 174
Freud, Sigmund, 79
Furies, the, 71
Fyfe, Theodore, 126, *188*

galvanoplastic technique, 136
Gardner, Ernest A., *27*, 28, 153, 154

gemstones. *See* sealstones, engraved

gender of images, 65, 71, 81, 87–89, 111–19, 155

and Boy-Gods, 110, 173–74

See also leaping figures; males, depiction of; women

Gennadeion Library (Athens), 147

Geological Society, London, 36

George V, king of England, 9

Gerhard, Eduard, 67, 70, 72

German Archaeological Institute (Athens), 136, 141, 142, 147

Germany, tombs plundered in, 19

Gérôme, Jean-Léon, 42

Gill, David, 106, 108

Gilliéron, Alfredo, 131

Gilliéron, Émile (*père et fils*), 122, 133, 192

catalogue of, 136, 137

Evans first employs, 56, 62

frescoes restored by, 115, 120, 126, 130–31, 133–35, 167, 174

and gold and ivory statuette (Boston Goddess), 141–43, 149–50, 152, 154, 176, 184

"Mother of the Mountains" sealing restored by, 73, 74

replicas created and sold by, 136–39, 138, 140, 171, 175

"Ring of Nestor" perhaps fashioned by *fils*, 157, 158

sketches by, 103, 121, 224n2

stamps designed by, 122, 138

Gilliéron, Émile III, 131

Gimbutas, Marija, 72

Giorgione, 31

Glaukos (son of King Minos), 80

Glotz, Gustav, 171

gold

analysis of, 185–86, 196, 201–3, 204

Egyptian (Eighteenth Dynasty), 186

gold-copper alloy, 186, 202, 204

gold loincloth, *see* Boy-Gods

Mycenaean goldwork, 139, 186

as ornamentation, 7, 17, 61, 92–95, 164, 171, 178–79

added during restoration, 182

stripped from Knossian ivory figures, 22, 23, 101, 178

See also chryselephantine statuettes

Golden Bough, The (Frazer), 71, 104

Gorgon Medusa, 77, 78

Gortyna, Crete, 18, 38, 46

Gothic design, 28, 50, 85

Gouri (goddess), 72

Gournia, Crete, excavations, 25

Great Goddess concept, 67, 89, 111

Great Mother. *See* Mother Goddess

Greece

ancient legal codes of, 46

antiquities from, 7, 37–38

Classical (Golden) Age of, 6, 9, 30, 37, 55, 59

Crete unified with, 45

deities of, 31, 65, 67–69, 72, 82, 88–89, 90

government control of excavations and exports, 19–20, 143, 147

and writing, 38

Greece, (*cont.*)
matriarchal myths of, 68
Minoan culture compared to, 75
patriarchal structure of society
of, 65
See also Crete; Greek mythol-
ogy; Knossos; Minoan civ-
ilization
Greek mythology
artifacts associated with, 37–38,
56, 58, 74, 158
deities of, *see* Greece: deities of
snakes in, 80, 82
Gruel, Leon, 164, 195

Hagia Triada, Crete, 137
Hajijannakis, Aristides, 20
Halbherr, Federico, 44, 46, 192
Hall, Edith, 157
Hall, H. R., 100
Harris, J. R., 186
Harrison, Jane, 66, 70–71, 72, 192
Harvard University, 137, 139, 201n
Harvester's Vase (from Hagia
Triada), 137, *138*, 139
Hathor (Egyptian goddess), 62, 75
Hatzidakis, Joseph, 44, 45, 192
Hawes, Charles Henry, *6*, 25, 55,
156
Hawes, Harriet Boyd (Mrs.
Charles Henry), 25, 35, 55,
146, 156, 192
Hellenic Society, 107
Hensley, George W., 79
Hera (goddess), 65, 67, 89, 90
Herakleion. *See* Candia (now
Herakleion), Crete
Herakleion Archaeological Mu-

seum. *See* Candia
(Herakleion) Archaeologi-
cal Museum
Hermes (god), 90
Herodotos, 30
Herrmann, J. J, Jr., 226n15
Hesiod, 72, 89
Hestia (goddess), 89
hieroglyphics. *See* writing systems
Higgins, Reynold, 42
Hill, Bert Hodge, 143–52, *145*, 192
Hill, Dorothy Kent, 96, 182
Hirsch, Jacob, 99
Hittite art, 85
Hoffmann, Paul, 23, 140, 197,
207n11
Hogarth, David, 59, 170, 192,
210n16
Holbein, Hans, 13
Holmes, Edward Jackson, 12
Holmes, Edward Jackson Jr., *6*, 14,
192
Holmes, Dr. Oliver Wendell, 12
Homer, 31, 37, 89
Horace, 31
"Horns of Consecration" motif,
177, 178
Hutton, Caroline Amy, 41
Hutton, Ronald, 67

I Brought Home the Ages
(Currelly), 111
Idaean Cave, artifacts from, 18, 121,
192
Ikaros myth, 9, 33, 38
Iliad (Homer), historicity of, 37
Illustrated London News, 106, 111,
113–14

Imperial German Archaeological
 Institute (Athens). *See*
 German Archaeological
 Institute
India, myths of, 68, 72
Institute for Aegean Prehistory,
 226n13
intaglios. *See* sealstones, engraved
Iron Age, 72, 226n15
Ishtar (goddess), 72
Isis (goddess), 72
Isnai (goddess), 72
Iswara (god), 72
Italian Archaeological School, 171,
 192
Italy
 gold from, 186
 matriarchal myths of, 68
 See also Roman
ivory
 ancient knowledge and use of,
 6, 182–83, 185
 radiocarbon dating of, 183–85,
 196, 198n, 199–201, 203–4
Ivory Deposit (Knossos), 58, 118,
 176, 178
ivory statuettes, 194–95
 anatomical details of, 172–73
 assembly of, 182–83
 forgers' factory, 169–72
 leaping figures (from Knossos),
 21–22, 56, *57*, 60, 137, *138*
 (*replica*), *181*
 See also Baltimore Snake God-
 dess; Boston Snake God-
 dess; Boy-Gods; Knossos;
 "Our Lady of the Sports";
 Palaikastro

Johnson, Buffie, 86
Jonas, Edouard, 194, 195, 221n15
Journey of the Priestess (Shepsut),
 85–86
Jung, Carl, 72
Juno. *See* Hera (goddess)

Kali (goddess), 89
Kalokairinos, Minos, 39, *40*, 43–44,
 47, 192
Kandinsky, Wassily, 16
Karo, Georg, *141*, 142–43, 150, 152,
 171, 192–93, 222n19
Karphi, Greece, 19
Kavousi, Crete, excavations, 192
Knossos, Crete, excavations at and
 artifacts from, 8–9, 13, 27,
 39–40, 44, 46–50, 91, 101
 along Royal Road, 154, 172
 antiquities purloined, 20, 22
 archaeological daybooks, 20, 22,
 49, 210n19
 see also Evans, Sir Arthur; loot-
 ing of archaeological sites;
 Palace of Minos
Knossos tablets, 20, 45–46, 90
Kunzle, David, 119
Kurz, Otto, 43
Kybele (goddess), 72, 74

Labyrinth, legendary, 9, 33, *34*, 35,
 38, *39*, 44, 55
 tangible underpinnings of, 46
"Ladies in Blue," 134, *135*, 136. *See
 also* frescoes
*Lady of the Beasts: Ancient Images
 of the Goddess and Her Sa-
 cred Animals* (Johnson), 86

Lady of the Sports. *See* "Our Lady
 of the Sports"
Lady of the Underworld, 80. *See
 also* Snake Goddesses
Lagrange, M.-J., 58
Lamb, Winifred, 106, 111
Lambert, E. J., 224n2
Late Antiquity, 7, 186
leaping figures, 21–22, *57*, 60, 117,
 118, 137, *138*, 172, 180, *181*
 restoration of, 56, 118, 137–38
 See also bull leapers
Leonardo da Vinci, 96
 Ginevra de' Benci, 16
Leto (goddess), 65
Levi, Doro, 171–72, 193
"Libyan sheath," 114
Linear B script, 46, *47*, 65, 90. *See
 also* writing systems
lion and lioness, connection of
 Goddess with, 74, 75
Loerke, William, 222n19
London Sunday Times, 119
London *Times,* 106, 107, 129
Longman's Magazine, 176
looting of archaeological sites, 17,
 21, 40, 42–43, 92, 157, 181
 in ancient times, 22
 and illegal export, 18, 19–20, 25,
 106
 and loss of context, 146
 See also smuggling of artifacts
Lucan, 29
Lucas, A., 186
Lysippos, 58

MacEnroe, John, 72
MacKenzie, Donald, 83, 84

Mackenzie, Duncan, 59, 61, 129,
 169, 193
 daybooks kept by, 22, 49, 210n19
Mademoiselle magazine, 16
Makrytichos, Crete, 39
males, depiction of, 65, 69, 74. *See
 also* Boy-Gods; gender of
 images; leaping figures;
 patriarchy
Marinatos, Nannó, 179
Marinatos, Spyridon, 171
*Marriage of Cadmus and Har-
 mony, The* (Calasso), 31
Marshall, J. H., 207n18
Marvin, Miranda, 225n6
Masaccio, 16
matriarchy. *See* women
maze. *See* Labyrinth
Mesopotamia, 9, 18, 37, 55, 72, 169
Metropolitan Museum of Art,
 New York, 3, 137, 139, 144,
 146, 166, 221n15
Meyer, Karl E., 153
MFA. *See* Museum of Fine Arts
Michel, Claude (Clodion), 42
Michelangelo Buonarroti, 58,
 168
Minerva. *See* Athena (goddess)
Minet-el-Bedia, ivory pyxix lid
 from, *88*
"Minoan" as term, 30, 35
Minoan civilization, 2, 7
 as antecedents of Greek myth
 and religion, 158
 art imitated, 28–29
 chronology, Evans's system of,
 50
 fall of, 64

females in imagery of, 65, 155
(*see also* women)
height of development of, 8, 15,
35, 59
modern interpretation of, 35,
51–52, 54–59, 72, 82, 88–90
Boston Goddess and, 187
restorations and replicas af-
fecting, 133–34, 175
religion of, 82, 89–90, 109–10,
114, 120, 161, 172
Evans's reconstruction of, 56,
67, 70, 74–76, 87–88, 104,
120
female deities, *see* women
Western interest in, 9, 13, 140,
156–57
See also Palace of Minos
Minoan Mother Goddess. *See*
Mother Goddess
Minoan Rhea, 74, 75
Minoan sheath, 111, 113, 173
Minoan Snake Goddess. *See* Snake
Goddesses
Minos, King (legendary), 30–31,
33, 34, 55, 65, 80, 89
ancient monuments linked to,
38
Law of, 46
palace of, *see* Palace of Minos
as Priest-King, 81
Minotaur, HMS, 40
Minotaur, myth of, 9, 33, *34*, 38, *39*
Mitsotakis, Jean G., 18
Mládek, J. V., 164, 195
Moak, Mark, 181
Mochlos, Crete, excavations, 136,
143

Monet, Claude, 12
Moon Goddess (Qetesh), 75
Morris, William, 54
Mother Goddess, 69–71, 87–89
Boy-God and, *104*, 110, 158, 173,
174
"Divine Mother," 80, 90
Evans's devotion to, 67, 73, 74–
75, 81
Egyptian, 75
ivory, 195
Minoan, 70, 72–75, 111, 195
King Minos linked to, 81
and "Mother idols," 70
"Our Lady of the Sports" as, 113
(*see also* "Our Lady of the
Sports")
profusion of fakes, 172
Snake Goddess equated with, 64
(*see also* Snake Goddesses)
stone, 195
Oriental, 70
prehistoric, modern views of,
69, 72, 73, 87–89, 91
Mother of the Mountains, *74, 84*.
See also Mother Goddess
Mount Dindymus, 74
Munich Glyptotek, 136
Museum of Fine Arts, Boston
(MFA), 3, 192
acquisitions by, 17, 139
Art School, 23
Annual Report, 8
Boston Goddess arrives at, *see*
Boston Snake Goddess
Bulletin, 8, 27, 153, 154
Centennial History (Whitehill),
22

Museum of Fine Arts, (*cont.*)
 Classical Art Department, 4, 6,
 25, 27, 187
 curators of, 4, 23, 143, 146,
 206n2
 Handbook, 15
 ivory and goldwork analyzed,
 185, 186
 Old Masters owned by, 13, 16
 reconstructions (of Boston
 Goddess) by, 15, 22–23, 25,
 87, 140, 154, 197
 Research Laboratory, 140
 analytical report by, 196–204
 staff photograph (ca. 1928), 6
Mutterrecht, Das (Bachofen), 30,
 68
Mycenae, Greece, Schliemann's ex-
 cavations at, 37, 59, 219n3
Mycenaean civilization, 38, 46,
 55
 artifacts from, 37, 133, 157, 186
 designs from, 124
 dominates Crete, 65
 gods of, 90
 price of replicas from, 139
Myres, John, 44
Myron (Greek sculptor), 59
mythology
 Celtic, 86, 179
 Greek, *see* Greek mythology
 and "truth in myth," 35
 Turkish, 68, 72, 74
Myths of Crete and Prehistoric Eu-
 rope (MacKenzie), 83, *84*

National Gallery, Washington, 16
naturalism, 58, 67
Near East, ancient, 35, 36, 38, 65

 Minoan culture compared to,
 75, 81
Neolithic period, 69, 70
Nero, reign of, 209n34
Newman, Richard, 220n15
Newton, Charles, 42
New York Times, 22
Nijinsky, Vaslav, 55
Numismatic Society, London, 36
Nuremberg Laws, 142

Oedipus and the Sphinx, *158*
Ogden, Jack, 186
Ogilvie, Robert, 198n
Olympics, first modern, 115, 121
Olynthos, Greece, excavations, 17
On the Origin of Species (Darwin),
 72
On the Trail of the Women War-
 riors: The Amazons in
 Myth and History (Wilde),
 119
Orchomenos, Greece, excavations,
 37
Orestes and Klytemnestra, *158*
Osiris (god), 72
Ottoman Empire. *See* Turkey (Ot-
 toman Empire; Anatolia)
"Our Lady of the Sports" (Royal
 Ontario Museum, To-
 ronto), 110, *111,* 112, 113, 115–
 19, 179, 194, 224–25n5
 gold of, 178
 origins of, 118, 141, 159
 price of, 110
Ovid, 29, 31
Oxford Boy-God. *See* Boy-Gods
Oxford University, 1, 37, 185. *See*
 also Ashmolean Museum

"Painter of Modern Life, The"
 (Baudelaire), 54
Palace of Minos (Knossos)
 Boston Goddess similar to arti-
 facts from, 29
 bull relief found in, 59
 destruction of, 64
 Domestic Quarter, 21, 56
 Evans excavates, rebuilds, 2, 9,
 35, 46–52, 62–64, 120–36,
 170
 faience statuettes found in, 60–
 64, 65, 75, 76, 120, 164
 Grand Staircase
 Isadora Duncan dances on,
 55
 repair of, 127, 128, 129–30, 170
 Inner Sanctuary, 125, 177
 ivory statuettes found in, 21, 56–
 58, 92, 159
 North Hall, frescoes in, 130
 pillaging from, 21
 plan of, 36
 as popular attraction, 131
 Queen's Megaron, 21
 scripts found at, 65
 Stepped Porch, 127
 Temple Repositories, 60, 61, 62,
 63, 64, 76, 77, 107, 120, 162,
 164
 dating of material from, 90
 Throne Room complex, 47, 48,
 49–50, 60, 120, 121, 177
 restoration of, 121, 123–25,
 126–27, 131, 132, 177
 Treasury, 21, 22
Palace of Minos at Knossos, The
 (Evans), 50–51, 58, 60, 64,
 71, 81, 100, 110, 160

frontispieces to, 59–60, 61, 62,
 76, 111, 177
illustrations in, 76, 77, 139
quoted, 4, 20–21, 55, 70, 101–4,
 108
Palaikastro, Greece
 gold and ivory youth from, 155,
 172–73, 179, 180, 181
 Marshall's "piracy" at, 207n18
Papadopoulos, John, 131
"Parisienne, La," 52, 53, 54, 130–31.
 See also frescoes; Knossos,
 Crete; Palace of Minos
Paris Opera, 121
Parthenon
 Hill's excavations inside, 147
 marbles from, 19, 58, 212n33
 Pheidias' statue of Athena in-
 side, 7, 106
Pasiphaë (wife of King Minos), 34,
 65, 80, 81, 212n33
 artifacts linked to, 38, 54
 Daidalos and, 31, 212n33
patriarchy, 65, 68, 69, 70–71, 89
Paul, Apostle, 29
Pausanias, 71
Peloponnesian War, 30
Peloponnesos, 30, 37
Pendlebury, John, 58
Perikles, 6, 7
Perrot, Georges, 39
Persephone (goddess), 67, 89
Persian Wars, 30
Phaistos, Crete, excavations, 171,
 192
 image from, 18
Pheidias (sculptor), 7, 106
Phillips, Ron, 1, 2–3, 143
Phiorakis, G., 20

Phoenician goddess of fertility, 75
Picasso, Pablo, 16
Pickman, David, 22
Pils, Isidore, 121
Piskokephalo, Crete, 162
pithoi, 39–40
Plundered Past, The: Traffic in Art Treasures (Meyer), 153
Pollock, Jackson, 16
polytheism, 65, 89–90
polythyra, 49
Poseidon (god), 31, 90
Pottier, Edmond, 53–54
Poussin, Nicolas, 13
prices, 91–92, 139, 157
 of Boston Goddess, 12–13, 146, 149, 150, 152
 of Boy-God, 99
 of forgeries, 168
 of Fitzwilliam Goddess, 97–98, 111
 of ivory statuettes, 168, 194–95
 of "Our Lady of the Sports," 110
 of Tanagra figurines, 42
Priestess figures. *See* Snake Goddesses; women: female deities
primitive thought and images, 51, 55, 70, 71, 72, 73, 79
Princep, Gavrilo, 4, 10
Procession Fresco, 134, 135, 167. *See also* frescoes
Prolegomena to the Study of Greek Religion (Harrison), 66, 70–71
Proserpina. *See* Persephone (goddess)
provenance, 16
 of Boston Goddess, 27–29, 152

of Boy-God, 108
of Fitzwilliam Goddess, 107
provenience, 16
 of Baltimore Snake Goddess, 92, 141, 182
 of Boston Goddess, *see* Boston Snake Goddess
 of Boy-Gods, 101, 104, 158–59, 172
 of Fitzwilliam Goddess, 107, 108, 141, 159–60, 164
 of ivory figure, 168, 194–95
 of Lady of the Sports, 118
 of stone Snake Goddess, 92, 159, 161–62
 See also forgeries; reconstructions and restorations; replicas
Pseira, Crete, excavations, 136
Psychro, Greece, 19, 212n33
Pueblo Indians, 79
Pylos, Greece, 191
 Nestor's tomb at, 157
 tablets from, 90

Qetesh (goddess), 75
"Queen of Valencia," 53
Quigly, Donald, 23

Radiocarbon Accelerator Unit (Oxford University), 184–85
Radiocarbon dating, 196, 198n, 199–201, 203–4
 carbon-14 tests, 184–85
Ragusa (Dubrovnik), Yugoslavia, antiquities stolen from, 19
reconstructions and restorations
 of Baltimore Goddess, 93, 143, 182–83

of Boston Goddess, *see* Boston
 Snake Goddess
of Boy-Gods, 140, 173, 207n11
of faience snake handlers, 62,
 63, 64, 93, 156
of Fitzwilliam Goddess, 140
of frescoes, 121, 134–36, 174
of leaping figure, 56, 118, 137–
 38
of Palace of Minos, 50–51, 120–
 21, 123–36, 170
See also forgeries; replicas
Rehak, Paul, 224n3
Reinach, Salomon, 52
Reinach, Théodore, 43
Rembrandt van Rijn, 13, 31
Renaissance, 42, 102, 109, 168, 185
 Minoan civilization and art
 compared to, 52, 56, 58
replicas
 of Boston Goddess, 140
 of frescoes, 130–31, *132*, *134*, 136–
 37
 Gilliérons' catalogue of, 136
 of "Minoan" artifacts, 139
 of Mycenaean goldwork, 139
 prices of, 139
 of Snake Priestess, 62, *63*
 See also forgeries
Rethymnon, Greece, antiquities
 from, 18
Revue de l'art ancien et modern,
 La, 58
Rhea (goddess), 74, 75
"Ring of Nestor," 157, *158*
Ritsos, Michael, 160
Robinson, David M., 17
Robinson, Edward, 146
Rodin, Auguste, 16

Roman
 antiquities, 7, 19
 coins, 39
 Church, 109–10
 civilization, writing in, 38
 concept of Great Mother, 68, 74
 culture, compared to Minoan, 75
 opinion of Cretans, 29
 society, patriarchal structure of,
 65
Romantic movement, 67
Rosetta Stone, 38
Royal Academy of Art, London, 13,
 110
Royal Institution, London, 96
Royal Ontario Museum, Toronto,
 110, 172. *See also* Currelly,
 C. T.; "Our Lady of the
 Sports"
Royal Society, London, 36
Rubens, Peter Paul, 31
Ruskin, John, 43, 211n32

Sakellariou, Agnes, 183
Sanborn, Cyrus Ashton Rollins, 6,
 25, 27
Sanctuaries of the Goddess: The Sa-
 cred Landscapes and Ob-
 jects (Streep), 87
Sandwith, Thomas B., 39–40, 41,
 42–43, 193
Schliemann, Heinrich, 37–38, 41,
 44, 45, 59, 121, 136, 151, 193,
 219n3
Scientific American, 58
scripts. *See* writing systems
Seager, Richard Berry, *8*, 55, 100
 as archaeologist, 1–3, 7, 9, 20, 25,
 35, 136, 193

Seager, Richard Berry, (*cont.*)
 and Boston Goddess ("the
 Lady,") 2–3, 143, 182, 187
 correspondence with Hill,
 144–46, 147, *148*, 149–51, *151*
 defends, 153–56
 illness and death of, 1–2, 21
sealstones, engraved, 18, 38, 44, 73,
 74, 83, 104, 105
 fake, 105, 157, *158*
Sears, Mrs. Sarah, 151
Seattle Art Museum, ivory "Boy-
 God" at, *97*, *99*, 100, *104*,
 109, 110, 173–74, 179, 185, 194
Selene (goddess), 72
Seltman, Charles, 96–98, 100, 106,
 107, 108, 110–11, 193, 195
Semitic Goddesses, 75
Seurat, Georges, 16
Shepsut, Asia, 85
Sicily, 30, 33
Simiriotti, D., 194, 195, 221n15
Smith College Quarterly, 25
smuggling of artifacts, 18, 19, 20,
 92, 106. *See also* looting of
 archaeological sites
Snake Goddesses
 Cambridge, *161*, 195
 chryselephantine, 6–7, 60, 177–
 78 (*see also* Boston Snake
 Goddess)
 gold from, 186
 Knossos (faience), 59, *60*, 62, *63*,
 64, 71, *77*, 107, 177–78
 as Mother Goddess ("Snake
 Mother"), 64, 80, 160, *161*,
 162, 195
 modern interpretations of, 80–
 82, 85

origins of, 92, 159, 161–62
restoration of, 62–64, 93, 156
Snake Priestess, 61, 64, 73–76, *77*,
 82, 87
stone, 160–62, *163*, 195
as symbol of strength, 89
terra cotta, 162, *163*, 195
whereabouts unknown, 194, 195
See also Baltimore Snake God-
 dess
snake handlers
 Minoan female, 4, 75, 76, 78, 81–
 82
 modern-day, *78*, 79
snakes, symbolism of, 76–77, 79–
 80, 82, 107
soap tin containing ivory frag-
 ments, 25, *26*, 139, 185, 198
Sophie, queen of the Netherlands,
 41
Spenser, Edmund, 31
sports, 114–19
 first modern Olympics, 115, 121
 Goddess of the, 74
 See also bull leapers; "Our Lady
 of the Sports"
Statius, 29
Steen, Jan, 13
Stillman, William James, 43–44
Stone Age, 69, 72
stone goddesses, 160–62, 195
Strabo, 38
Streep, Peg, 87
Sumerian art, 85

Tammuz (god), 72
Tanagra, Greece, and Tanagra
 figurines, 40, *41*, 42, 43, 52,
 96, 157, 182

Taureador Fresco, *112. See also* frescoes

Temple Repositories. *See* Palace of Minos

Tenau of the Golden Breast (Celtic goddess), 86

Tennyson, Alfred, Lord, 31

terra cottas, 40–41, 76, 108, 160
forgeries of, 42–43, 157

terra cotta Snake Goddess, 162, *163*, 195

Theseus myth, 9, 33, 38, 65

Thiersch, Hermann, 82

Thisbê gems, 104, *105*, 157, *158*

Thomsen, Christian Jürgensen, 72

"Throne of Ariadne," 50

Throne Room. *See* Palace of Minos

Thucydides, 30

Time and Chance (Evans), 45

Tintoretto, 12, 13

Tiryns, Greece, excavations, 37, 141

Titian, 31

Toronto figure. *See* "Our Lady of the Sports"

Trapeza, Greece, 19

Trier, Germany, Roman tombs at, 19

Trojan War, 33, 37
falsely "deciphered" account of, 209n34

Troy, excavations, 37, 44, 151, 191

Turkey (Ottoman Empire; Anatolia), 30, 37, 38, 45, 186
archaeological discoveries in, 37, 41
Crete governed by, 18, 40, 44, 45, 55

mythology of, 68, 72, 74
Minoan culture compared to, 55, 113

Tutankhamun, tomb of, 1, 2

Tylissos Goddess (stone), 162–64, 195

"Ugly Sisters," 162, *163*

Underworld, 75
Lady of the, 80
snakes as symbols of, 80, 107

University Museum, Philadelphia, 3

van Meergeren, Han, 168

Van Rensselaer, Mariana Griswold, 28, 82, 137, 140

Vapheio cups, *115*, 121, 139

Venetian empire, 39, 205n1, 211n32

Ventris, Michael, 46

Venus. *See* Aphrodite (goddess)

Venus of Willendorf (figurine), 69

Vermeer, Jan, forgeries of paintings by, 168

Vermeule, Cornelius C., III, 23, 25, 27

Vickers, Michael, 3

Victoria, queen of England, 35, 40, 69, 114

Victoria and Albert Museum, 139

Virgin Mary, 72, 75, 89

Votary figures, 64, 73, 107. *See also* women: female deities

Wace, Alan J. B., 106–7, 108, 118, 159, 168

Waddell, L. A., 85

Walters, Henry, 92, 93, 95, 96, 98, 164, 167, 172

Walters Art Gallery, 96. *See also* Baltimore Snake Goddess

Warburg, Andy, 79

Warren, Francis Bramley, 82

Waugh, Evelyn, 120, 134

Wells Cathedral, Somerset, England, 50

Western culture, foundation of, 9, 55, 59, 187

Wheeler, James R., 150

Whistler, James McNeill, 42

Wilde, Lyn Webster, 119

Winckelmann Institute (Berlin), 137, 139

Winstone, H. V. F., 221n19

Wolters, Paul, 136, 137

women
 clothing of, 52, 61–62, 64, 73–74, 93, 95, 107–8, 164, 167, *179*
 male clothing combined with, 111, 113–14, 117
 and modern fashions, 85, 119
 corseted, 52, 108, 117, 119, 162
 female deities, 65, 67–71, 73–76, 87–90
 in Greek mythology, *see* Greece: deities of
 female figurines, excavated, 65, 69–71, 155, 183
 bare-breasted, 3, 61–62, 73–74, 81–82, 83, 119
 female snake handlers, 4, 75, 76, 78, 81–82
 "La Parisienne," 52–54, 130–31
 and matriarchy, 67, 68, 70–71, 89, 104

role of, in society, 88–89
 and sports, 114–19
 See also gender of images

Woolley, Sir Leonard, 169, 170, 171, 173, 184

World War I, 4, 142

World War II, 85, 140, 142, 219n8

writing systems, 38, 44, 46, 65
 search for, 18
 significance of, 36, 38
 undeciphered, 90

Würtembergische Metallwarenfabrik, 136

Xanthoudides, Stephanos, 168, 193, 222n19

x-ray analysis of gold, 185–86, 196, 198, 201n

Young, William H., 97, 102, 140

Young, William J., 140, 185, 197–98

Younger, John, 222n19

Youth, gold and ivory. *See* Palaikastro, Greece

Yugoslavia, antiquities stolen from, 19

ZAF (fundamental parameters) method of metal analysis, 201n

Zeus, 30, 31, 65, 80
 Cave of the Idaean, 18, 121
 fake terra cotta, 157
 gold and ivory statue of, 7
 mother of, 74

Zygouries, Greece, excavations, 150